TIMEFRAMES

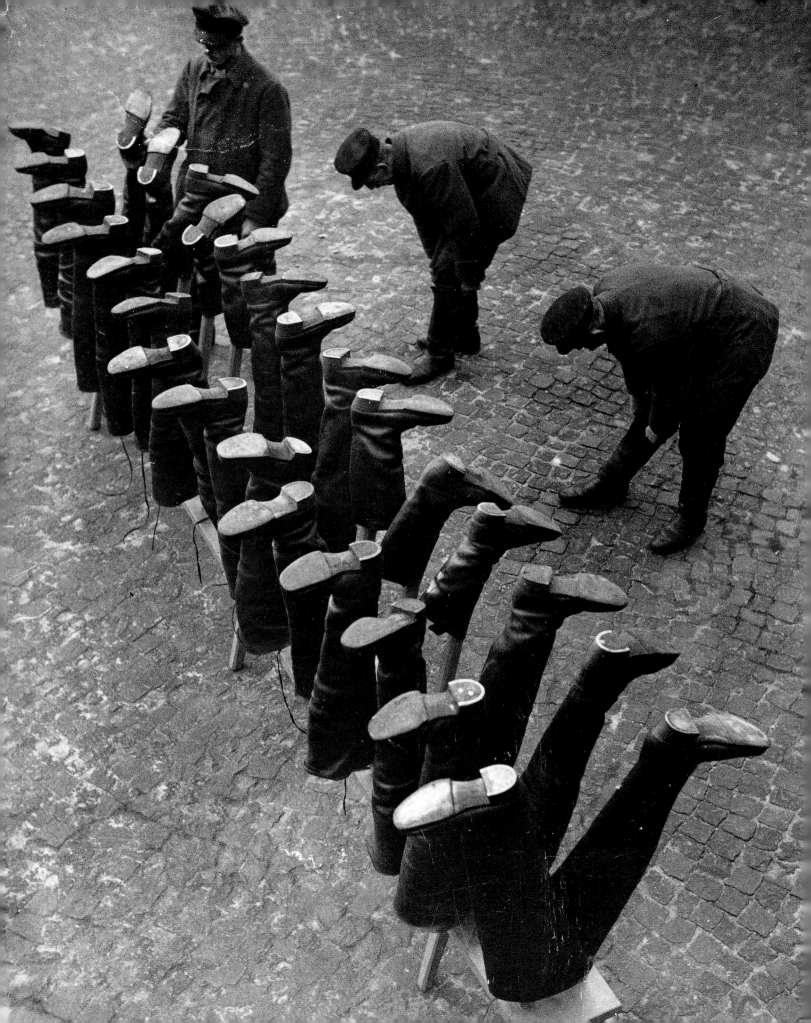

IAN JEFFREY

TIMEFRAMES

THE STORY OF PHOTOGRAPHY

AMPHOTO
A · R · T

Copyright © THE IVY PRESS LIMITED 1998

First published in the United States in 1998
by Amphoto Art,
a division of BPI Communications, Inc.,
1515 Broadway, New York, N.Y. 10036

Library of Congress Cataloging-in-Publication Data

Jeffrey, Ian.
 Timeframes : the story of photography / Ian Jeffrey
 p. cm.
 ISBN 0-8174-6015-2
 1. Photography--History--20th century. 2. Photography, Artistic.
 I. Title.
 TR15.J44 1998 98-34411
 770'.9--dc21 CIP

This book was conceived, designed, and produced by
THE IVY PRESS LIMITED
2/3 St Andrews Place
Lewes BN7 1UP, UK

Art Director: Terry Jeavons
Editorial Director: Sophie Collins
Designer: Alan Osbahr
Picture Researcher: Lynda Marshall

Printed in Hong Kong

First printing, 1998

1 2 3 4 5 6 7 8 9/06 05 04 03 02 01 00 99 98

C O N T E N T S

INTROD

P hotography participates in a collective imagination that changes its preferences from decade to decade, and even from year to year. We think of it as deeply involved in the mass media and in the shaping of public opinion. At the beginning, in the nineteenth century, when pictures were made for restricted audiences and assembled in albums that hardly ever saw the light of day, this was not the case. The twentieth century, with its mass markets and mass culture, has given photography both its audience and its subject. Beyond the short-term changes of style and subject matter, most evident in fashion photography, lie larger turns of mind, in particular Modernism and Postmodernism. The Modernist outlook prevailed between the World Wars, and then for some time into the 1940s. A typical Modernist photograph would feature a handsome human figure in action, enhanced by a backdrop of a wide expanse of space and sky. The figure might be a high-diver, a dancer, or a model, in the prime of life and an emblem of perfection.

Then Postmodernism introduced itself in the 1960s, and by the 1980s was virtually taken for granted. It might admit that the world was beautiful, but also that it was baffling, a scene of crimes and social collapse. If Modernist aesthetics were monochrome and abstract in tendency, Postmodernism favored saturated color and lush tropical backdrops. The Modernists knew more or less what they were doing because they were ideologues working for social justice and a better

1853

Thompson was originally an engraver who went on to make photographic records of displays in London museums. The self-portrait may have been inadvertent, but it adds another dimension to the picture, and aligns it with Postmodern art photography.

CHARLES THURSTON THOMPSON

Venetian mirror c.1700 from the collection of John Webb

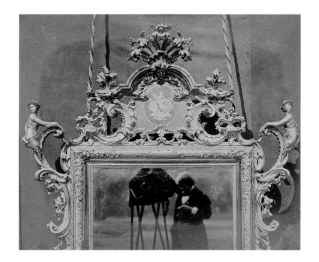

UCTION

future – although this future took distinctly different forms. Their successors, however, had more evidence at their disposal, and not all of it pointed to human perfectibility. They were haunted by the thought that present social systems were under threat, and that the fabric of society was likely to unravel. Photographers became interested in scenes of disorder, in part because such scenes figured as harbingers of a larger destiny.

Modernism, with all its confidence in New Men and Women, streamlining, design and organization, was a denial of the Symbolist outlook that flourished around 1900, especially in the arts and in photography. Artists in this period thought of themselves as seers able to respond to rhythms in nature, rhythms which underlay appearances. We were all seers up to a point, but artists were endowed with special sensitivity. The order underlying appearances could be apprehended anywhere, even in the noisiest streets of the biggest cities, but could be best sensed in the country, on the shores of lakes and rivers, among trees and reeds. Symbolist photography came into being in the 1880s, but by 1910 it had become commonplace and imitable. If almost anyone could

Bourne arrived in India in 1863. He took pictures throughout the area – including the Himalayas – at a time when the process was still laborious. One of the first documentarists, he represented India in normal terms, as a culture in action.

SAMUEL BOURNE

A burning ghat on the Ganges

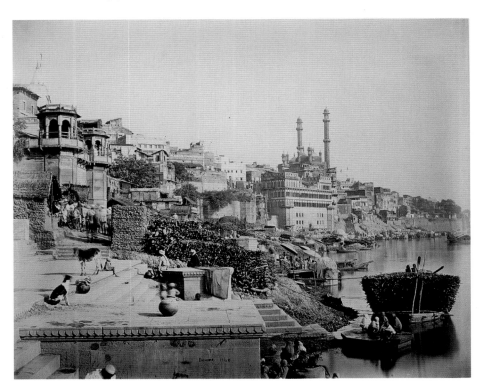

set up as an artist and seer, in touch with the depths beyond appearance, then those depths couldn't be worth exploring. Thus Symbolism passed into the public domain and lost its cachet and credibility.

Why do changes take place in art and in culture in general? The answer could be said to lie in changes in value systems that make old formats intolerable. Thus the idea of the artist as a specially sensitized seer became laughable in the context of the Great War. Photography history, however, qualifies such grand theories. The Symbolist phase, for instance, began to wane some time before World War I, and it was undermined by the advent of color, principally the Autochrome process, introduced commercially in 1907 by the Lumière brothers in France and soon taken up all over Europe. Color made a difference because it meant that pictures ceased to be abstractions, as they introduced more of the scent and look of the real world, or of things as they happened. Pictures started to be about local color, about oranges and lemons in boxes in local markets in the South of France. If pictures were no more than transcripts from the world as it stood, what then happened to the artist who became no more than an operator or agent? Color entailed quite sharp ethical difficulties for it classed the photographer as a largely passive tourist and consumer. Color was, in reality, a perfect medium for all those Postmodernists who chose to abstain from ethical judgments of any kind. It is worth noting that color, after the initial novelty had worn off, was not revived seriously as an artistic

c. 1880

Photography-of-record kept accounts and assumed a collective depository where such significant events as this would be noted. This aesthetic was based on the idea of a life deliberately assembled, rather than on one influenced by the culture of the moment – as would be the case in the 1920s and after.

UNKNOWN PHOTOGRAPHER, POSSIBLY
WILLIAM WILLOUGHBY HOOPER

A dead rhinoceros

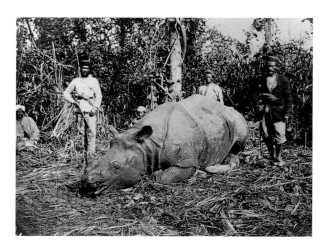

medium until the middle of the twentieth century, when conditions were more suitable for its value-free declarations. Modernism, or the manner of the interwar years, depended on the bright severities of mono-chromatic photography.

It is tempting to believe that technical developments made a difference, and that the history of the medium can be told as a progression. The example of color should stand as a warning against this simplistic formulation, as should that of instantaneity. It is generally agreed that the capability to take instantaneous pictures in available light was a giant step forward, made possible by the Leitz company in Wetzlar and the Ernemann company in Dresden in the 1920s – German manufacturers of the Leica and the Ermanox, respectively. It was because of these cameras that there was such an expansion of photojournalism in the late 1920s and through the 1930s. There had been a need for instantaneous reporting during World War I. It may have been a conflict on an epic scale, but its photographic reporting did no sort of justice to events. Instead, the war appeared as a series of demure episodes: the Kaiser on horseback, captured Russian guns, flat hori-zons with barbed wire. The Leica and Ermanox would in theory make it possible to transcribe events as they happened. However, events proved slippery, and the appetite for news was sated in the great age of photojournalism by a displaced reportage, more

The building of the new Opera House in Paris was recorded in detail, even stone by stone, as a commemoration and/or celebration of the work. The whole, c.1875, was most usually understood as an assemblage put together from such items as this – discrete pieces.

EDOUARD DURANDELLE
Sculpture Ornamental, Le Nouvel Opera de Paris

a kind of documentary, which had daily life for its subject rather than a record of great events. What emerged in the first great age of photojournalism was that movement and spontaneity were of interest in themselves, irrespective of their importance or otherwise on the world stage.

Any explanation of Modernism has to take account of the Great War. The cataclysm of 1914–18 encouraged its survivors to think of a future in which business – in particular other wars – would be carried out at one remove. Aircraft and tanks, developed toward the end of the war, seemed rich in promise so far unfulfilled. They put the future very firmly on the agenda. Aerial photography, developed during the war as an aid to artillery fire, also made it possible to envisage the earth as a map and as a resource ready for manipulation. The Great War reinvented photography as a new technique very relevant to the perfected future which so many had in mind.

Life at the Front also introduced a whole generation to firsthand experience of making and arranging: trenches, billets, gun pits. It was as if the industrial and metropolitan drift of European culture had been thrown into reverse, and a generation of bookkeepers was suddenly reintroduced to the fields, and to the tools and work practices of their peasant forebears. This accounts for the look of much interwar photography with its array of manipulable objects: tools, feathers, typewriter keys. Soldiers – especially in the German and Austro-Hungarian armies

This picture is taken from *Animal Locomotion*, a series of 11 folio volumes of 781 photo-mezzotint engravings, published in 1887. Muybridge's studies of animal locomotion were begun in California in the 1870s and finished at the University of Pennsylvania in 1884. The sheer ordinariness of his subject matter verges on the bizarre. His medium allowed him to look afresh at what had previously been taken for granted, and his discovery became an obsession.

EADWEARD MUYBRIDGE

Woman Throwing a Ball

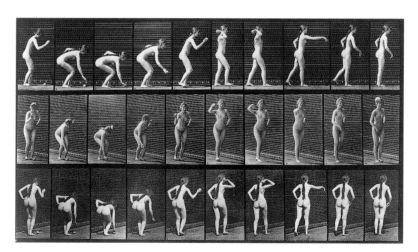

– were also inveterate photographers, using hand-held cameras to make reports on conditions behind the lines – reports that would go some way toward challenging bland official statements. It was during the war of 1914–18 that photography was first associated with truth to actuality. Many of the soldier-photographers of that war went on to become reporters in the 1920s and 1930s, and their skepticism established the tone of photojournalism.

Modernism was characterized above all by a respect for totalities and systems: the city, the state, welfare organizations. This sense cannot be ascribed to experiences in the Great War, but it did have important consequences in photography. In particular it encouraged photographers to think in terms of fragments: London, for instance, seen in terms of soup kitchens, late-night revelers, soldiers in uniform, swells in top hats. After 1939–45 this pervasive sense of small worlds, which might be invoked via details, disappeared in the face of ideas about a world culture.

Modernism had consequences, too, that outlasted the 1920s and 1930s. The new illustrated magazines of the 1920s (*VU*, which was set up in Paris in 1928, *Weekly Illustrated* and *Picture Post*, established in London in 1934 and 1938, respectively, are good examples) had an appetite for new material, and agencies under such names as Neofot, Fotoaktuell, Pacific and Atlantic, Pix, and Planet News distributed pictures far and wide of anything that would sell: dancing bears, barges, hypnotists, ocean liners, airships, ski resorts, and kindergartens.

1937

The picture was taken during a visit to Gee's Bend in Alabama, an isolated community of tenant farmers. It is a fine instance of documentary, of simply making known details of architecture, lettering, costume, and deportment. Good documentary – of the kind practiced by the Farm Security Administration – invites audiences to put themselves in the position of the other, writing on that improvised blackboard or wondering just how to place those letters in the space available.

ARTHUR ROTHSTEIN
Mr. Hale from Snow Hill conducting school in the Pleasant Grove Baptist Church building

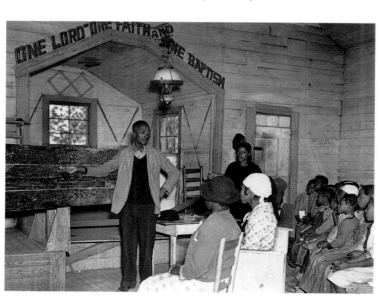

Photographers were thus under commercial constraints, and those who had their own political agendas could not declare them too strongly. What emerged was a photographic art rich in metaphor, and this remained true of photography from the 1930s through to the 1960s. Photography became an art of the imagination and helped to establish the idea that even if utopia itself might never be realized, there might exist a surrogate in the domain of art or style or fashion. This world of the imagination, which amounted to Modernism's last bid for utopia, usually goes under the name of Pop Art, but many of its adepts were photographers – fashion photographers especially: Armstrong-Jones, Avedon, Bailey, Bourdin, Donovan, Duffy, Klein, Newton, Penn.

Modernism had its flaws. There was a high point in the late 1920s when a few optimists believed in the powers of a new generation to make the world over again and in a lucid form. But there were forces abroad with other ideas. Modernism, or Functionalism as it is sometimes known, proposed a well-ordered common environment that might be applied anywhere at all or nowhere in particular. Nationalists were aghast, believing, as the Symbolists had done before them, in a special relationship between people and places – a relationship mediated chiefly by language and building. In Germany the nationalist response was to cite peasant people in their regions, traditionalists close to the soil. But a modern state, if it was to be competitive, also had to be up-to-date and efficient, or in a word, Modernist. The result, in Germany

c. 1945

The wheelbarrow and can on the balustrade show this as a site recently deserted or about to be occupied. Sudek's was a walker's view of landscape as ground to be crossed, paths to be followed, and steps to be climbed. This aesthetic was a personal or subjective response to the impersonal and managerial aesthetics of Modernism, which had attracted Sudek in the 1920s.

JOSEF SUDEK

Troia Park, Prague

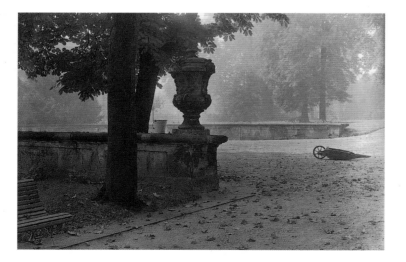

and elsewhere, was a hybrid style featuring modernized peasants at the controls of new machinery. In the later 1930s in the U.S.S.R., for example, and among photographers of the Popular Front in France, there were attempts to picture utopia as togetherness in communities and families, as if the future could be simultaneously well managed on a global scale and at the same time tolerant of particular differences. This tendency matured after the war and reached its apogee in the great *Family of Man* exhibition, devised by Edward Steichen at the Museum of Modern Art, New York, in 1955.

Modernism was undermined finally by the kind of thinking that underlay *The Family of Man*. In its heyday, around 1930, it had proposed, even if discreetly, one world ergonomically organized – a civilization of sorts. That utopian vision receded as more and more allowances were made for particular cultures, until the very notion of one world made up of many diverse cultures became contradictory and vacuous. In the end there were only other people, in other costumes, with other customs, radically alien – a Postmodernist precept.

The aesthetics of *The Family of Man* proposed a future in which cultural identities would be safeguarded. Photographers charted the decline of that notion. Maybe it just looked like wishful thinking and fell apart in the face of readily available evidence. Photography's first dystopia was uncovered by the Czech Joseph Koudelka taking pictures in Slovakian Gypsy communities in the 1960s – pictures only published

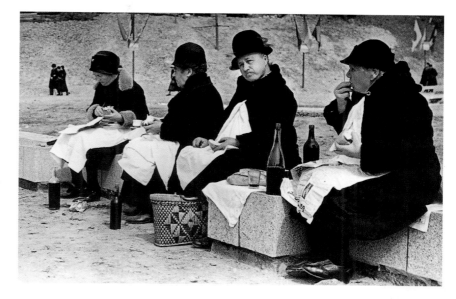

1937

The new documentary photography of the 1930s liked to reflect on ways of life or on what could be learned from the kind of details on show here: napkins, bread, newspapers, and wine. It was art respectful of cultures, and flourished from the 1930s through to the 1950s.

ROBERT CAPA

Calvados, Lisieux, the pilgrimage of Saint Theresa

1980

Moore, a major British artist in photography, understood landscape less as an objective terrain out there than as a theater of incidents instigated by his presence – subjective landscape, that is, responsible to his own sensitivities.

RAY MOORE
Harrington

in full in 1975 in *Gypsies*. Koudelka identified the sort of personnel who had figured in utopian cultural projections in the 1950s, but to him they appeared as survivors in decrepit, mud-stained contexts. With no sustaining idea to fall back on, as there had been in the 1950s, it became possible to imagine an apocalyptic end to history in which mankind, dressed in discarded sportswear, eked out a pitiful existence amid the ruins. The other major testimony to disenchantment in the 1960s was the work of Philip Jones Griffiths during the Vietnam War, published in 1971 in *Vietnam Inc.* The Vietnam War, as understood by Griffiths, looked like nothing so much as a campaign against the sort of cultural values that had been such an important part of the tolerant multicultural vision outlined in *The Family of Man*. Vietnam dealt the cards out differently, but the game still involved the old spectrum of values: an overbearing system in relation to a regional culture – even though the regional culture was itself committed to a world order of its own.

Though important, Vietnam was not a watershed in comparison to the collapse of the U.S.S.R. in the late 1980s. Since the 1920s Russia had exemplified social order and had often been portrayed as utopia realized. Its disintegration might have been welcomed, but it also made it possible to imagine anarchy on a world scale. In a society without long-term cultural commitments, the problem of potential breakdown becomes urgent. What will happen in the case of a massive economic collapse in any society without deeply rooted cultural institutions? Western photographers in the 1990s put themselves to examining this sublime possibility, using material from what were – at least from a European standpoint – small wars, often in Africa. Communism,

which was the Modernists' subtext, had capitulated, less from external pressures than from internal incapacity; and mankind's self-image was fractured in the process. What remained was a piecemeal approach to political difficulties, and an enhanced regard for the present – which alone seemed reliable.

The present moment had always been at issue in photography, and it was especially appreciated in the 1930s, mainly because it delivered the kind of fragments from which the whole – the city, society, the nation – would be constituted. It was also a staging post on the way to the better futures by which all set such store. For Postmodernists, however, in the 1970s and thereafter, it was as if utopia had been realized up to a point in the here and now. The present mattered as never before, and in its own right, and photographers tried to show it sustained and enhanced, or sumptuously colored and extended. One important consequence of this new regard for the moment as fullness was that it put early photography in a new light. Early pictures – especially albumen prints from the 1850s and after – were often taken from negatives exposed at length. They show the world as rich in objects, studiously represented in a tangible, varnished atmosphere. They represent things in their settings as if they might be weighed, measured, and even possessed. Photography's implication was that it had always been thus. Photography, the most natural of media, seemed to offer evidence that the Postmodern present had its own long prehistory, and that it was indeed endorsed by nature.

1948

Webb, who worked with a large-format camera for the Standard Oil Company from 1946 to 1949, took pictures of whole environments rich in the kind of traces on show here. This interest in mere facts – a torn newspaper and an eroding pavement – was exceptional in 1948, although 40 years later it would become the stuff of landscape, in what would be called New Topography.

TODD WEBB

Springtime flood on the Allegheny River, Pittsburgh, Pennsylvania, April, 1948

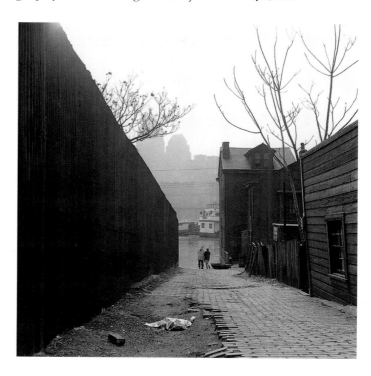

ADVENTURES

1998

This is a photomontage meant to advertise the Ariel Transport Company during the Great Exhibition of 1851 at the Crystal Palace, London. Llorens's tall story involves the ARIEL, a huge pioneer aircraft put on show in the Machinery Court in the Crystal Palace, and subject of a "famous" stereocard by the optician Jules Dubosq. The phantasmic ARIEL, it seems, was a steam-powered aeroplane developed by F. J. Stringfellow (1832–1905) and W. S. Henson. Llorens's account of the ARIEL is in progress.

MARTI LLORENS

Mr. John Stringfellow watching the ARIEL in flight over Gizeh

1934

Street pictures from India c.1930 are rare. This one is coded KLO, and was distributed by Leon Daniel, a small agency at 150 East 52nd St., New York. German captions introduce Bombay as a source of strange experiences, and the chalk-dusted fakir as the true ruler of the bazaar – due to the power of his curse.

UNKNOWN PHOTOGRAPHER

Bazaar in Bombay

They went to Egypt originally to take pictures of ruins and of statuary, and then to the Holy Land for the sake of the sites; after that to India to record the new railroad system, bridges, temples, landscape, and the people. Adventures came their way, but they weren't necessarily welcomed for in the 1840s and 1850s photographic processes were cumbersome and the operatives vulnerable. After surveys of the American West, China called – because of the possibilities of trade – and by the 1870s photography, with the development of dry plates, became more convenient. Scouting for trade meant looking at roads, waterways, and at the fabric of life, on behalf of those who would follow.

China was as intriguing as India, and established itself for Europeans and Americans as the epitome of all foreign lands. China was complemented by the Antarctic, a supreme testing ground in which nature set the agenda. The Great War was both thrilling and fatal, and afterward excitement began to center on the cities – Paris, London, Berlin, and New York – in which new civilizations were in the process of formation. Metropolis kept its cachet through the 1950s and 1960s at least. Europeans in the 1930s also turned to the U.S., home of the West and of wide-open cities, such as San Francisco. The photographer-traveler became as accepted a figure as the travel writer, and Magnum Photos – set up in 1947 – is the living testament to that idea. As the genre became established, newcomers traveled farther afield, meeting greater dangers; in Africa and in the newly established lawless zones – the old U.S.S.R. in particular. Behind the practice lay an impatience with the settled, suburbanizing cultures of the West.

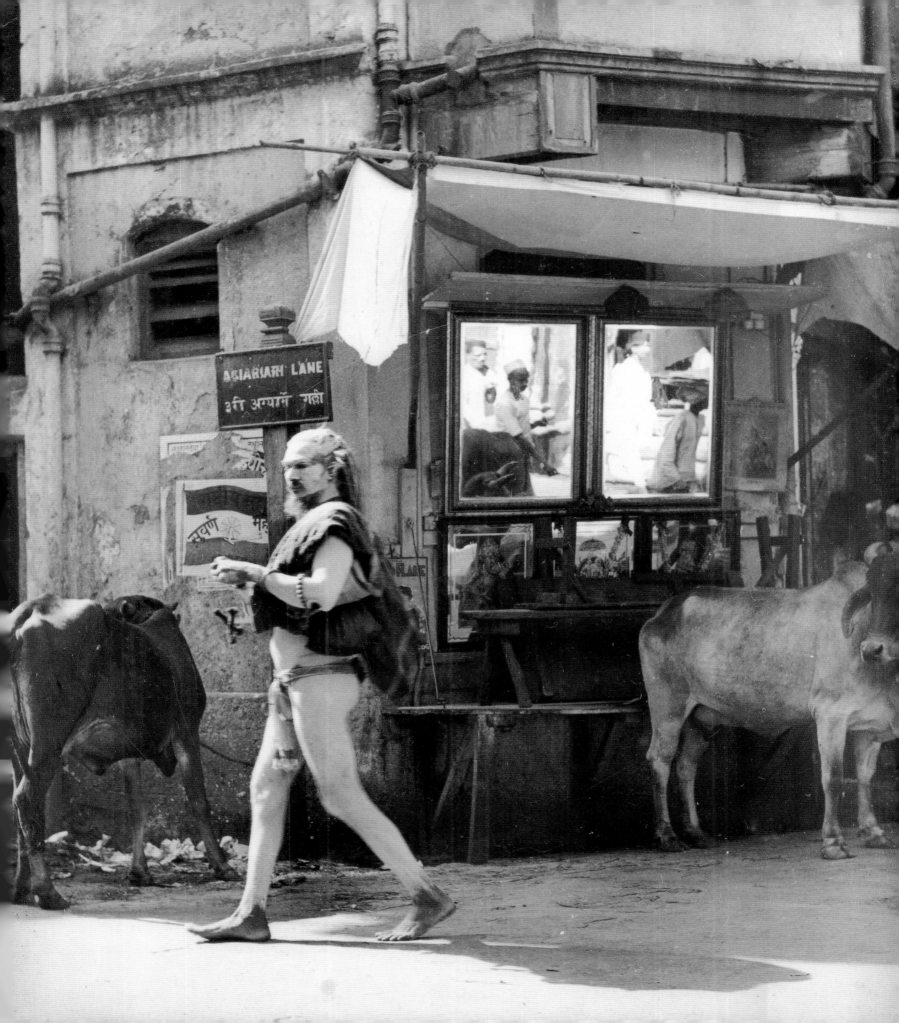

Photographers have always traveled for the sake of events and sights far away from home. The documentary photographers among them take an interest in just how things are done in foreign cultures, but there are others drawn more to the excitements of travel rather than to the particulars of housing and agriculture.

The photography of adventure is a response to the secure and the predictable, to suburbias of the mind – somewhere else social order and convention have been thrown to the winds. In the 1920s, that would probably have been Paris – if not Paris, then Berlin, London, or New York. But although the metropolis appealed to artists, not all photographers were artists. Many were geographers, naturalists, explorers, or simply curious. In the 1880s and 1890s they went to China, photography's first land of adventure. It was renowned for opium dens and strange customs, and it figured strongly in the imagination of Europeans. At around the same time, there was the Antarctic of Scott and Amundsen, a supreme testing ground free from all the distractions of advanced and complex cultures. By the 1930s, the Balkans, characterized by secrecy, coups, exotic dynasties, and an archaic peasantry, had become Europe's idea of an adventure playground – much as the former U.S.S.R., with its picturesque cast of bandits and bosses, has in the 1990s.

1870

Thomson, a Scotsman, arrived in Hong Kong from Singapore in 1868, and in 1870 he began to photograph on mainland China. Thomson used the wet collodion process, which meant that plates had to be prepared and developed on the spot, after which they were packed for carriage and later printing back at Thomson's base in Hong Kong.

JOHN THOMSON

Our interpreter Chang

A theory for adventure photography might be: the greater the actual danger, the more restrained the acts of the imagination, and vice versa. If apocalypse seems to be just around the corner, then there is every incentive to wish normality back into being. On the other hand, it is apparent that, despite many crises, Western cultures became more and more ordered and conformist as the twentieth century unfolded, and with that stability came a nostalgia for more dangerous times and a craving for adventure.

From the early 1930s onward, the U.S. played host to many of photography's adventurers. German reporters in particular began to travel throughout the country on behalf of German agencies, such as Presse-Photo. Europe at this time was becoming overbearingly ideological

as either Communism or Nationalism gained ground. As a matter of course, reporters from Berlin and Paris took sides, sometimes at their employers' behest. Reporters worked under instruction and were required to specialize in folk-life, high society, or the world of manual work. Specialization was irksome because it classed the reporter as an artisan at a time when any newcomer with ambition was only too aware of the liberating influence of the Surrealists, whose revolutionary spirit and disturbing dream imagery had quickly become common currency in the renewed art of advertising.

One way out of the impasse in the 1930s was to travel to exotic cultures, such as those of the U.S. and India. Travel liberated for if your subject was a nation and its culture, there was no

need to concentrate on the details of everyday life. The U.S. was no more than a general notion to European audiences – it seemed to be a place where anything was possible, as indeed it was in a culture evidently in the process of inventing itself. The U.S. developed a reputation among libertarian photographers in the 1930s that it never lost. It remained a land of adventures, its wide open spaces in sharp contrast to a Europe inhibited by frontiers.

This is not to say that the Americans themselves took this view. Indeed, local American photography in the 1930s was as constrained as anything in Europe. The Depression presented a problem, to be overcome by the promotion of national icons: images of attentive motherhood and persevering labor. When tension began to relax in 1945, with the war over and prosperity restored, American photographers, too, took to the roads,

but without fanfare and on journeys of discovery – as if informality itself were something to wonder at in its own right.

Adventure photography developed on a large scale in the 1930s, mainly because the newly disciplined societies of that era called the concept of freedom into question. Photographers set out for cultures less regimented, more improvised, and above all, heavily inscribed with handwritten texts and signs which looked like expressions of the national will in formation. They turned away from society as a whole, continuing to deal with it only insofar as it could be encountered face to face.

GOING WORLDWIDE

The war of 1939–45 raised the stakes in photography. In the 1930s it was mainly a question of finding benign and small-scale alternatives to the massed ranks of the régimes. After 1945 it became necessary instead to act on behalf of humanity itself across the globe, as if the fabric of life everywhere could be transformed for the better. This was a tall order, and photography's role was to advertise such traditional groupings as could be found in a world newly emerged from a world war and badly shaken by the evidence of the Holocaust and the atomic bomb. Children, craftsmen, monks, and musicians were the icons of this new age, which culminated in 1955 in the

San Francisco's Chinatown had been destroyed by earthquake and fire in 1906, and Genthe's pictures, originally meant for friends and relatives back in Berlin, stood as the main record of what had been a picturesque area in the city. American Chinese, subject to earlier abuse and persecution, had made for themselves a close, private culture in San Francisco which intrigued the scholarly Genthe.

ARNOLD GENTHE

The Alley

The Family of Man was prepared in 1955 by the Museum of Modern Art, New York. It became photography's most celebrated exhibition and featured every major name in the business. Photographers had toured the globe since 1945, and their labors and adventures were systematized in this great compilation, edited by Edward Steichen and Wayne Miller.

Family of Man exhibition, a world survey put together under the auspices of the Museum of Modern Art in New York. Magnum Photos, a cooperative picture agency set up in 1947, became synonymous with this new tendency. One of its founders, George Rodger, traveling at length in Africa in the mid-1950s, came across everything that the moment desired in the shape of isolated tribes people in the Sudanese interior. Werner Bischof, another early photographer with Magnum, made similar discoveries among traditional communities in Japan and Indonesia. In 1955, Bischof was killed in a road accident in the Andes. Photographers risked their lives on behalf of humanity, but the risks were still not part of the subject.

Bischof, Rodger, and other photographers of that generation traveled in pursuit of an ideal rather than to present the search itself. Contemporaries and successors, some of whom also worked within the Magnum organization, were more skeptical. Events – certainly as they unfolded on the world's stage – couldn't properly be fathomed. Instead, they were to be acknowledged and witnessed rather than explained. The most mysterious of these events was the Chinese Civil War of the late 1940s, which was photographed by Henri Cartier-Bresson, another founder of Magnum Photos. Cartier-Bresson's tactic in China, as it had been earlier in India in the 1940s, was to present events in fragments or as part of a continuum. Cartier-Bresson's account of China, *D'une Chine à l'autre,* was first published in 1954 in France. Its influence still can't be assessed, but it amounts to the first admission on a large scale that neither the causes nor consequences of events can be fully comprehended. This outlook soon became widespread in reportage, and photographers who had briefly been touted as representatives of a new and kindly world order in the immediate postwar years came to present themselves more and more as loners

thrown back on their own resources. That old view of history, as something that can be contested, was no more.

From the 1950s on, there was no possibility of a consensus regarding the make up of a picture. Photographers now traveled knowing that decisive moments were out of the question – the phrase itself, "the decisive moment," only entered the mainstream in 1952 with the publication of Cartier-Bresson's famous retrospective under that title. Henceforth, there would only be "moments," most of them personal, cryptic, and transient. Photographers traveled as before, but now chose to admit that they mostly came across the commonplace: others as enigmatic as themselves occupied the half-light on the edge of towns too insignificant to mention. The major instance of this new photography was Robert Frank's *The Americans* published in France and in the U.S. in 1958–59. Frank brought his own mindset and personal poetics to the business, and *The Americans* is a culture seen through a temperament. At more or less the same time, René Burri, another Swiss and an early member of Magnum Photos, traveled through Germany meeting or running up against its people – no longer the "representative" people of the 1930s, but individuals wrapped up in the moment.

Frank, Burri, and others in the 1950s – Josef Sudek, for example, intent on Prague – refused to take daily life for granted. It was, they proposed, as indecipherable in its details as history was in toto. Photographers were determined to contradict the idea of normalization or of calculable lives lived out in the light of opinion polls.

To make their point, they went farther and farther afield. Ed van der Elsken, the great Dutch contemporary of Frank and Burri, went to Africa in the 1960s and emerged with *Bagara*, the chronicle of a barbaric hunt placed within a context of village life, which looked back to the idealizing vision of *The Family of Man*. Van der Elsken's suggestion was that comforting formats have to be treated with reserve. *Bagara* anticipates a great deal in its combination of the garish hunt and the normality of village life.

HIDDEN AGENDA

Frank and Burri had gone to extremes, presenting themselves as solitary excursionists. That tendency became lodged in American photographic aesthetics in the 1960s. Other photographers – like van der Elsken – preferred as they traveled to invoke something of the world they had left behind. The hidden agenda that shaped this kind of photography from the 1960s on, claimed that society, no matter how established it might appear, held within it the seeds of its own destruction, and that nothing could be taken for granted. The Iranian Revolution of 1980 was a case in point, brilliantly envisaged by Gilles Peress in *Telex Iran* as having been carried out behind closed doors. The tendency culminated in the collapse of the U.S.S.R., the most normalized of societies, suddenly exposed to fortune, contingency, and all that was unpredictable.

A photograph taken from van Manen's book of 1994, *A hundred summers, a hundred winters,* a collection of 73 pictures from Russia – portraits mainly of people at home, eating, bathing, waiting, and responding, sometimes apprehensively, to the photographer. Van Manen's Russia, like that of Carl De Keyzer, is both a report and an anticipation of post-industrial society everywhere.

BERTIEN VAN MANEN
Novokuznetsk

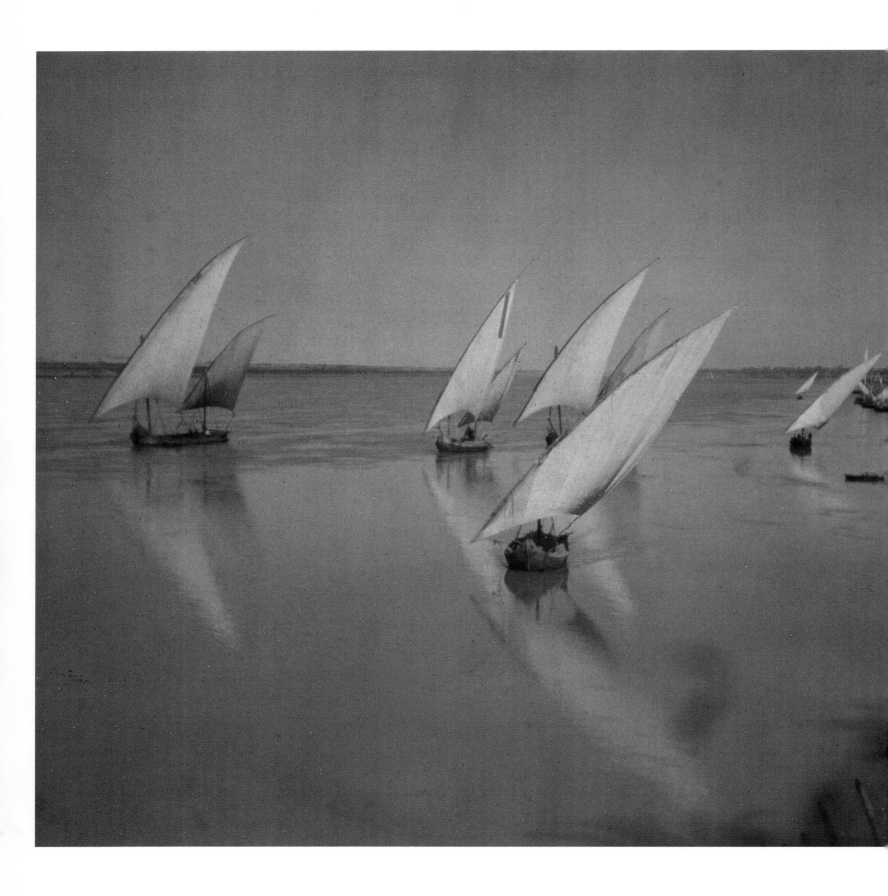

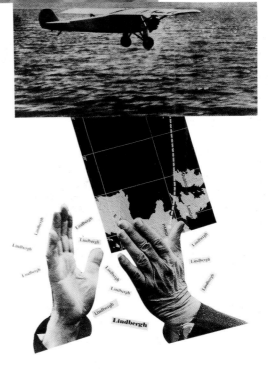

In this photocollage Berman, a Polish graphic artist, celebrates Lindbergh's first solo crossing of the Atlantic: 33½ hours, from New York to Paris. Modernists in the 1920s were intrigued by the promise of new technology. It would dissolve the old earthbound order with its boundaries and national distinctions – at least in theory. In the 1930s, however, aviators were seen increasingly as symbols of national prowess. Lindbergh's exploit, on the other hand, seemed to stand for the future in general.

MIECZYSLAW BERMAN
Lindbergh II

Murdoch was an American who traveled and photographed, using the new Autochrome process, which had been developed in France by the Lumière brothers and made public in 1904. Autochromes had a pointillist look, due to the colored starch grains of which they were composed, and allowed photographers to register elements – such as sails, skies, and the surface of rivers – that would formerly have been seen as mere intervals between objects.

HELEN MESSENGER MURDOCH
The Nile at Luxor

Pacific Fair (*Rummel am Pazifik*)
was a series of around
20 pictures prepared by an
anonymous photographer for
the Berlin agency Presse-Photo.
It shows America both in an
attractive and a degenerate light,
as a culture of distractions – the
sailors, testing their strength, are
meant as parodies of the heroes
of labor then so popular in Soviet
and Fascist documentary-
propaganda. This tour through
the entertaining U.S. by a
secretive (detective) cameraman
anticipates much of the low-life
photo-reportage of the 1940s
and 1950s. The agency's caption
reads: "Artificial stars spread
their light over visitors."

UNKNOWN PHOTOGRAPHER

One o'clock in the morning

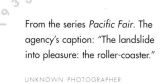

From the series *Pacific Fair*. The
agency's caption: "The landslide
into pleasure: the roller-coaster."

UNKNOWN PHOTOGRAPHER

Six o'clock in the afternoon

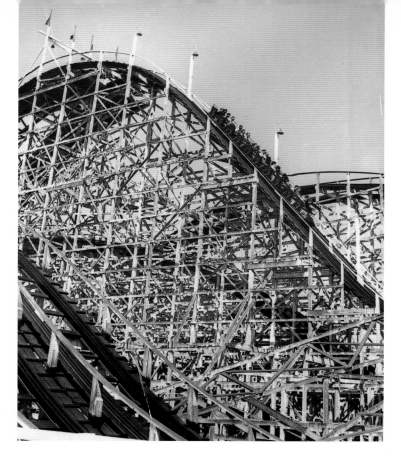

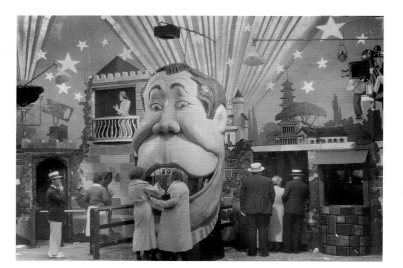

From the series *Pacific Fair*.
The agency's caption: "Physical
strength in action: American
sailors win prizes. The ball has
to be thrown hard at the target."

UNKNOWN PHOTOGRAPHER

Two o'clock in the morning

24

1933

From the series *Pacific Fair*.
The agency's caption: "5 cents
for sex: naturally there are
peep-shows too on the
fairground at Ocean Park."

UNKNOWN PHOTOGRAPHER
Three o'clock in the afternoon

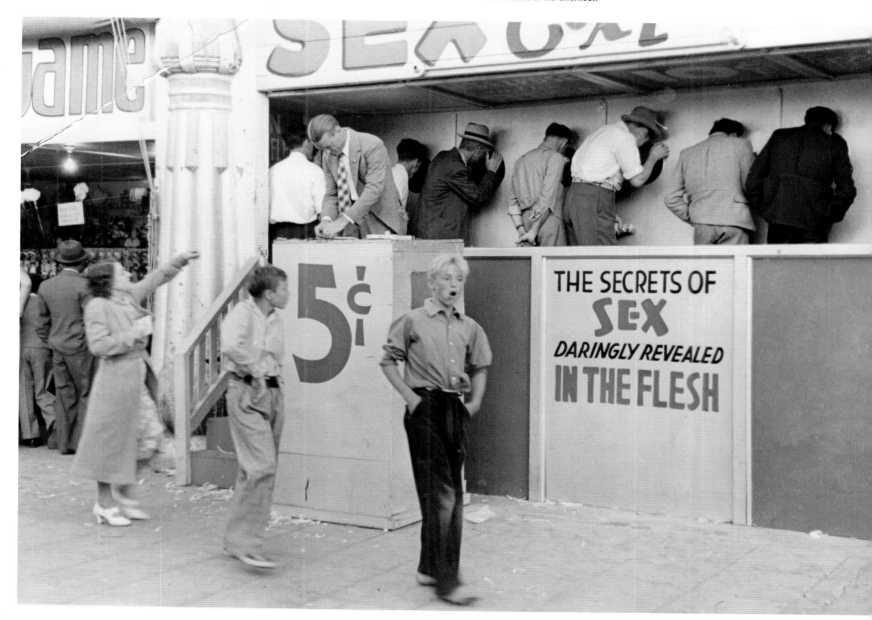

THE SECRETS OF
SEX
DARINGLY REVEALED
IN THE FLESH

1934

This was part of a series
prepared on the death of the
West for Presse-Photo, a Berlin
agency for which Gutmann had
worked since leaving Germany
in 1933. Gutmann, brought
up like all Europeans on the
myth of the West, was
surprised by its actualities:
drive-in restaurants, jitterbugs,
burlesque displays, majorettes,
and advertising everywhere.

JOHN GUTMANN

**The Saddle,
Rodeo Salinas, California**

1934

From the same series on the death
of the West, or its incorporation
into the new commercial culture.
Gutmann was the first European
to identify the American
vernacular as fascinating
in its own right.

JOHN GUTMANN

**Around the rodeo –
a moment of tension**

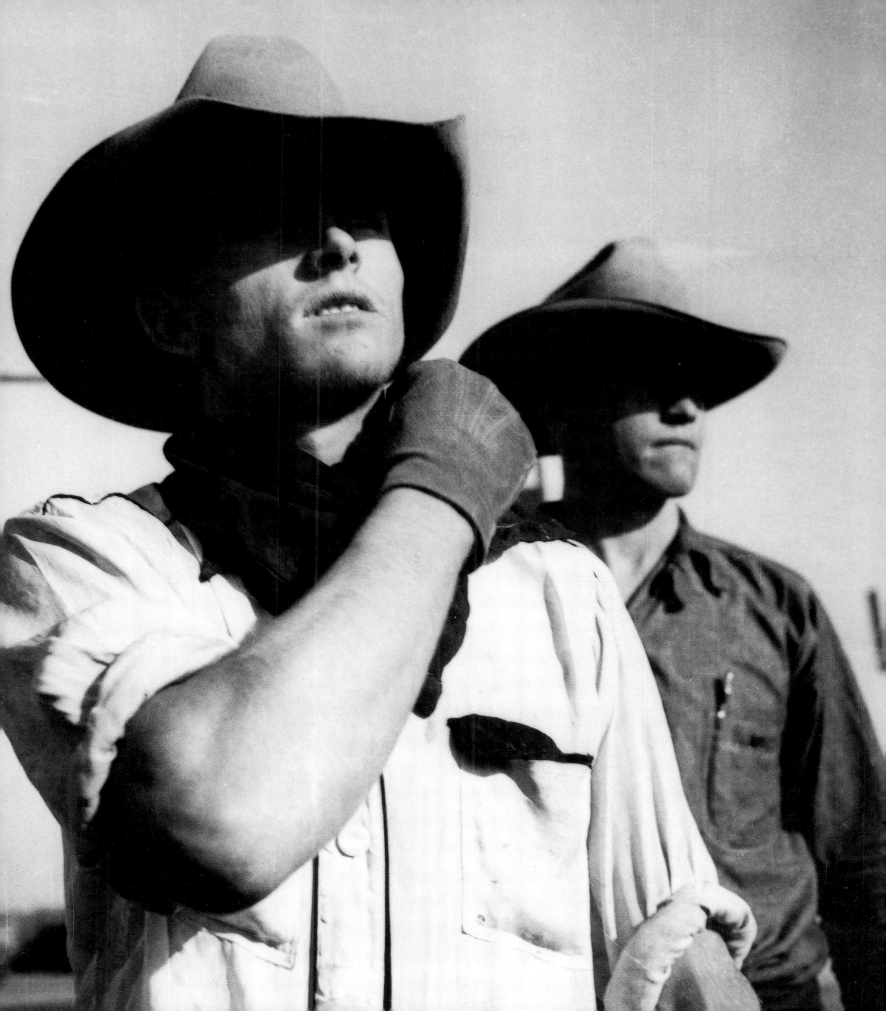

1943

Bubley took the three pictures shown here for the U.S. Office of War Information, with reference to the difficulties faced by traveling soldiers on leave in wartime. Bus travel introduced Bubley to a wide range of people, incidents, and anecdotes; and it was through trips such as these that the idea of photographic excursions through the U.S. became well established.

ESTHER BUBLEY

The highway between Gettysburg and Pittsburgh photographed through the windshield of a bus

1943

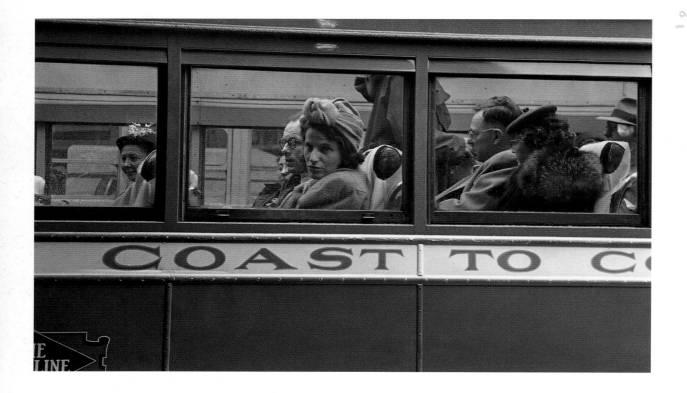

Bubley began to work for Standard Oil in 1943 as a documentary photographer. This "bus story" of 1947 won her fame and awards, and helped to confirm the idea of the highway as habitat – a commonplace of the 1950s and 1960s.

ESTHER BUBLEY

Loaded bus ready to depart the Greyhound bus terminal, New York City

1943

Whereas documentary photographers of the 1930s focused on problematic extremes, their successors in the U.S. in the 1940s began to look at the people in general and almost at random.

ESTHER BUBLEY

Passengers waiting to board the Greyhound bus to Memphis

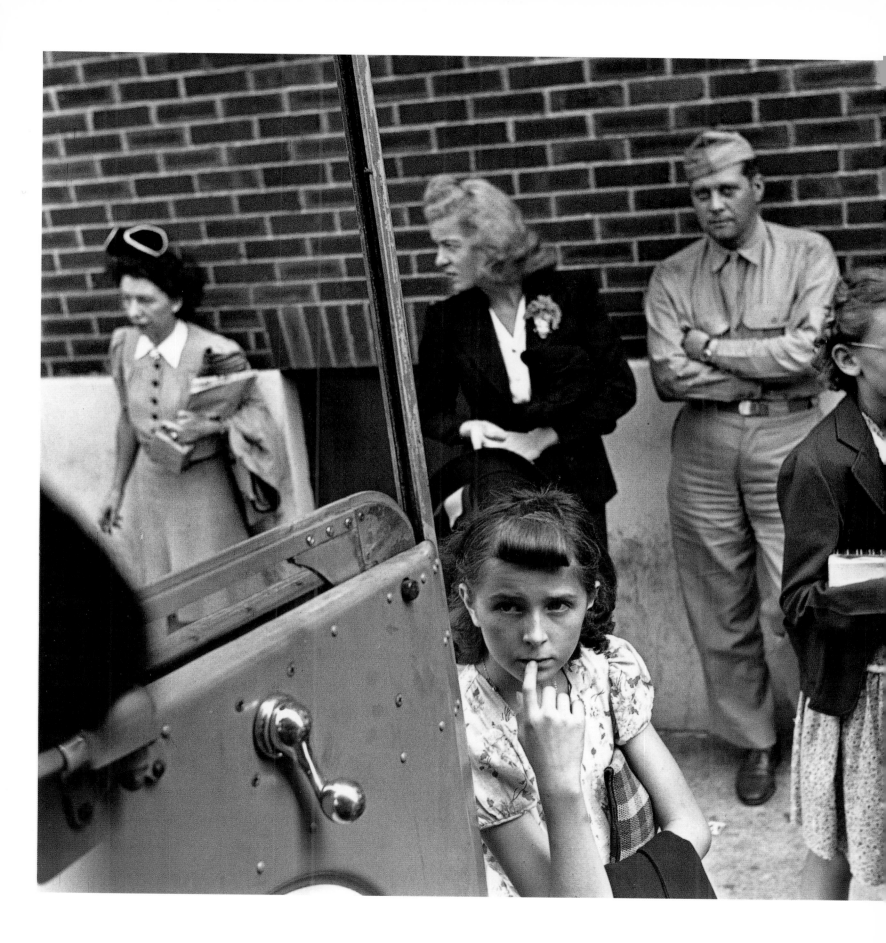

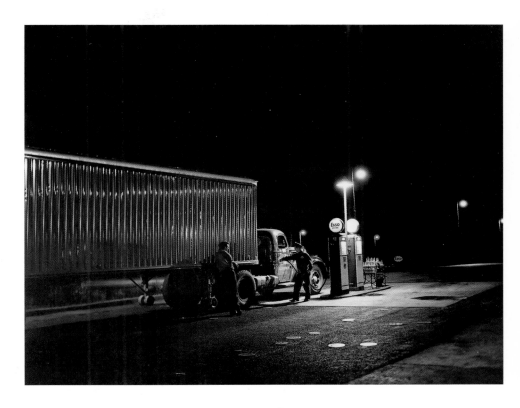

1945

Libsohn, a member of the important Photo League in New York in the 1930s, went to work as a documentarist for Standard Oil in 1943. On one two-month assignment he set out to record the life of truckers – this in the period before the building of America's interstate highway system. Libsohn's vision is of heroic national workers able to endure the kind of solitude touched on by the painter Edward Hopper.

SOL LIBSOHN

Refueling on the Pennsylvania Turnpike, Bedford, Pennsylvania

1945

In addition to the "trucking story," Libsohn completed an in-depth picture story on the Ringling Brothers Circus in 1946. He worked for Standard Oil until 1950.

SOL LIBSOHN

Trucker driving at night, US 22 Pennsylvania

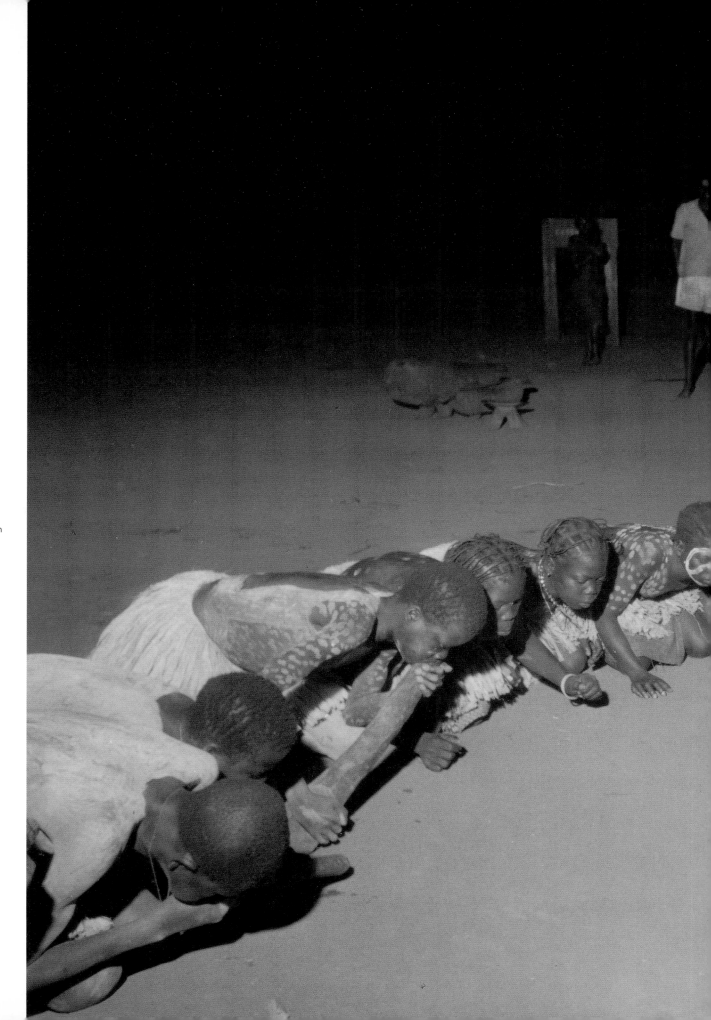

1961

The photographer, working
with a Leica and flash in the
midst of ceremonials and hunts,
gives an impression of immersion
in events never previously
considered or achieved in
photography. The picture is
from van der Elsken's *Bagara*
(1961).

ED VAN DER ELSKEN

**A circumcision rite of
the Ganza tribe**

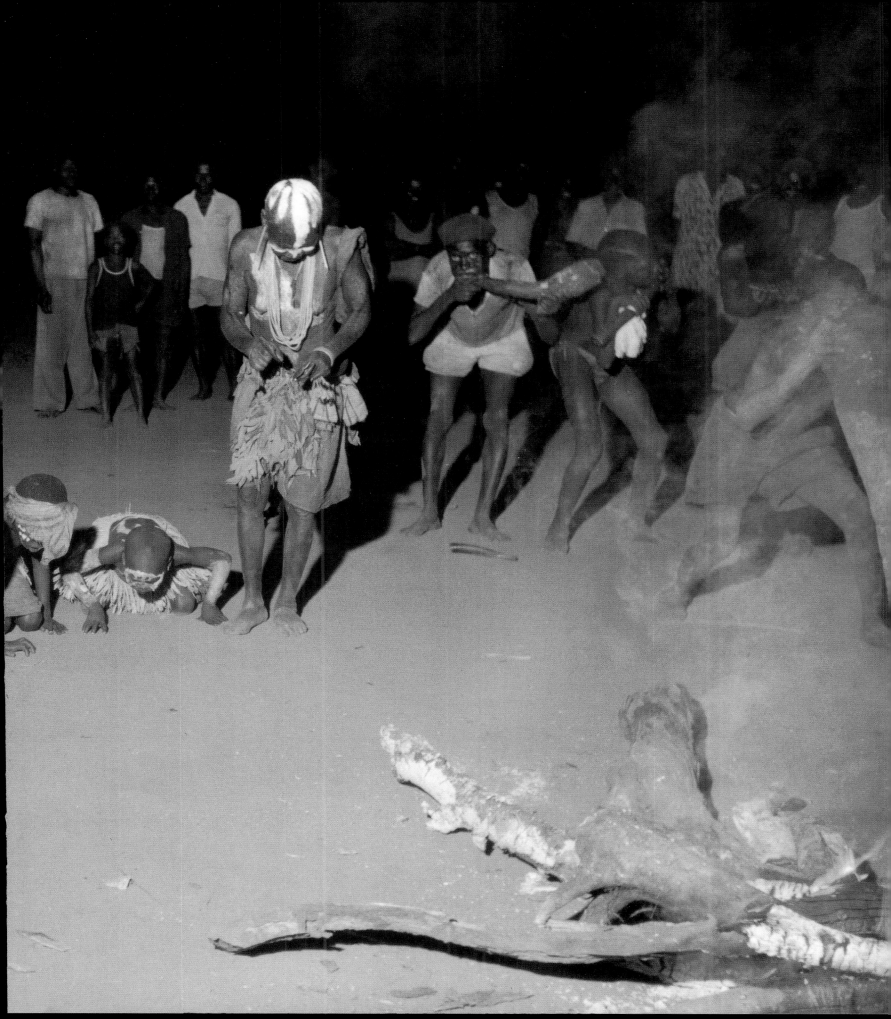

1983

Peress's photographs, taken on Leica M4 and M3 cameras during a five-week period after the Iranian revolution, December, 1979, to January, 1980, "do not represent a complete picture of Iran or a final record of that time," to quote the photographer's own disclaimer. His pictures are, as here, less of the news itself than of a culture and the events that shape it, events that can be viewed only through a glass darkly and surmised at a distance.

GILLES PERESS

Tea shop, Tabriz

1989

In 1988–89, De Keyzer, a Belgian
photographer and member of
Magnum, paid 12 visits to the
U.S.S.R. His pictures of daily life were
published in *Homo Sovieticus* (1989)
and introduced via Russia a prospect
of post-industrial society at large.

CARL DE KEYZER

**Irkutsk, Siberia,
along the shore of Lake Baikal**

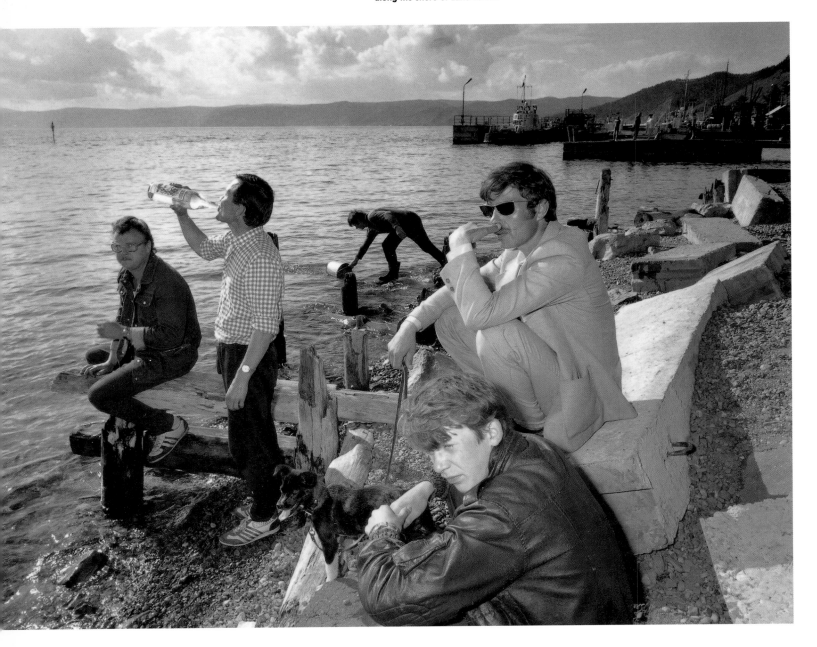

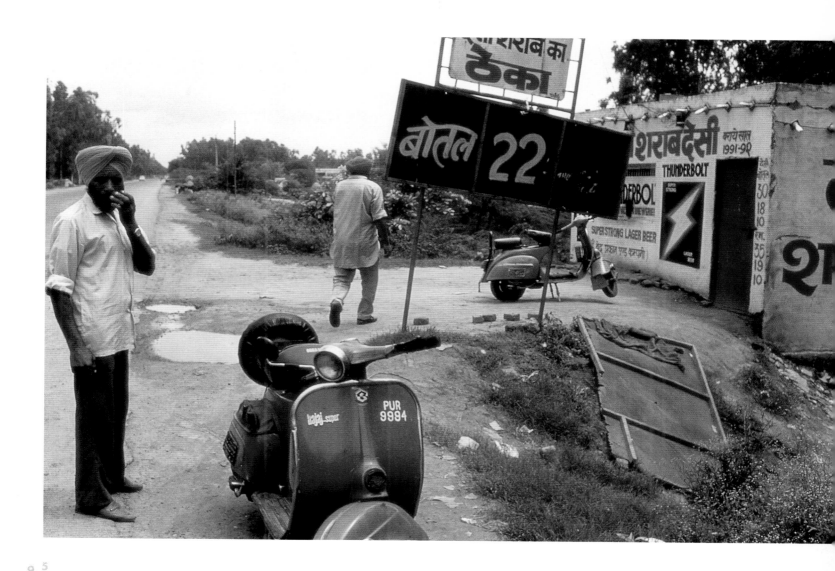

1995

The liquor shop, with its skewed
signs and debris, promises
intoxication ahead. Singh's vision
is of a culture improvised and
sometimes barely held together,
struggling postmodernistically to
keep going. The Grand Trunk
Road runs from Calcutta to Kabul.

RAGHUBIR SINGH

**At a liquor shop, Haryana,
illustration no. 109 in *The
Grand Trunk Road: A Passage
through India*, 1995**

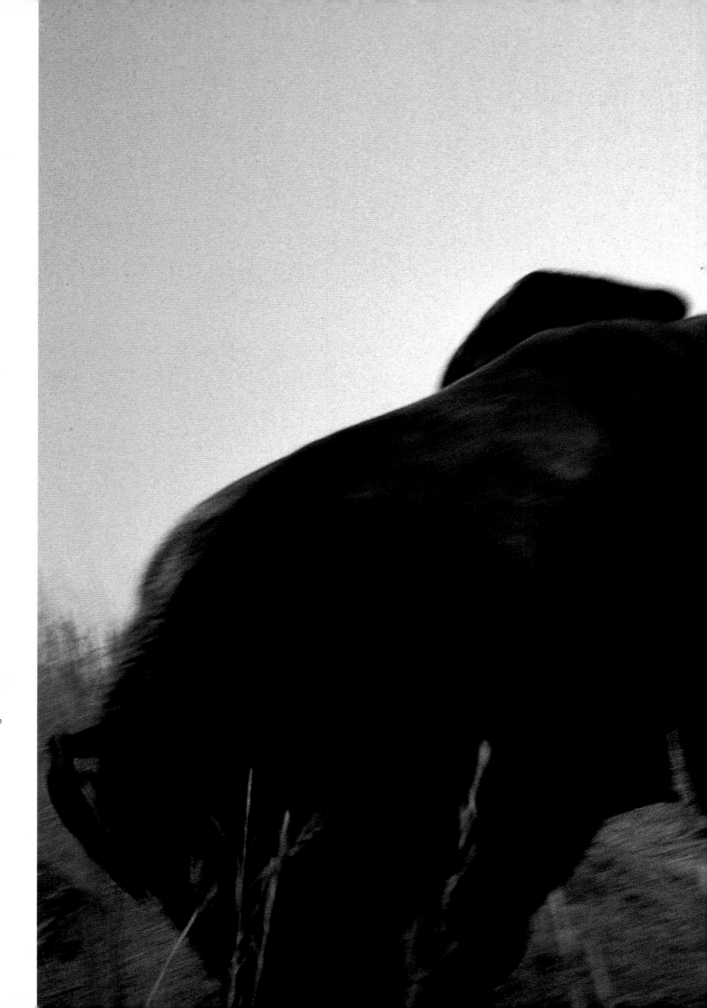

1995

Johns, closely associated with *National Geographic*, concentrates on the interface between Man and Nature, or on wildlife management rather than on wildlife itself. This, for instance, is the sort of spectacle that a wildlife park might provide – on an ideal visit. See "A Place for Parks in the New South Africa," *National Geographic*, July, 1996.

CHRIS JOHNS

African Elephants

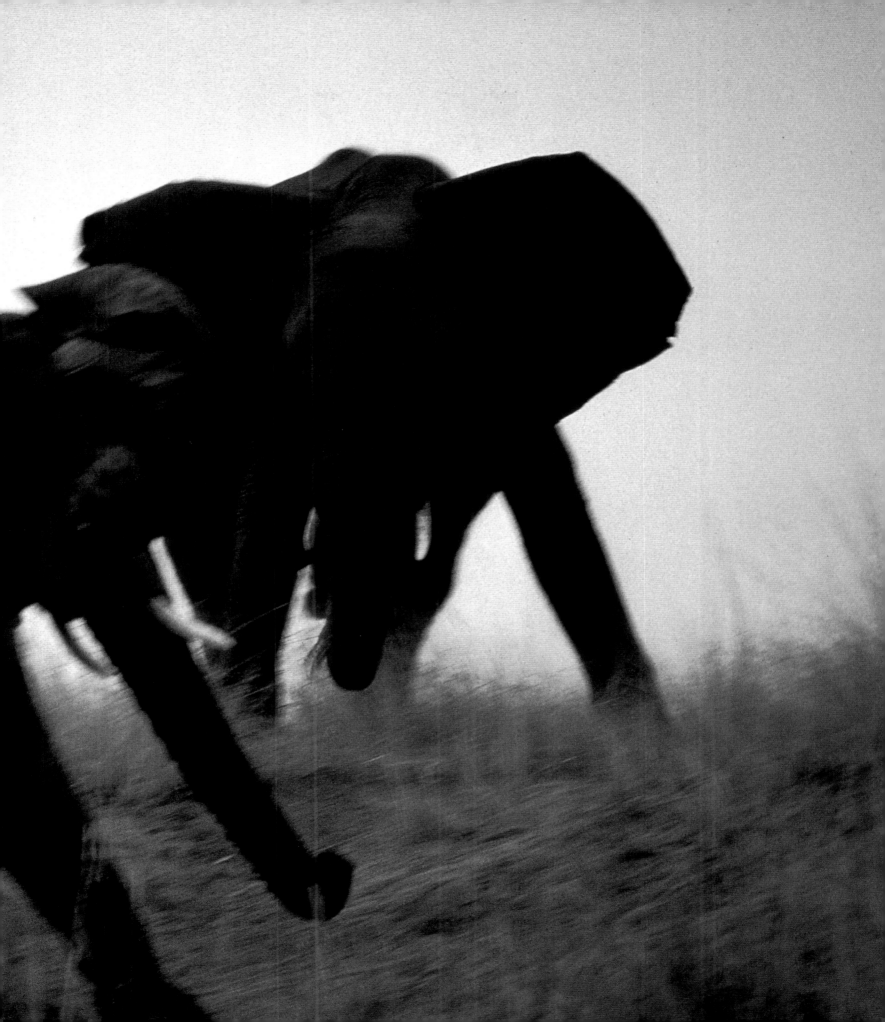

FRONTIERS

c.1930

Ruge had his own photo agency, Fotoaktuell, in BerlinSW68. He specialized in aerial subjects and in photo-narrations enacted by friends. After 1914–18 and the example of Franz Immelmann and Baron von Richtofen, pilots epitomized modernity, especially in Germany.

WILLI RUGE

The Aerial Photographer

Many pictures intended to make no more than a local point end up as icons and symbols in the collective imagination. Time, in particular, interested experimenters, and photography promised access to the split second. Nothing more than scopophilia or love of seeing was at issue in the first instance, but instantaneous pictures in echelon also came to represent objectivity or the body as apparatus merely. X–rays, too, developed in the 1890s, promised access to underlying structures. The idea that there were no longer any mysteries intrigued "Modern" artists in the 1920s.

Wire photography had also interested scientists from around 1904 onward, and it was in commercial use by the 1930s. It meant that news pictures could be published without delay. Wire pictures, however, were of poor quality and often had to be reworked by hand. They undermined confidence in the photograph as a true record, but at the same time helped to establish the category of the simulacrum or dubious report, so entrancing to Andy Warhol and other Pop artists in the 1960s.

1874

A large plaster-of-Paris model of the moon had been made on the basis of sightings through a telescope, and this was photographed by Nasmyth, for a book which he compiled with James Carpenter. The plaster moon, "captured" by Nasmyth, established a compelling image of a Great Beyond, wild and pure like the Antarctic of the explorers of the Edwardian era.

JAMES NASMYTH

From *The Moon: considered as a Planet, a World and a Satellite* (London: John Murray, 1874)

VESUVIUS.

P aintings and mosaics, with the exception of the Lascaux cave images in southern France, were for the most part meant to be shown in the full light of day and for all time. Photographs, by contrast, have mainly been intended for storage in darkened libraries and archives, in boxes and in albums. They fade on exposure to light, it is true, but the practical explanation is not the only one. Photographs have been, as it were, sedimented in a collective unconscious. They were a means of getting rid of the present, putting it safely out of the way but within reach. Records were kept of major events and structures in formation – the Crimean War, bridge- and shipbuilding – and then the event was summarized in a memorial or embodied in the thing itself. The photograph was, and always has been, used up as soon as it saw the light of day, and then preserved, often casually, for an unforeseeable future. At the moment of first disclosure there was never any doubt about the meaning behind an image, but after decades in darkness images re-emerge bereft of context, like diary entries from a forgotten culture. Such rediscovered pictures are enigmatic and readily applied to new uses, and the history of the medium is also a history of these uses. Historians act as if satisfying accounts can be given, but the account is often an excuse to entertain images that make only the dimmest kind of sense. The time-lapse can be anything from 30 to 100 years, and it often involves specialized imagery.

From *Spemanns Natur-Kalendar*, 7–13 May, 1933. Closeups were a feature of Modernist photography; like X-rays they promised knowledge of inner workings and gave a scientific dimension to nature. Wolff had used a Leica since 1925 and helped in its refinement. His name crops up continually in photo-publications of that era.

DR. PAUL WOLFF

A fern-frond

Eadweard Muybridge is the most famous case in point. He was the author in 1887 of an illustrated book, *The Human Figure in Motion*, that was the outcome of years of experimentation in instantaneous photography. The process had begun in 1872 with staged shots of a running horse, taken in Sacramento, California. Attempts to represent motion by means of instantaneous pictures projected in rapid succession had been going on since the early part of the nineteenth century. In the 1880s and 1890s experiments intensified: in France the movement is associated with the name of Etienne-Jules Marey and in Germany with that of Ottomar Anschutz. Each pursued a course of development that resulted in moving pictures. Contemporaries seemed to think that there was some quality of self-evident interest in the nature of rapid movements and to leave it at that. Curiously, however, the pictures came into their own only much later, when the idea of split-second exposure was taken for granted – in the 1960s and 1970s, for example, when Muybridge provided an endorsement for performance art and various kinds of staged photography. The events in *The Human Figure in Motion*, subtitled *An Electro-Photographic Investigation of Consecutive Phases of Muscular Actions*, showed nothing in particular: a woman descending a stairway, for example, and another feeding a dog. The woman on the

stairway is naked, and in eleven frames she descends two steps while maneuvering a blouse over her head. The series presents her thrice, seen from the left side, the front, and the rear, against a gridded background, carefully measured and explained in Muybridge's text.

What were originally experimental arrangements became, in the fullness of time, embodiments of mere being. Audiences in the 1950s were accustomed to seeing the human figure poignantly invested, victimized, misused, and yearning. Muybridge and his contemporaries seemed, on the other hand, to be quite indifferent to such values, merely seeing the human figure as a mechanism, sometimes unequal to its task: one series is of a naked child making heavy weather of the same set of steps. Thus, Muybridge, originally a bona fide experimenter with a technical agenda, came increasingly to look like a precursor of Samuel Beckett, the author in 1938 of *Murphy*, a novel that opens with an emotionless account of a naked man tied into a capsized rocking chair. There is nothing, Muybridge's pictures seem to suggest, beyond a carefully tabulated here and now: no transcendental dimension, no human spirit.

Chronophotographs, as they are called, allow that possibility to be entertained under cover of history.

Muybridge points to a rationale in the practice of photography. At any moment, in the twentieth century at least, the foreground is occupied by state-of-the-art products: instantaneous pictures taken so quickly as to beggar belief, or luxuriant surveys of distant planets. Photography, understood as a wide-ranging collective enterprise, responded by searching the past for primitive variants: the moon, for instance, as a wizened apple or as a model in plaster of Paris. Early versions, even if they have little to do with the phenomenon of the moment, offer an account of origins. Thus, Muybridge's disinterested accounts of human actions seem to have been made with Beckett in mind. It is worth adding here that photography has always prepared itself for this kind of eventuality. Right from the beginning, pictures were taken speculatively or in response to the merest impulse, and then left as negatives or contacts and never properly brought to fruition. Every career, in fact, contains a range of tentative essays that might only be realized in the light of the successor's intentions.

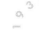

This picture was published in *Animal Locomotion: An Electrophotographic Investigation of Consecutive Phases of Animal Movement* (1887). Muybridge's animals were humans mainly, and they were photographed from three points of view performing simple tasks. It was an attempt to analyze time and its contents, but it fascinated later observers because of its reductivist equation: human = animal.

EADWEARD MUYBRIDGE

Pouring basin of water over head, *Animal Locomotion*

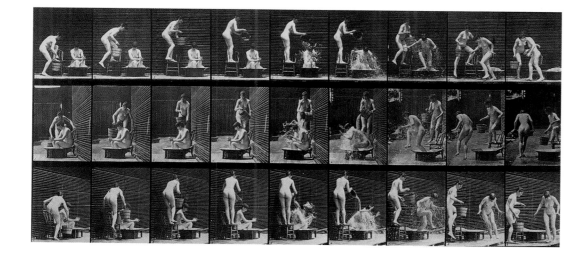

c. 1929

This picture opens *Technische Schönheir (Technical Beauty)*, introduced by Dr. Emil Schaeffer, for Orell Füssli Verlag (1929). Heavy industry, fuming and glowing, gave a romantic aspect to the modern world, which in general preferred laboratories and cleanliness. Roerts was based in Hannover.

W. ROERTS

Environs of a Bessemer Furnace

Photography laid down deposits that could be mined for the sake of the present. Usually this mining took the form of looking for a primitive variant of present practice. Sometimes, however, you find that genres and emphases shift, and that great themes go undercover. The rediscovery of Muybridge, Marey, and Anschütz came about because of a rejection of humanism. In the 1930s, at a time when almost everywhere regimes were anxious to impose controls and to claim that all was well, photography – unconsciously or not – turned to nature and to micropicturing because it was in nature that savagery could be acknowledged disinterestedly. Animals and insects ate each other voraciously and died horribly of natural causes. Eagles and other birds of prey looked as rapacious as could be; and even plants, seen in a certain light, appeared to act malevolently. From the 1930s through to the 1950s, instantaneity, an interest in which was established in the 1880s, was portrayed through images of nature: leaping and swooping animals, feeding in the darkness. Nature taken thus either reflected the savagery of the times by proxy or served as

a reminder – in the more optimistic 1950s – of tooth, claw, and primal impulse. Photography's other source of metaphor was industry. Iron works in particular provided a vision of inferno to set against the carefully calculated spaces of the Functionalists in the 1930s.

Postmodernists, reflecting on their position in society in the 1970s, became interested in objectification, or the ways in which a subject might be defined and constrained. Anthropological picture-making, which had been confined to research institutes and virtually forgotten, was republished because it exemplified objectification. Pictures, made to demonstrate cranial measurements and show off tribal types, represented humans as objects, subject to research, management, and use. Gradually the deadpan styles of anthropological photography infiltrated the mainstream, in Europe especially, resulting in a taste for large-scale objectivized portraits. The style was pessimistic, and typical of the Postmodern turn of mind, its fears were retrospective and self-induced.

Previously, visions of the future had been relatively well defined. They included a fair measure of utopia on companionable collective farms, to be set against the promise of blitzkrieg in the 1930s and Armageddon in the 1950s. The Postmodern future, by contrast, as it developed from the 1970s, was always less strongly figured and contained nameless possibilities – often of ecological or social breakdown. The Postmodern future never seemed to have a positive aspect, merely a promise of more of the

same stretching to infinity. One problem from the 1970s on – at least from the point of view of photography's imagery – lay in outer space, and the stars became subject to spectacular imaging. Prospects of near eternity were revealed, which belittled the future as it had commonly been imagined. To naturalize this vision photographers turned back to nature, which had its own time spans, less nebulous than those offered by the galaxies. One of the great genres of the 1970s was underwater photography. At first it featured bathyscapes suspended at great depths, and images of divers coping with as much

difficulty as the first moon walkers. Specializations then evolved, and the oceans became an alternative firmament inhabited by great whales and bright fish, sometimes in the company of froglike anthropoids. The importance of the ocean vision as an alternative to the heavens was that it allowed for man as a tentative explorer and humble presence. If objectified portraits seemed meant for primal ID-cards, prepared for a state beyond society, the underwater explorers present themselves as awkward interlopers, far removed from all those heroic figures who walk photography's pages in the 1930s.

1965

On March 18, 1965, Leonov, a Soviet cosmonaut, became the first man to step into outer space when he left his spacecraft *Voskhod-2*. The pictures show him leaving his hatchway to somersault above the spaceship. Poorly registered pictures taken from TV transmissions became the norm in "space" in the early 1960s, and their look became a sign of futuristic developments in technology.

PICTURES TAKEN FROM TELEVISION
Lt. Col. Alexei Leonov, the first space walk

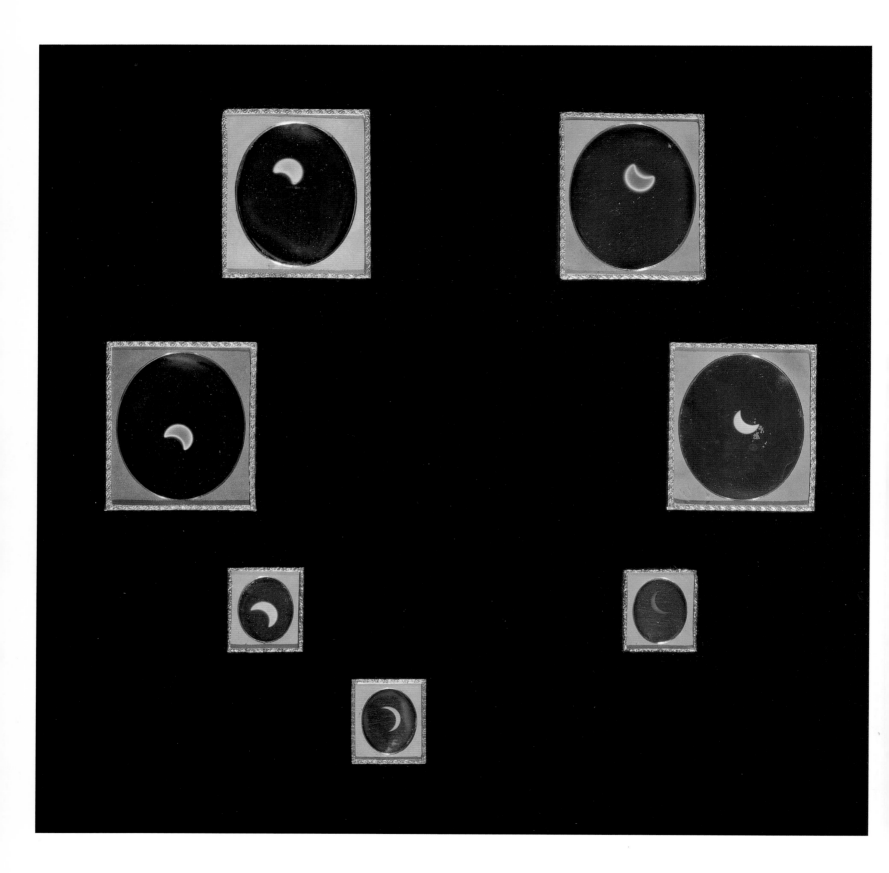

854

This series of seven daguerreotypes shows the first total eclipse of the sun since the invention of photography. The Langenheims were Germans who set up a daguerreotype studio in Philadelphia in 1841–42. Photography's history includes many such firsts as this – as if nature set an agenda for photographic process. Total representation seems to have been written into photography's program from the beginning.

WILLIAM LANGENHEIM AND FREDERICK LANGENHEIM

Eclipse of the Sun, 26 May 1854

c.1930

Closeups of wildlife became a feature of German photography in the Modern period. They testified to photography's ability to catch a subject *in flagrante*, and they were suggestive of cruelties beyond the normal range of photography.

DR. SCHMIDT-SCHAUMBURG

A chameleon eats a butterfly

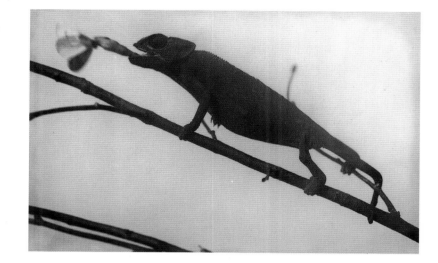

c.1930

Nature's engineering, seen closely enough, recalled that of modern designers and suggested a connection between nature and manufacture – even that nature could be understood technically.

DR. SCHMIDT-SCHAUMBURG

Wing of a dragonfly

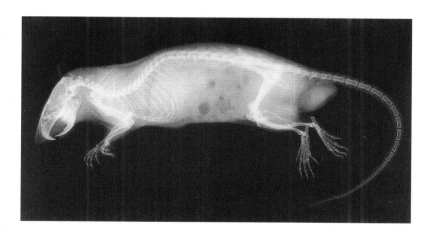

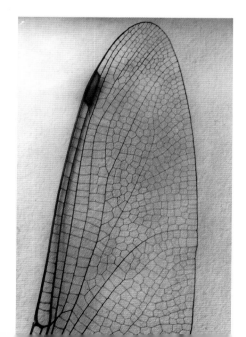

1896

The X-ray process was discovered by Wilhelm Röntgen in November, 1895, at the Institute of Physics at the University of Würzburg, in Bavaria. X-ray aesthetics contributed to Cubism and to analytic photography in the 1920s. This picture was published with many other pioneer X-rays as a gravure in *Versuche über Photographie*, Vienna, 1896.

J. M. EDER AND E. VALENTA

An X-ray of a rat

2. Stone pyramid on 49th parallel, or right bank of eastern

1855

Thompson photographed the great exhibitions of the decade for the record – London in 1851 and Paris in 1855. Early photographers worked in a material culture which set great store by objects – as if the world could be inventoried once and for all as a series of specimens that might be seen and touched. This outlook appeared exotic to Postmodern audiences in the 1970s and after, and encouraged the collection and appreciation of old pictures.

CHARLES THURSTON THOMPSON

Raw produce of India

1860-61

Soldiers in the Royal Engineers had been taught photography by C. Thurston Thompson of the South Kensington Museum, London. They recorded the work of the British Boundary Commission in Canada – work which began in 1857. The idea of photographing an abstraction, such as a boundary, may have been a practical task in 1860, but more than a century later, it was interesting as an example of conceptual photography, long before the term had been considered.

UNKNOWN PHOTOGRAPHER

Soldier-photographer of the Royal Engineers, working on the U.S./Canada Border Survey

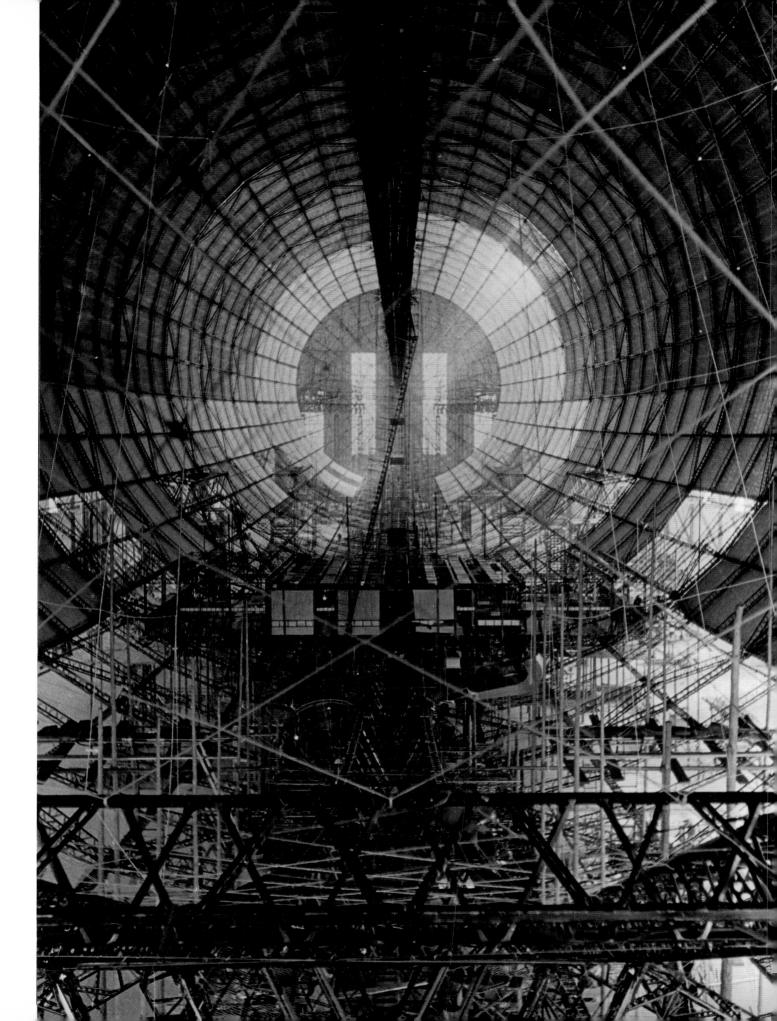

Air travel and sighting were Modernist preoccupations, although most of the technology on show here looks traditional: basketmaking and ropework. Modernists were always appreciative of handmade culture. Before long, Rodchenko's humor would count against him in Soviet photo-circles.

ALEXANDER RODCHENKO

Hot-air balloon

A frame from an automatically operated 16mm movie camera. Space walks feature in the iconography of the 1960s, often reintroducing Man as Embryo, tentatively starting afresh.

Major Edward White II outside the *Gemini IV* spacecraft

In the picture by Presse-Photo (Friedrich-Strasse 12, Berlin SW68), the innards of the airship are exposed and explained, in terms of rings and longitudinal girders. Airships epitomized structural complexity in the Modern age.

UNKNOWN PHOTOGRAPHER

Work on Germany's airship goes ahead. "Our new Zeppelin."

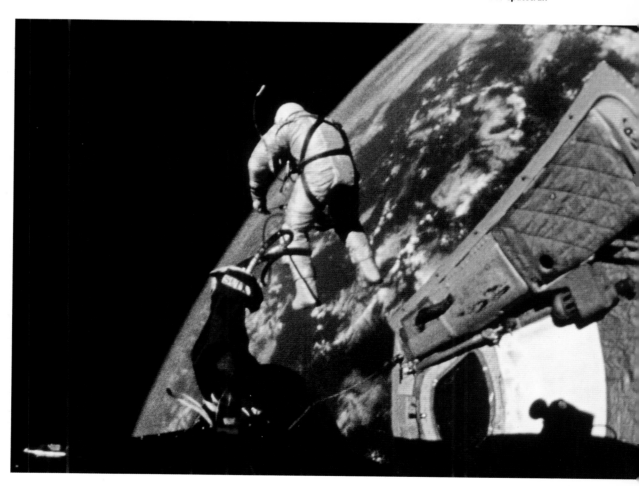

1952

The Associated Press Agency caption for this Radiophoto from New York reads as follows: "Growth of an H-bomb fireball. These photos, taken from an official movie record, show the development of a nuclear fireball from a hydrogen bomb explosion set off in the Pacific Eniwetok Atoll in the autumn of 1952. At top left is seen the small building which housed the bomb device in an instant before the explosion. Following, from top to bottom, are seen the various stages of the development of the fireball until it reached a record size of three-and-a-quarter miles wide." Pictures such as this developed the sequence as a topical format.

UNKNOWN PHOTOGRAPHER

H-bomb fireball, Eniwetok Atoll

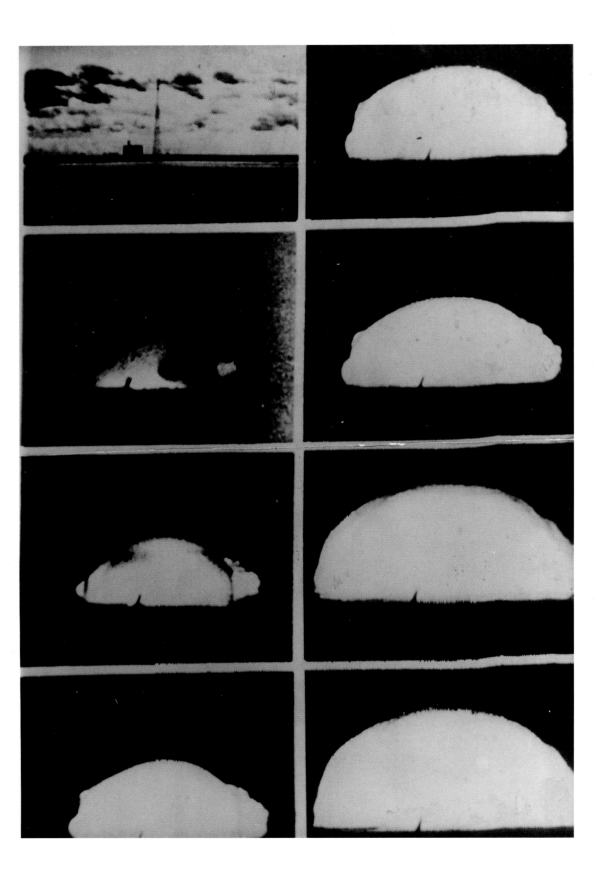

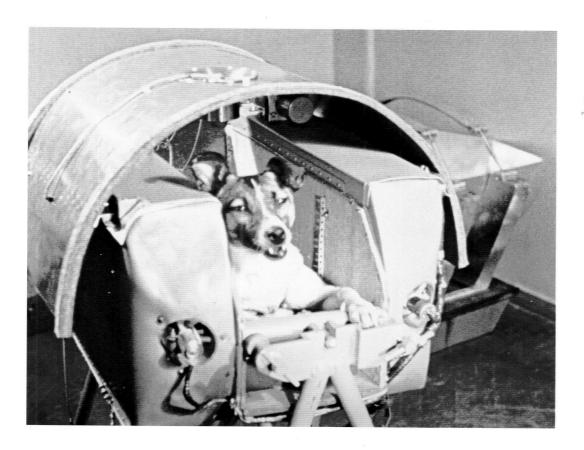

The first dog in space – the first living creature for that matter. She traveled on *Sputnik II* and belonged to a breed, related to the Husky, known for endurance. Laika, heroine of the Space Age, represented domesticity caught up in an outlandish project. Space had always been imagined in superhuman terms – never like this.

UNKNOWN RUSSIAN PHOTOGRAPHER

A view of Laika, November 5, 1957

In the Age of Transmission it was broadcasting itself that fascinated. *Telstar* was developed by the American Telegraph and Telegraph Company, and this picture was taken from an NBC monitor screen at the RCA Building in New York City. Beyond the flag is the Radome covered antenna at Andover, Maine – national motifs.

UNKNOWN AMERICAN PHOTOGRAPHER

The first TV broadcast from space – from *Telstar*, July 10, 1962

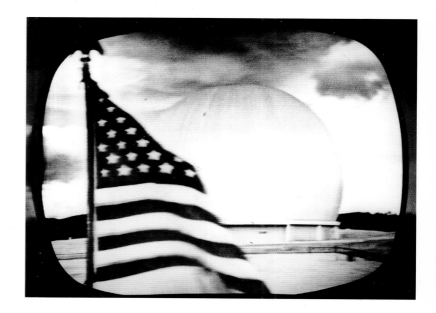

1987

An integrated circuit of the "Utah Arm," with an artificial hand behind it – at the University of Utah, from a picture series called "Changing World." Hartmann in the 1970s and 1980s introduced science in terms of art – circuitry as Surrealism in this case, calling on Dali, Tanguy, and Magritte, among others.

ERICH HARTMANN

Circuitry of an artificial arm

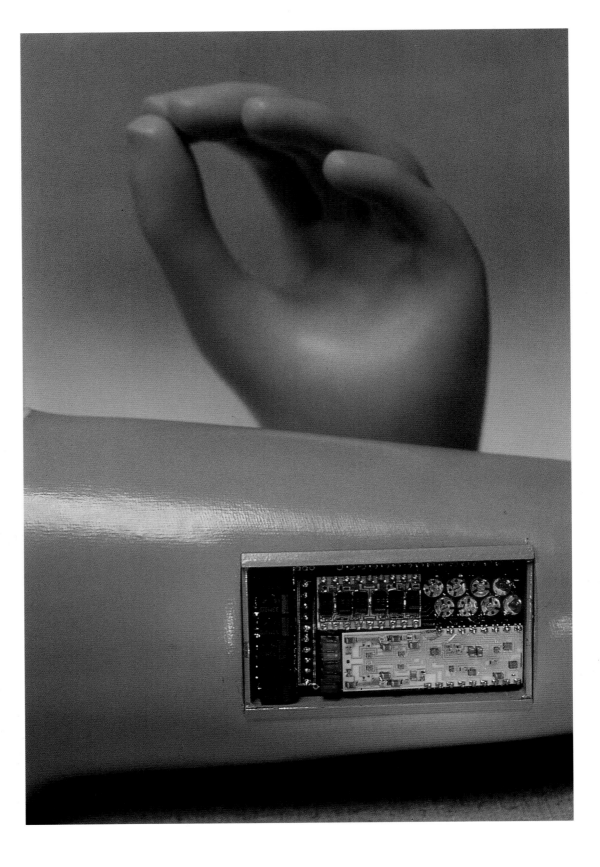

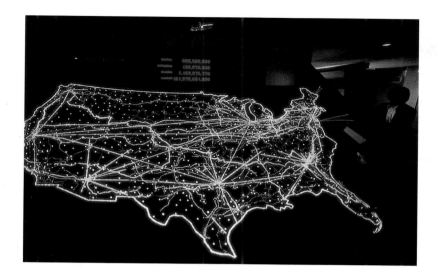

New technologies, from the
1960s on, projected the
old order literally in a new light –
the U.S., in this instance, as an
illumination, phantasm, or even
an inner vision.

ERICH HARTMANN

An airport hub-map of the U.S.

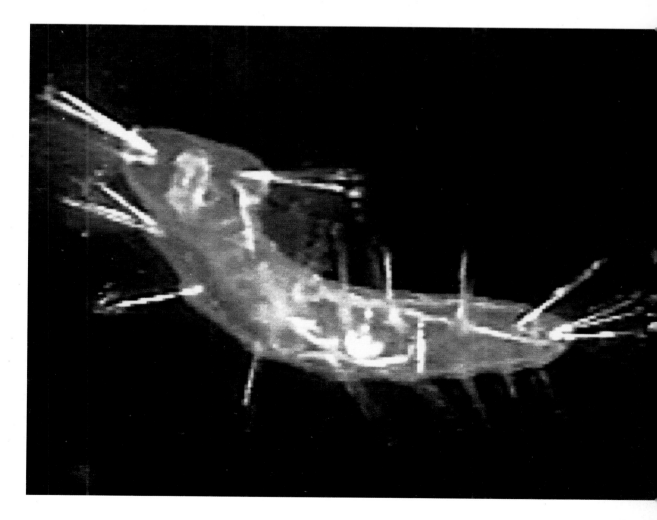

A previously unknown species
of wormlike polycheate, about
1 inch long, that swims using its
glasslike bristles. The picture was
taken from the *Shinkai 6500,* a
research submarine, 4 miles
below the surface in the Japan
Sea Trench in the Pacific Ocean.
One of photography's latest
trophies, in digital mosaic. The
ocean in the 1980s and 1990s
epitomized elsewhere a world
quite apart, impervious to the
usual analyses.

JAPAN MARINE SCIENCE AND
TECHNOLOGY CENTER

**Species of polycheate,
Japan Sea Trench**

METROPOLIS

The city was photography's greatest stage. At first, however, it was of little interest because photography was unable to catch its details and movements. These only entered photography's agenda in the 1880s, and then discreetly, for the aesthetics of the period looked to spirits or to truths beyond appearance. The city came into its own in the 1920s because it was the laboratory in which the society of the future would come into being. In the metropolis new cultures were in formation. Young photographers, often newly arrived from eastern Europe, made their way in Berlin, Paris, London, and New York. To cope they had to have their wits about them, and the photography that emerged in the 1930s was quick and inventive.

Metropolis survived after 1939–45 as a nostalgia. Wartime experience put a premium on tradition and tranquility, and produced a spate of studies of the inner suburbs of Paris and archaic London, both of which were pedestrian venues. Modernizers turned increasingly to New York in the 1960s as a motorized phantasmagoria – the city of the future. Eventually old metropolis lost its credibility in the face of the suburbs and the automobile, with their fatally attractive proposal that where we were was nowhere in particular, in transit through a non-place, the Postmodern homeland.

1876

The original is a Woodburytype, which was a kind of carbon print used in book illustration in the 1870s – the picture appeared in Thomson's *Street-life in London*. Billy (William Parragreen) told his story to Thomson's collaborator, Adolphe Smith. Contemporaries around 1876 imagined the city as a vast open-air theater housing any number of living legends who knew they had a tale to tell – in this case of the good old days, of omnibus racing and its dangers, love of alcohol, and the onset of rheumatics.

JOHN THOMSON

"Cast-Iron Billy," an omnibus driver

1983

As they are puzzles he might be understood as one who has failed the test or been worn out in the process. Walker's structured pictures ask to be read and spoken into another kind of being, treating audiences as readers, possessed of an imagination ready for use. Other colorists in the 1980s often like to show the city drenched in sensations, illegible.

ROBERT WALKER

More Puzzles, West 33rd St., New York

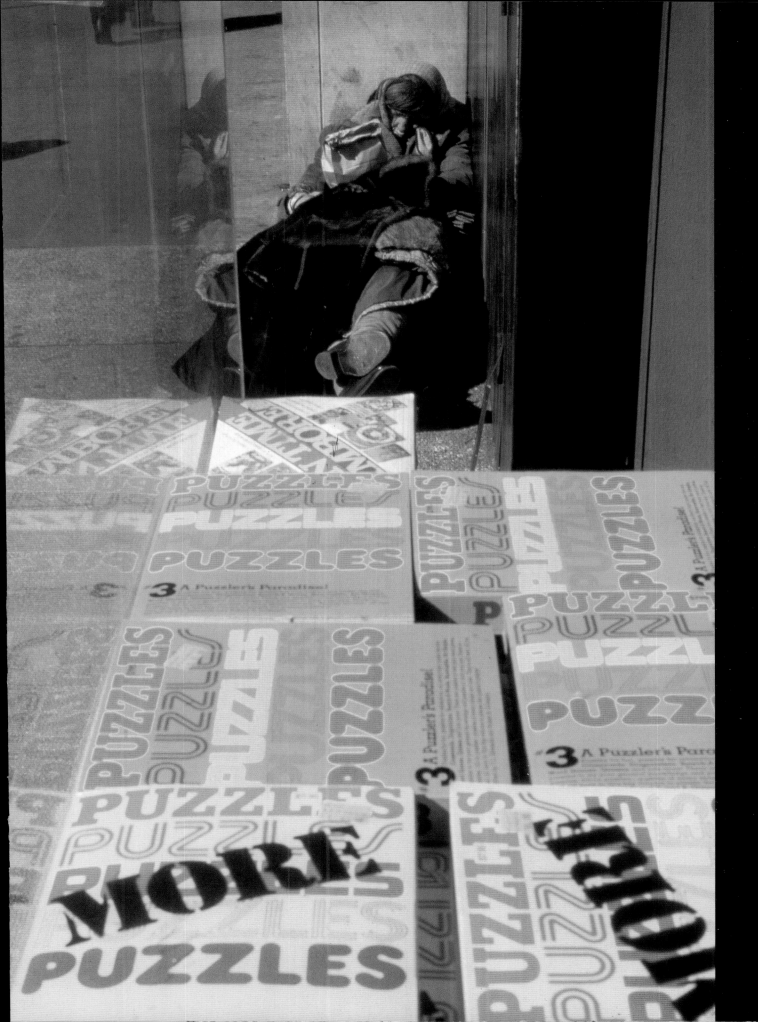

c. 1 8 8 0

Martin, a wood engraver by trade, adapted a "Facile" hand-camera for use in the streets. He was one of the earliest of all photo-reporters, and interested – like John Thomson before him – in types who gave identity to the city. Several French photographers took up this interest in *petits métiers* in the 1890s and after. Their vision was of the city as a culture, which might be enumerated and anthologized.

PAUL MARTIN

A magazine seller at Ludgate Circus, London

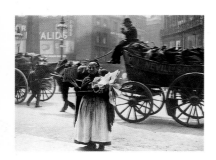

Photographers were taking pictures of city streets as early as the 1840s, when exposure times were too slow to register the movement of pedestrians and passing traffic. But it was only in the 1880s and 1890s, and then to serve as social commentary, that the city became a subject in its own right. By the late nineteenth century, many active industrial cities had developed slum areas that civic authorities were keen to demolish or to improve. Photographers were employed to make records of these dark, dilapidated areas. The underlying idea was often symbolic – that is, the pictures were intended for posterity rather than for practical use on site. They often feature groups of local people darkly clad and curious, watching the photographers at work.

John Thomson, a Scottish traveler and geographer who had visited and photographed China in the early 1870s, turned his attention to London and in 1876–77 contributed the pictures to a series of 11 parts called *Street-Life in London*, the first major study of a city's people undertaken in photography. It was a pastoral vision of the city – a society rich in traditional types picturesquely named: Cast-Iron Billy, Black Jack, and Hookey Alf. Thomson identified a whole range of street vendors, traders, craftsmen, and beggars, and a writer called Adolphe Smith contributed long commentaries on street life and terminology; the whole forming a comprehensive guide to the life and drama of the streets. Inevitably, Thomson and Smith had improvement in mind, but the importance of the work lay far in the future: from the 1930s on it would serve as a reminder of traditional urban life, establishing an image of London as reassuringly old-fashioned.

Thomson's successor was Paul Martin, a wood engraver by trade who modified a portable camera for use on the streets amid passing traffic. Martin's pictures from the 1890s are also attentive to urban types, and to situations in the street and places of public resort. Between them Thomson and Martin did more to stock the British image bank than any artists since Hogarth and Rowlandson.

Jean Eugène-Auguste Atget, the greatest of urban photographers, came to the medium quite late in life. Born in 1857, he took up photography in 1900, hoping to make a living with a series of pictures of architectural details of Paris that he might sell to artists – by which he meant painters. Atget worked successfully as an artisan photographer and died more or less unknown in 1927. His art was appreciated by a group of younger painters and photographers, including the Americans Man Ray and Berenice Abbott. Abbott saved his archive from dispersal and destruction. In 1930 he was the subject of *Atget photographe de*

Paris (*Atget photographer of Paris*), that would become one of the most admired books in the history of the medium. He undertook his project in an era of Symbolism, in the shadow of self-aware artists who wanted to look beyond mere appearances and believed that the greatest reality lay in the realm of the imagination.

ARCHAIC PARIS

Atget, on the other hand, was interested only in appearances, and principally in bricks, mortar, metalwork, and pieces of molding around doorways and windows. Parisians sometimes appear in his pictures, looking on from shop entrances, but Atget was no portraitist; nor was he attracted by street life. His view of the city was of an archaic place assembled by hand, and this chimed with the aesthetics of a new generation of artists who were interested, quite literally, in the manufacture of artworks. They were alarmed by the prospect that metropolitan life would become increasingly prefabricated, and that firsthand experience of material would become a thing of the past. Atget's project on archaic Paris suited their agenda perfectly for it established their new art in a traditional context. Not only that, but Atget's tactical liking for deserted sites suggested a dreamworld reserved for pedestrians.

Metropolitan streets may have been alive with traffic in the 1920s, but photographic equipment was still not sensitive enough to come to terms with the bustle. Nor were photographers necessarily interested in city life for its own sake, as they would be to a degree in New York in the 1960s. They were far more engrossed by personal reinvention – a theme common to many of their contemporaries. They were often from smaller towns in other countries, sometimes eastern Europe. They had experienced the war of

1914–18 and believed that they could start afresh in Berlin, Paris, or London. Starting afresh meant watching others' behavior – how, in Paris, you would smoke a cigarette or wear a cap – and the study of manners was a dominant theme of many metropolitan photographers in the 1920s and 1930s. Few of them were native speakers of French and German, and were intrigued by the imaginative and social idiosyncrasies of their new host environments. Above all, they had to be attentive to just how things were done in the metropolis – here, survival depended on quality of attention, just as it had during the war. The myth of the photographer as observer was established in these interwar years.

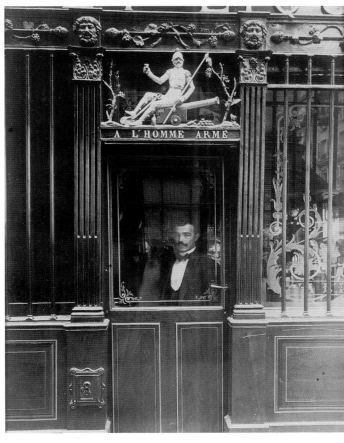

Not every member of this generation of photographers was a displaced loner spying out the land and the *mores* of the locals. Some took the part of the new orders of designers and architects, and thought of themselves as implicated in the shaping of culture. Yet they still shared with their radical contemporaries a feeling for manipulation. They might see the city from a greater distance, but liked to envisage it as being at arm's length, even as a sort of board game in which the checkers were cobblestones, pedestrians, passing cars, and carts. They liked to take

Atget took pictures of fragments of old Paris, for sale to museums and to artists. An artisan in his lifetime, he began to be recognized as an artist in the 1930s. His is a view of the city as rich in entrancing objects and inscriptions, peopled by the kind of transient humanity on show here.

JEAN EUGENE-AUGUSTE ATGET
Boutique, 16 rue Dupetit-Touars, Paris

1910

A gum platinum print. Benington's idea of the city was as a system or body brought to life by transportation and communications networks – symbolized, for instance, by the cab rank. His precursors had applied this idea to nature and to the countryside, but he was among the first to see the city organically, as possessed of a spirit or life force.

WALTER BENINGTON
The cab rank

the planners' point of view and to photograph from balconies or from above; but for them the city's streets always formed part of a game with pieces. Naturally this playful approach to the metropolis was intolerable to the collective regimes of the 1930s.

If the war of 1914–18 produced a generation that wanted to reinvent itself individually in Berlin or Paris, World War II led only to a feeling of relief that it was all over. Berlin, one of the great lodestars, was also seemingly out of action – and for the foreseeable future. Photographers, as shocked as any of their contemporaries by what had happened, tried to pick up whatever threads led back to a better world; and in Paris these threads were principally to be found in the east of the city, in the Belleville-Ménilmontant area, north of the Place de la Nation. In archaic backwaters it was possible to imagine a metropolis still made up of villages in which an undisturbed individual or family life was possible. London was also favored as a center, principally because it still looked dark and antiquated, and in touch with the past.

No city ever took the place of Paris and Berlin. This wasn't due to any innate inferiority on the part of New York, which was for a long time the world's capital of high culture and contemporary art. What happened was that an aesthetic of movement was put in place in the 1950s and after, and this aesthetic was as easily fulfilled in one built-up area as another. Its principal exhibit is William Klein's *New York* of 1958, followed by Robert Frank's *The Americans* of 1958. In 1966, the George Eastman House of Photography in Rochester, New York, staged an exhibition of contemporary photographers subtitled *Toward a Social Landscape*. Put together by Nathan Lyons, it featured a new generation, including Bruce Davidson, Danny Lyon,

Lee Friedlander, Garry Winogrand, and Duane Michals – all major artists of that decade and the next. In the same year John Szarkowski organized an exhibition at the Museum of Modern Art in New York which he called *The Photographer's Eye*, comprising work from the entire history of the medium. Szarkowski's world is one of fleeting encounters, small rushed events taking place in milieus without hierarchy. Their counterpart in France was picture editor Robert Delpire. The last homage to that aesthetic is to be found in *In Our Time*, a survey of the art of Magnum Photos arranged in 1989 by Robert Delpire.

EXISTENTIAL AESTHETICS

Participants in Paris in the 1930s had wanted to catch the moment in its entirety, and to learn from it. Adepts in the new mode wanted both to acknowledge the instant and to remark on its transience – there was nothing more to be drawn from it other than the fact that it had been and gone. The city, with its teeming life, was one place in which acknowledgements of this kind could be made, but they could be asserted more radically out of town or on the road, and a lot of this new "existential" photography took place in quasi-urban environments.

Modernists who traveled to the city in 1930 knew that they could learn by observation in cafés where their peers and precursors acted learned roles. One difficulty from the 1950s on was that the metropolis was no longer a stage. Life had been diffused into the suburbs and screened from view behind automobile windshields. Somewhere in the city there might be authentic insiders, but for all intents and purposes they were undetectable; and one of the topics of the new (Postmodern) photography of the 1970s became interference and illegibility.

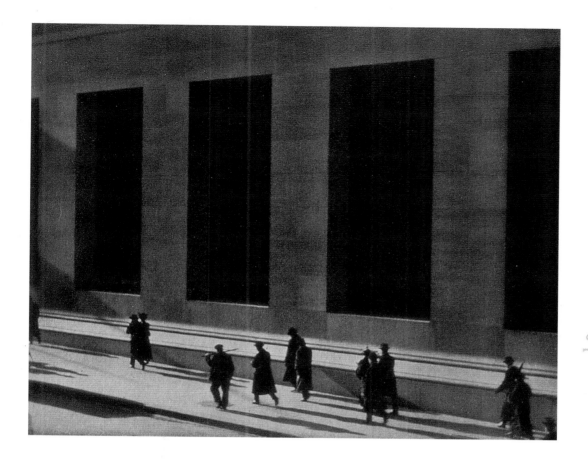

1915

The metropolis, represented by that screen of darkened windows, exists as a monstrous backdrop to the people passing by – potential victims. This Expressionist vision was taken up by German photographers in the 1920s, although for Strand himself it was only a brief phase in a career as a documentary photographer in small-scale traditional communities, in the U.S., Italy, and the Hebrides.

PAUL STRAND

Wall Street, New York

Berlin and Paris, from the 1920s through to the 1950s, served as urban refuges for artists anxious to escape from the infinitely boring provinces. The avant-garde always had as its hinterland an area like the Hungarian plains of the American Midwest. It is usual to reflect on the metropolis as a Tower of Babel, intricate and swarming with traffic, but it also provided small-scale village environments. That was the case until the 1950s when cities began to become part of extended conurbations as they grew toward their airports and along feeder routes. The metropolis had always been a point of intensification, but the conurbations began to assume the scale and dullness of the provinces. They became as extensive as deserts, and subject to as little control. Planners and responsible citizens may have deplored the new situation, but to postmoderns the new metropolis was a challenge precisely because it was limitless, ill-defined, and indifferent, both to traditional history and to the original landscapes which it overrode. Suburbia was banal, of course, but it was also sublime, to the extent that it foretold a change in human nature itself. The change would be devolutionary, at least with respect to the heroic individuals of Modernism, and it could be imagined in front of the great nowhere-in-particular that had engulfed the magical cities of the early twentieth century. Photographers, intrigued by this new negative futurism, looked for suitable sites, transit zones for the most part improvised to cope with short-term needs. Ideally, if they were to fit the bill, they had to be undistinguished or interesting only up to the point where you might ask, Why here? To further this indifferent aesthetic, photographers chose to work patiently rather than hastily, with broad and panoramic formats, for they were – after all – delineating what promised to be a new civilization.

1934

Borchert made a special trip to Paris in 1934 to make a number of stories, one called "The Other Side of Paris," showing the city as decrepit and dirty. This picture was meant as a warning and as bad publicity, although to some of the refugee photographers then in Paris, it was exactly this aspect of the city they found attractive. Borchert, one of Germany's most distinguished documentarists and reporters, was killed in North Africa in 1942.

ERICH BORCHERT
A street scene outside a Parisian bar

1935

This is printed from a positive to give a negative print, which Rodchenko has handcolored. It is a still from Leonid Obolenskii's film *Albidum* (1928), for which Rodchenko designed costumes and sets. By 1935, however, Russian photography was turning toward epic scenes from collective life in the provinces, and Rodchenko's vision of a culture of invention was beginning to seem anachronistic.

ALEXANDER RODCHENKO
Foxtrot

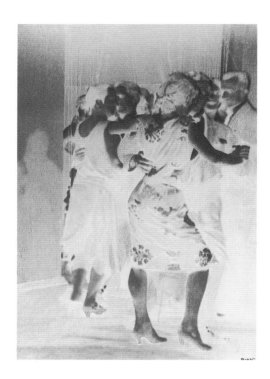

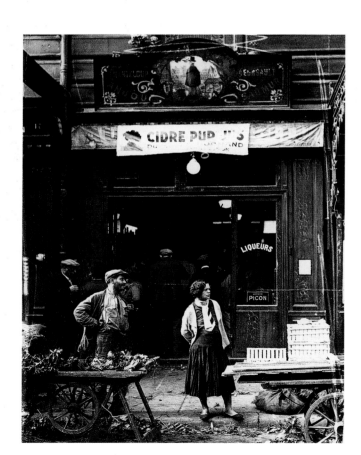

c. 1935

Modernists liked to imagine the city's streets diagrammatically, as if they were surveyors involved in traffic management – or as if social life were a game (chess or checkers) in which the pieces might be manipulated. This aesthetic survived into the early 1930s when it was ousted by the "blood and soil" values of nationalism. Sudek himself is best known for his landscape panoramas made in the 1950s on the outskirts of Prague.

JOSEF SUDEK
Prague street scene

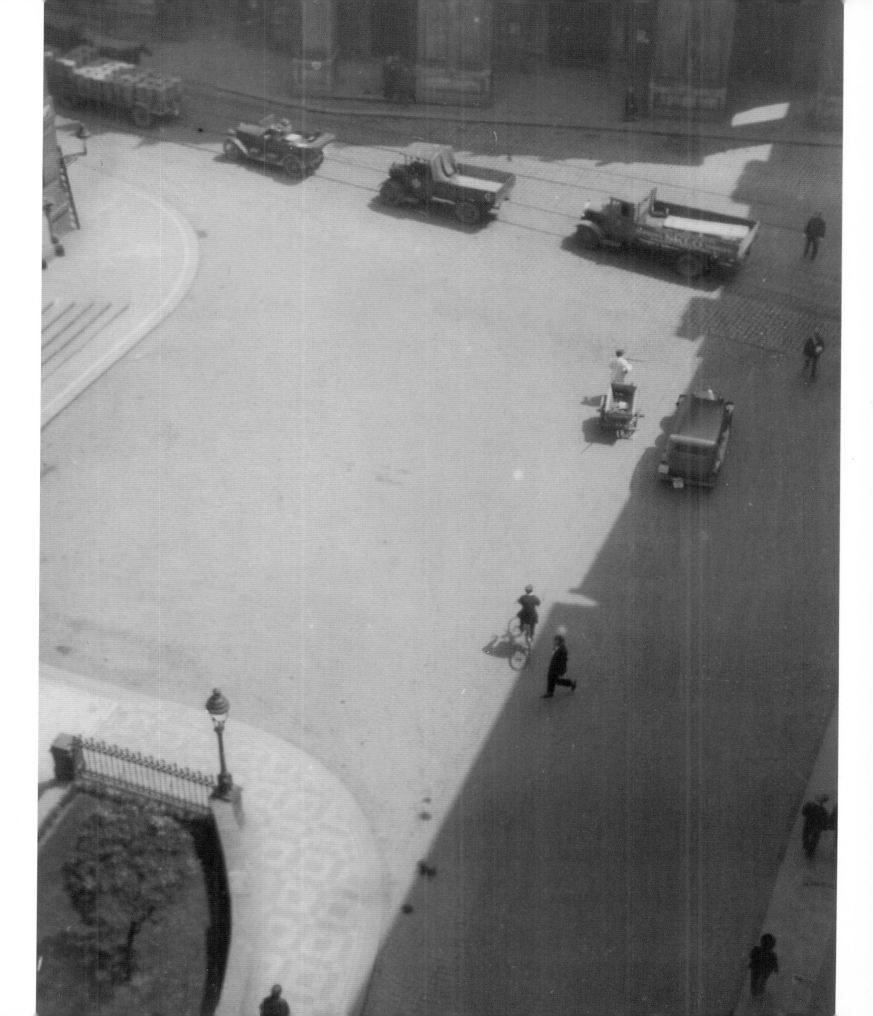

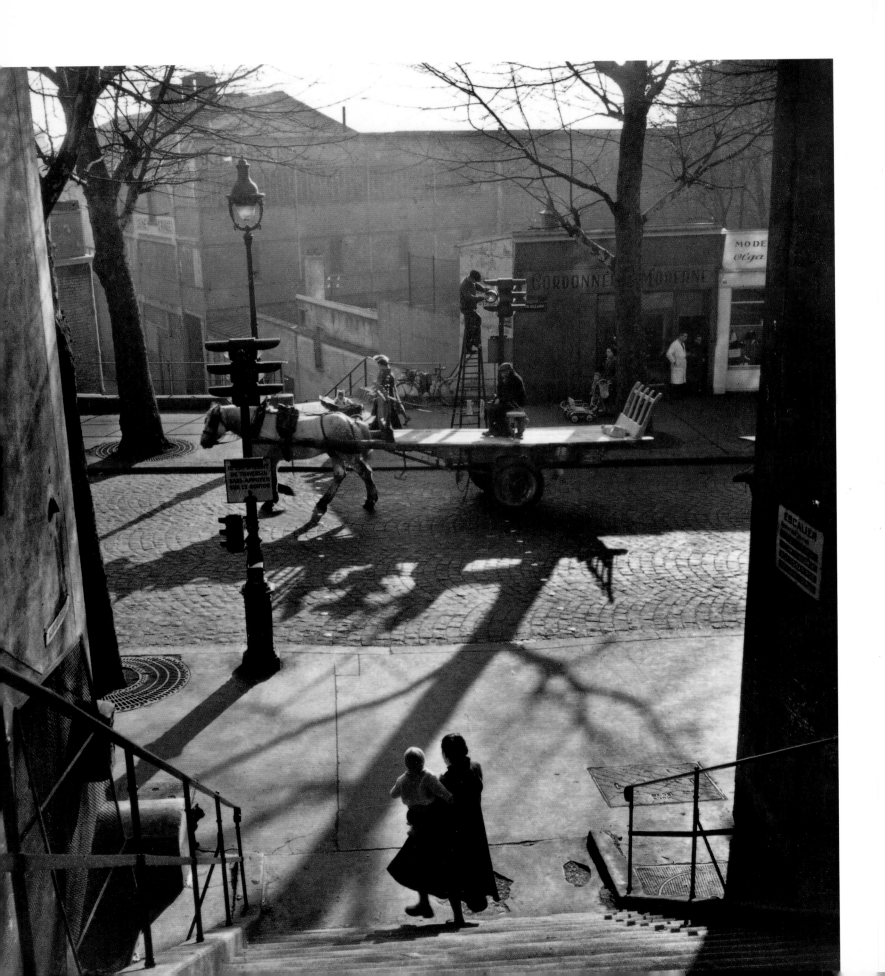

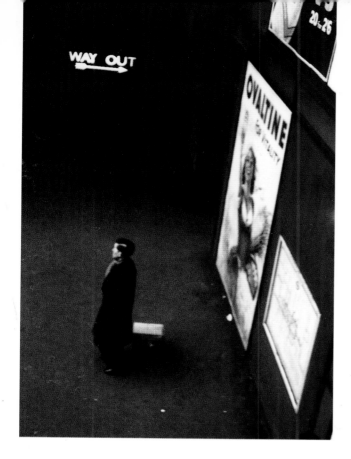

1958

Larrain took pictures in London in the 1950s, maybe because it was a dark, old-fashioned place, secretive and almost Pre-modern. London was a relief from the goodheartedness of so much of post-war photography, with its faith in childhood and happy families. Larrain, the only Chilean to work at Magnum Photos, saw Europe's cities with the eyes of a Parisian around 1930.

SERGIO LARRAIN

London, 1958. Way Out, Ovaltine and darkness

1954

Klein's *Life is Good and Good for You in New York: Trance Witness Revels* (1956) was an important book for it helped establish photography as a medium fit for the imagination. Klein wanted "to get out of studios into the streets… to be monumental." He intended the book "as a monster big-city *Daily Bugle* with its scandals and scoops that you'd find blowing in the streets at three in the morning…." Klein's New York helped dispose of the arcadian pieties of the *Family of Man* aesthetic then in the ascendant worldwide.

WILLIAM KLEIN

Four heads, corner Broadway and 33rd St., New York

1948

This suburb in the northeast of the city attracted photographers interested in old-fashioned patterns and rhythms of life. Ronis's *Belleville-Ménilmontant* of 1954 is the most idyllic urban study of the post-war period.

WILLY RONIS

The Avenue Simon Bolivar and the Rue Lauzin, Belleville-Ménilmontant, Paris

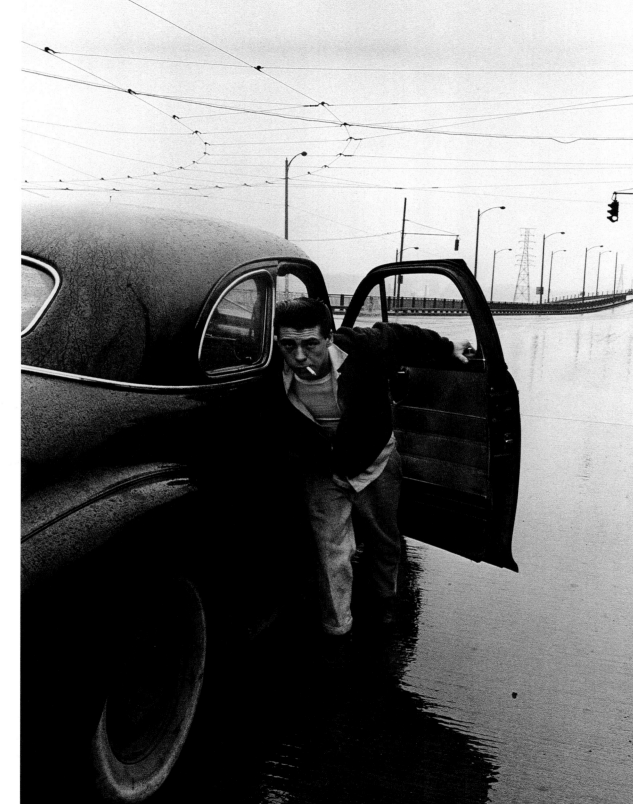

c.1975

This picture appeared in
*Propaganda and other
photographs* (1976), a book of
74 pictures of street life in the
cities of New York state taken
during the late 1960s and early
1970s. Metropolis, c.1970, was
envisaged by Kalisher and his
contemporaries as a harsh
entertainment, a melodrama
in black and white. Color
photography later in the decade
softened the impact of the city.

SIMPSON KALISHER

Broken down in the rain

1982

The city in the 1960s announced itself in neon and billboards, and it was clearly legible. Photographers in the 1970s, however, became more and more interested in the difficulties of seeing: reflections and distractions. The city, under these terms, became more like a phantasmagoria or state of mind – certainly not a documentary subject.

HARRY GRUYAERT

Las Vegas

1969

An urban collage nicely spaced and spelled: Conoco, TraveLodge – a festival of inscriptions. In the 1960s, Pop Art – the last movement in Modernism – looked forward to the future as an urban carnival, brightly furnished. Haas, originally a humanist in the style of Magnum Photos – to which he belonged – switched to color and a new aesthetic in the 1960s.

ERNST HAAS

Albuquerque, New Mexico

1998

Taken outside the Hayward, an art gallery. "Art is within" both literally and metaphorically. The photographer collaborates with other public commentators, graffiti artists, and vandals, making use of opportunities and found materials.

DOROTHY BOHM

**Torn poster, London,
8 February 1998**

1987

Torn posters featured in European "painting" in the 1950s – torn usually to the point of illegibility, as if an attempt to rematerialize the written word and the printed image. An alternative, for photographers, was to use torn or damaged posters as found in examples of Dada, carrying cryptic messages from the unconscious.

DOROTHY BOHM

Torn poster, southern France

c.1965

Torn posters were a useful medium, and in this instance Hartmann – a member of Magnum Photos – uses one to project the city in a heroic light, capable of significant utterance. Pop aesthetics still harbored a grandiose vision of mankind, even if discreetly or under cover of play. Hartmann is one of the pioneers of color photography in the Postmodern era, mainly with respect to science and electronics.

ERICH HARTMANN

Torn poster on 42nd St., New York

c. 1994

A representative man rises from a building site in New York City. Mermelstein's pictures are typologies, or rediscoveries of ancient icons in everyday life in the streets. In this case it might be the Resurrection or Icarus struggling to take wing. Mermelstein's view of the city is of a stage on which marvels might be expected – marvels rather than the mere events which characterized street photography in the 1950s, for instance.

JEFF MERMELSTEIN

New York

1997

The Guardian Angels Campaign – "Just say no" – was set up by then First Lady Nancy Reagan to help fight drugs. Here it stands for the noise of the city in communication with Everyman, symbolized by the man in the red car. Metropolis in the 1980s and 1990s became a collage in transition, a message continuum fixated on the here and now. Walker's poetics, developed in New York, take account of the lettered city recognized by Pop in the 1960s, but differently weighted – to the disadvantage of the streetgoer.

ROBERT WALKER

**Guardian Angels, West 42nd St.,
New York**

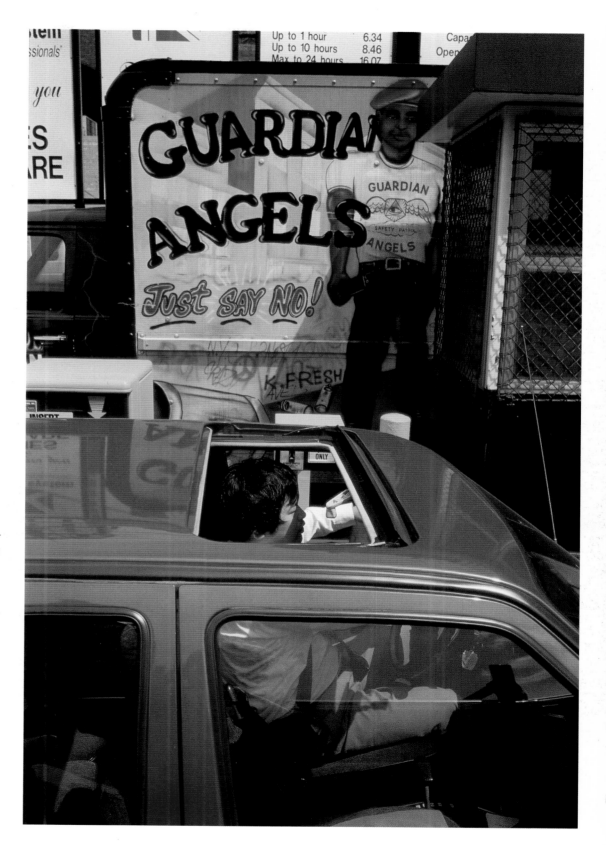

c.1958

Burri's *Die Deutschen (The Germans)* came out in 1962. It showed German life in passing and from ground level – distinctly ordinary. In the modern era the city was often mysterious; Burri, however, chose to show it as a prosaic way of life, as a condition to be endured.

RENE BURRI

Imbiss-Ecke (Corner bar) Berlin

Cities, New York in particular,
were valued for their street life:
mankind animated and hopeful
even down the social scale.
Photographers in the 1970s
and 1980s, however, began to
imagine it as a theater of quite
lurid spectacle, designed to
impose on astonished streetgoers:
spectacle out of control and
mankind Postmodernized.

HARRY GRUYAERT

**The Avenue, Manhattan,
New York**

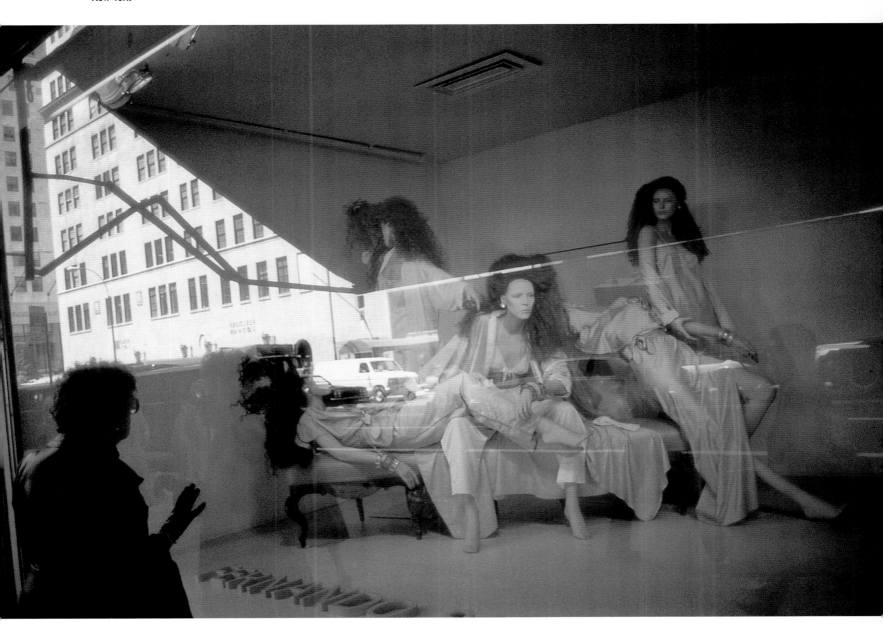

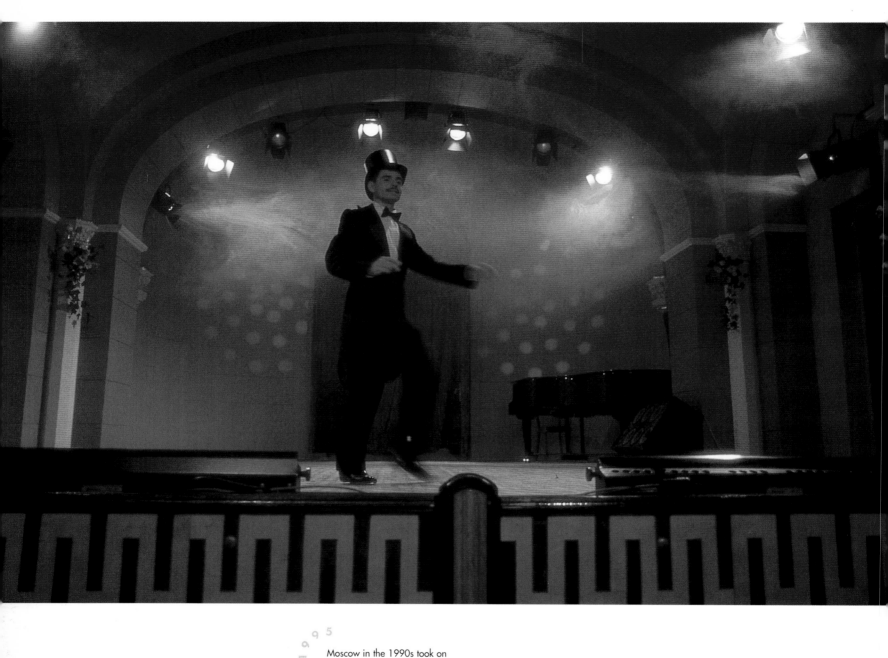

1995

Moscow in the 1990s took on
the role of world capital of sin –
in succession to Berlin in the
1920s and Paris in the 1930s.
Color drenches the atmosphere –
as never before – implying that
Postmodern pleasure is pervasive,
cloying, more appetite than
imagination. Sarfati is one of
a new generation of Magnum
artists capable of using color
as a primary material.

LISE SARFATI

Hotel Moskva, Moscow

Bond's famous account of street
life in London in the early 1990s
focuses on cultural coding: dress,
gesture, and posture. The fabric
of the city itself hardly appears
as other than a backdrop in
motion blur.

HENRY BOND

**Photograph from *The Cult
of the Street***

WAR

1865-66

Matthew Brady, originally a portraitist in New York, sent his staff photographers to make a comprehensive record of the Civil War, from the Northern side. The black sashes worn on their left arms are a sign of mourning for the assassinated President Lincoln. Minor informalities in dress and posture give them a businesslike air. Crimean War portraits taken by Roger Fenton in the 1850s show the British, by comparison, in what amounts to fancy dress.

UNKNOWN PHOTOGRAPHER

General Martin T. McMahon, seated in fringed chair, and staff of six

Wars were always the epitome of news, but in the beginning – in the Crimea in 1855–56, and then in the American Civil War in the early 1860s – photographers had either to work at a distance or after the event. By 1914–18, governments were becoming aware that reporting had to be controlled. Scenes of carnage unsettled civilian audiences. Reports on the actualities of World War I were made by soldier-photographers and distributed unofficially, and several of these amateurs became major photojournalists in the 1920s and after. The first unsupervised war to be recorded in Europe was the Spanish Civil War in the late 1930s. It established a pattern among democrats: with right on their side there should be no controls, and that attitude held through to Vietnam in the 1960s.

World War II was fought out between peoples. Photographers were committed to their respective causes, and there was little scope for "reality," irony, or subversion. Korea in 1950 pitted the U.N. and the U.S. against Nature, in the shape of bad weather, and mysterious, incalculable enemies – harbingers of Vietnam in the 1960s. Subsequent small wars, in Africa and in the decayed U.S.S.R., featured irregulars – partisans, bandits, and looters – who all too easily stood for a future in which the structure of civilization had collapsed.

1993

Civilian victims in the recent iconography of war stand for orphanhood and future misery. Carnage c.1910 was intentional, but aerial bombardments from the 1930s on introduced civilian victims who forever after stood for the gratuitousness of war.

LUC DELAHAYE

Victims of a Taliban bombardment of a village

Hollywood familiarized audiences in the 1940s and after with the idea that it was possible to report from the thick of the battle. In fact – and for quite practical reasons – photographers have usually kept their distance. At the very outset, in the Crimean War for instance, photographic processes were too cumbersome to permit direct reporting and the same was true of the American Civil War in the 1860s. Roger Fenton, the first war photographer of note, had trouble in the Crimea because his horse-drawn van provided an attractive target for Russian gunners. Hampered by their vulnerability, early photographers worked well behind the lines and after the event. The earliest war pictures show battlegrounds, depots, and soldiers manning guns and barricades. From these basic and quite static materials the best photographers reported less on the course of war than on its substructures. Fenton, for instance, made a series of exceptional pictures of British soldiers in the Crimea, officers who look like stylish participants in a fancy-dress parade. Fenton may only have intended a series on the men who fought, but at the same time it is clear that his eccentrically got-up subjects don't look like members of a well-organized army. The Crimea was – at least from the British and French point of view – a badly managed war, which eventually led to army reforms.

1855

Although Fenton's portraits from the Crimea cut a dash they were poorly received at the time. Their obvious romanticism was incompatible with a new climate of opinion altogether more businesslike. It was only in the 1960s and after that such bravura performances were appreciated.

ROGER FENTON

Captain Cunningham

By contrast, the American Civil War was professionally conducted by uniformed soldiery. While the Crimea was an excursion, almost a training exercise, the American Civil War involved a real clash of cultures and values. Most photography in this war of the 1860s was carried out by Northerners reporting back to audiences in the Northeast, to the people who provided the troops and resources. They represented the war as an achievement in logistics, as an affair of bridge and railway building. The unprecedentedly large armies that fought at Gettysburg and at Antietam needed provisions on a grand scale in what was, in effect, the first modern war. The Southern opposition, by contrast, was defined in Northern photography as an archaic, even an ancient culture, symbolized by classical building in stone – reduced to ruination by the power of the industrialized North.

World War I (1914–18) – the greatest of all wars – produced little photography that was remarkable, but a lot that was important. Previous wars, including the American Civil War, had involved campaigns, drives toward strategic sites culminating in battles that lasted for a day or so and were resolved in favor of one side or another. World War I, by contrast, was fought on fronts and in depth, and by infantry and artillery. It was marked by technical disequilibrium, in that the infantry on both sides were at a disadvantage with respect to the artillery, barbed wire, poison gas, and machine guns arrayed against them.

Thus the defensive arts were highly developed, and soldiers learned to dig in and to establish themselves. Soldiers in all sectors became, of necessity, excavators and builders. Many, especially in the German and Austrian armies, carried the new lightweight cameras that had been developed in the first decade of the century, and with these they recorded the improvised lives they had been forced to make for themselves on and behind the lines. A lot of the photography of World War I is amateur, and is about nothing more than daily life: groups of men eating, drinking, and conversing in temporary shelters. Many of the outstanding reporters of the 1920s first learned of the medium as serving soldiers in Galicia and Flanders. André Kertész was one of these, and Josef Sudek and Felix Mann – all of whom would become outstanding artists in their time in Paris, Prague, and Berlin.

More importantly, World War I accustomed a whole generation to think in terms of small-scale, everyday matters that were then so much under threat. Equally, World War I helped establish an idea of reportage as a career. More attritional than spectacular, it didn't lend itself to grandiose propaganda, although it was of course reported on by accredited agents. The horrible actualities experienced by all sides couldn't be broadcast to the nations participating, but soldiers with cameras had relatives and companions for whom they took and printed pictures – often of the aftermath of battles.

AUTHENTIC RECORDS

Many of these are to be found in soldiers' albums of the period. That is to say: soldiers themselves took authentic pictures of the war and helped to establish an idea of authenticity in reportage. Henceforth there would be official photography,

carried out at the behest of the authorities, and a more believable version carried out behind the scenes.

World War I helped shape the modern psyche. It may have been intended as a series of triumphant maneuvers and wild cavalry charges, but instead it became famously bogged down. Soldiers, many of them from the middle classes and from the cities, gained firsthand experience of the earth and mud of Flanders, Russia, and Italy. They learned how to excavate and furnish dugouts, and as they did so they dreamed of other ways of being less earthbound and precarious. There grew up a vision of warfare – not in itself discredited – as something that could be conducted at long range or from the relative comfort of tanks and aircraft. 1918 held out hopes of a new age of warfare that would be more like a motorized excursion conducted at speed across picturesque landscapes – by Germans in Russia, for example.

The Modernist aesthetic of the inter-war years, with its interest in streamlining and dynamics, drew on this vision of mastery. What happened, in response, was that photographers sympathetic to the Popular Front developed a conversational aesthetic, or one in which soldiers appeared as very ordinary people, writing letters, conversing, and playing cards. This new vision of warfare first emerged in the mid-1930s in reports from the Spanish Civil War. That war was relatively small scale by comparison with World War I,

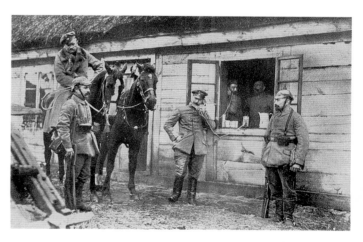

This photograph, captioned "How drinking-water is served round at the Front: drawing supplies for the French trenches," is taken from the *Illustrated War News*, January 26, 1916. Photography in 1914–18 concerned itself with how practical processes were carried out: cooking, washing, transporting fodder. Photographers on all sides envisaged the war domestically, as the work of an extended household – and that tendency survived in photojournalism into the 1930s. World War II, by contrast, was conceived of rather as a geography lesson.

UNKNOWN FRENCH PHOTOGRAPHER
FOR THE ALFIERI AGENCY

French trenches, World War I

but it was extensively reported, especially on the Republican side. The Democrats, who eventually lost the war, had neither the will nor the capacity to control how the war was reported – and the media in the Western Democracies were on their side anyway.

The Spanish Civil War produced more memorable photography than was made during the whole of World War II. Although Russia and Germany had developed very strong traditions in photography in the 1920s and 1930s, both were under control-conscious regimes, and by 1939 had evolved orderly national styles. The French, who had the most inventive and individualistic culture, failed to stay the course. The British and the Americans then had no option but to manage war reporting themselves, and the results often seem staged – although sometimes quite brilliantly so. Russian war photography in particular, seen by the Party as a matter of acute national importance, was put together on an epic scale, on themes of collective suffering.

The Spanish Civil War pitted individuals against the system as embodied in the collective cultures of Germany and Italy. It was the last war to be fought for a vision of the future: free-thinking individuals on the one side against marching automata in the grip of a collective idea on the other.

APOCALYPSE

World War II, however, altered the whole concept of a future after war, for it introduced not only the atomic bomb but memories of the Holocaust, of a system wickedly out of control and even abetted by the rank-and-file. There had been carnage enough in 1914–18, but it had been the tragic outcome of stupidity. Common-sense explanations after 1945 ceased to apply, and the situation was exacerbated by Western visions of Communist cultures as fundamentally other, closed societies with limitless human resources. Wars, carried out at first in Southeast Asia and then in Korea, appeared as desperate battles against an enemy that seemed like a force of nature. The Korean War of the early 1950s was imagined by Western cameramen less as a conflict between equals than an

unequal match between man and nature. Not only was the Korean weather often bad, but the opposition seemed limitless. Korea, as envisaged by photographers, was a war of individual suffering, with mainly American suffering at the forefront.

KOREA TO VIETNAM

In the past, war had always featured identifiable enemies. The other side had different flags, homelands, and a different social system which could be brought to mind without too much effort. All that was taken for granted until World War II. Korea was the first war pictured as a matter of endurance and as a psychodrama. Western soldiers underwent unimaginable hardships – or so it seemed from the images of wildly staring survivors. What was established as a possibility in Korea became an actuality in Vietnam in the late 1960s. In absolute terms it may have been a small war but its pictorial legacy was huge. In memoirs American survivors remark on the difficulties of confronting a large invisible opposition, somehow implicated in the environment at large, yet always capable of inflicting wounds and death. More even than Korea, Vietnam was a war carried out under the auspices of nature. It could only be judged in terms of its effects, which were to drive its participants

insane – they had seen, and been subject to, atrocities which seemed to be without discernible cause. Thus, Vietnam became a war which imploded. Photographers and the media responded by means of pictures of terrible and casual violence. In World War I citizens had been pitted in droves against tanks and guns and planes, but the same citizens had still been confident that, as these machines were their creations, they could be managed. In Korea and then in Vietnam, on the other hand, Westerners, who had succeeded in bringing weaponry under control, found themselves faced by forces unknowable in secular and liberal terms. Thus, their individuality was both challenged and undermined. The photography of the Vietnam War presented, in the style of Goya, a stark portrayal of the true horror of war, a glimpse into the abyss. At one level it is merely war reporting, but at another it serves as a token of the collapse of Western culture as it has long been taken for granted.

This appeared in Nachtwey's important book of 1989, *Deeds of War*. Documentarists ask you to imagine what it would be like to be on that site, and Nachtwey has always been remarkably attentive to the management of events, dragging a body, in this case, made hideously real. Nachtwey's wars involve individuals, person-to-person; his successors have tended to see war as plague or contagion, at least as collective catastrophe.

JAMES NACHTWEY

A suspected rebel shot and buried by the army, Tecoluca, El Salvador

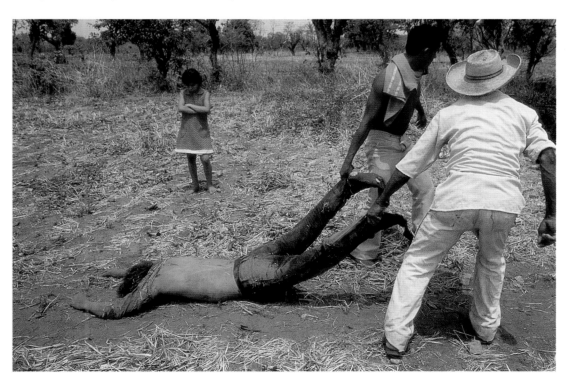

The forts at Taku guarded the mouth
of the river, leading to Peking.
British and French forces invaded
China, hoping to open the country
to trade, including trade in opium –
these were the Opium Wars.
Beato was on hand, as he would
be in a similar expedition to Korea
in 1871, to take pictures oddly
impressive for their documentary
content – quite apart from their
standing as reportage.

1860

FELICE A. BEATO

**The Great North Fort at Taku,
at the mouth of the Pei-ho**

1855

Roger Fenton gave a full account of
the Crimean War, including many
portraits of participants on the British
side. Although in regular regiments,
most of Fenton's soldiers look like
stylish amateurs acting romantic
parts from the Napoleonic era.

ROGER FENTON

Lieutenant Colonel Seymour

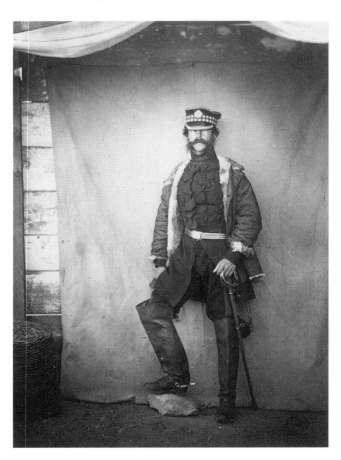

1855

Fenton's aristocratic soldiery were
the last of their kind, survivors –
at least in imagination – from
Wellington's armies. They were
meant as celebrities for sale to the
public, but it was only in the 1960s
that this sort of dressing up came
into its own.

ROGER FENTON

Captain Lord Balgonie

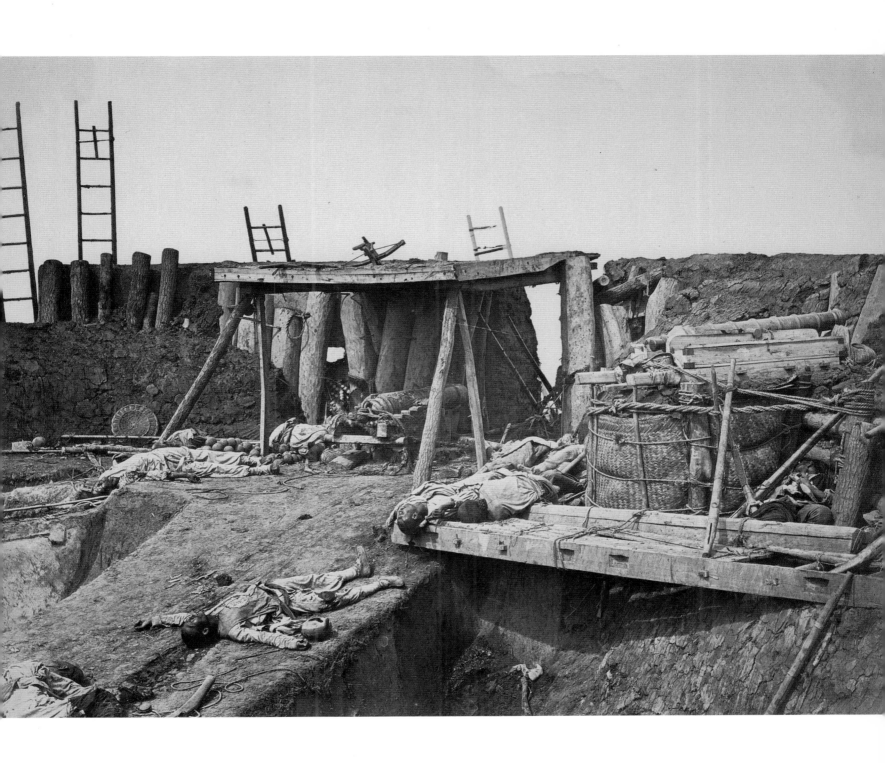

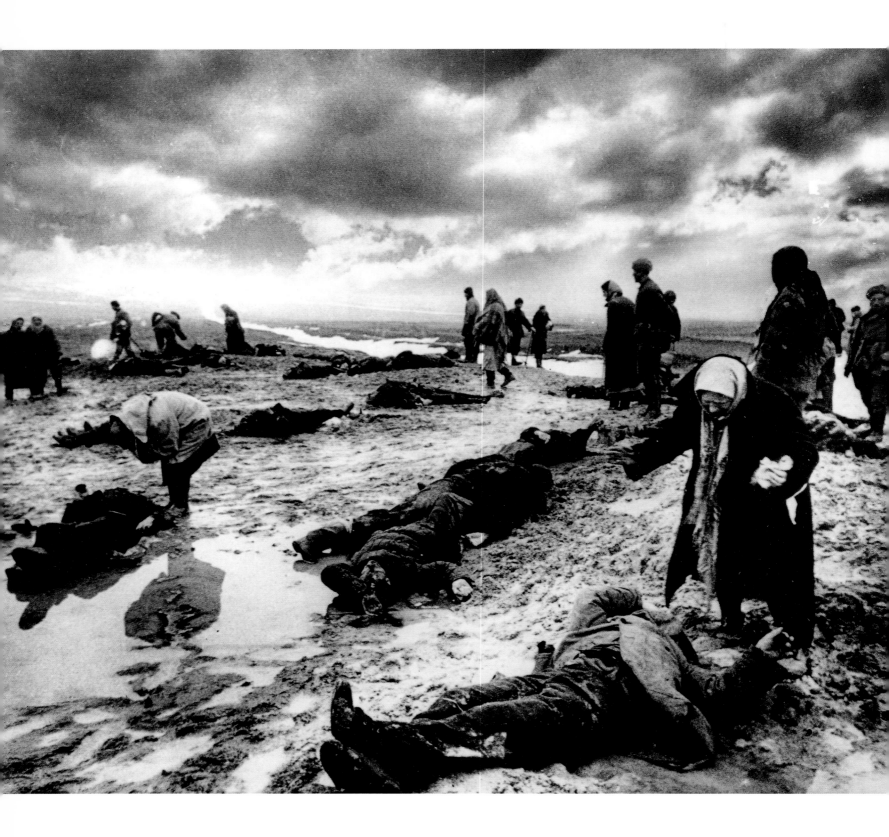

The dead are identified and mourned over after a battle or a massacre. Baltermants took up photography in 1936 and belonged to a new generation of artists who pictured life in the U.S.S.R. in epic, naturalistic terms – a departure from the design-conscious, "modern" photography of the 1920s.

DIMITRI BALTERMANTS
Kerch, Crimea (Grief)

Sergeant Len Chetwyn worked as an official war photographer, and for the Keystone Agency. In this – Britain's most elegant war photograph – an officer, identified by his pistol and lanyard, gallantly leads a group of soldiers into the smoke of an explosion, in a scene which recalls actions in World War I, 1914–18.

LEN CHETWYN
Charging to Victory in Egypt, October, 1942

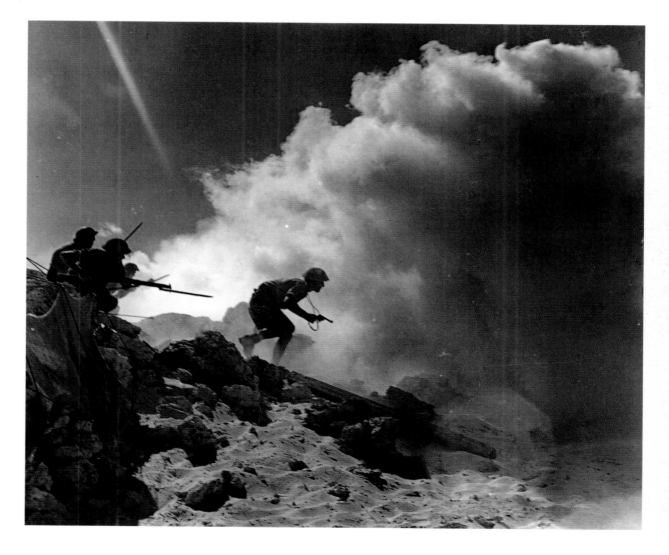

From 1941 Frissell, originally a fashion photographer, covered the war in Europe for the Red Cross and then with the Eighth Air Force. A documentary photographer by instinct, she was interested in the after-effects of war rather than in its more terrible moments.

TONI FRISSELL

German prisoners of war taken by the 10th Mountain Division, Monte Belvedere, Italy

Anticipating just such a moment, Chaldej had taken the precaution of carrying an improvised red flag with him – made from a cover for a billiards table. Nationalist formats of this kind were part of the mindset of World War II.

JEWGENI CHALDEJ

Russian soldiers place the flag of the U.S.S.R. on the ruined Reichstag building in Berlin, May 2, 1945

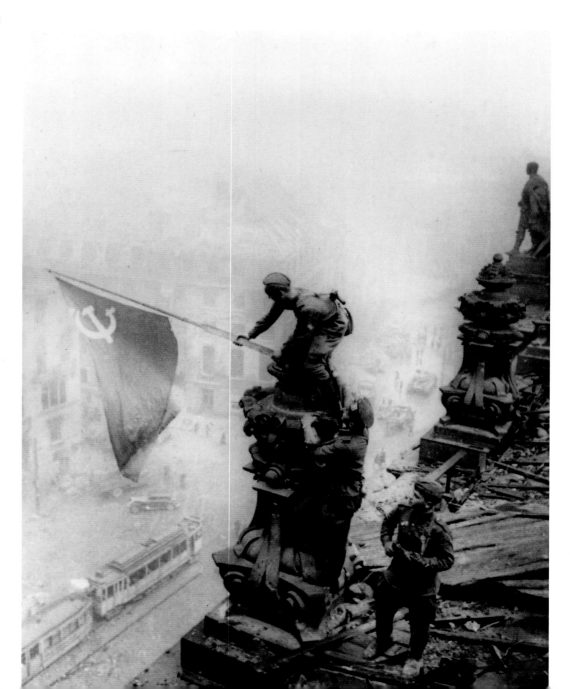

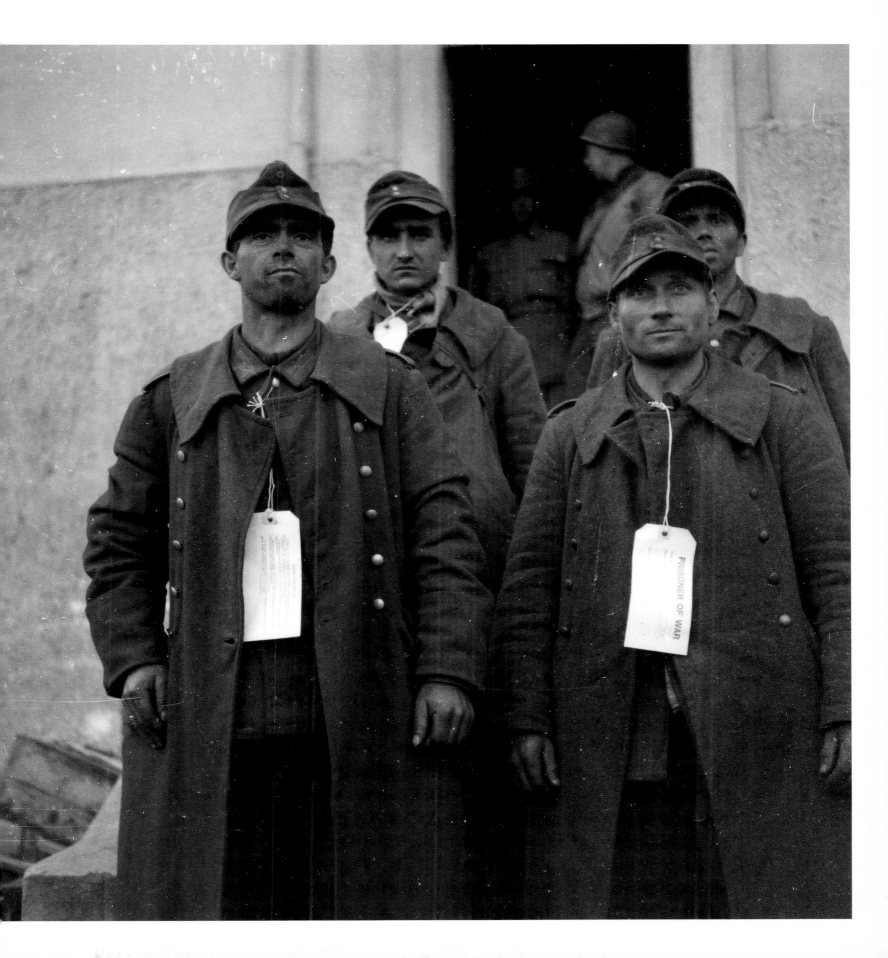

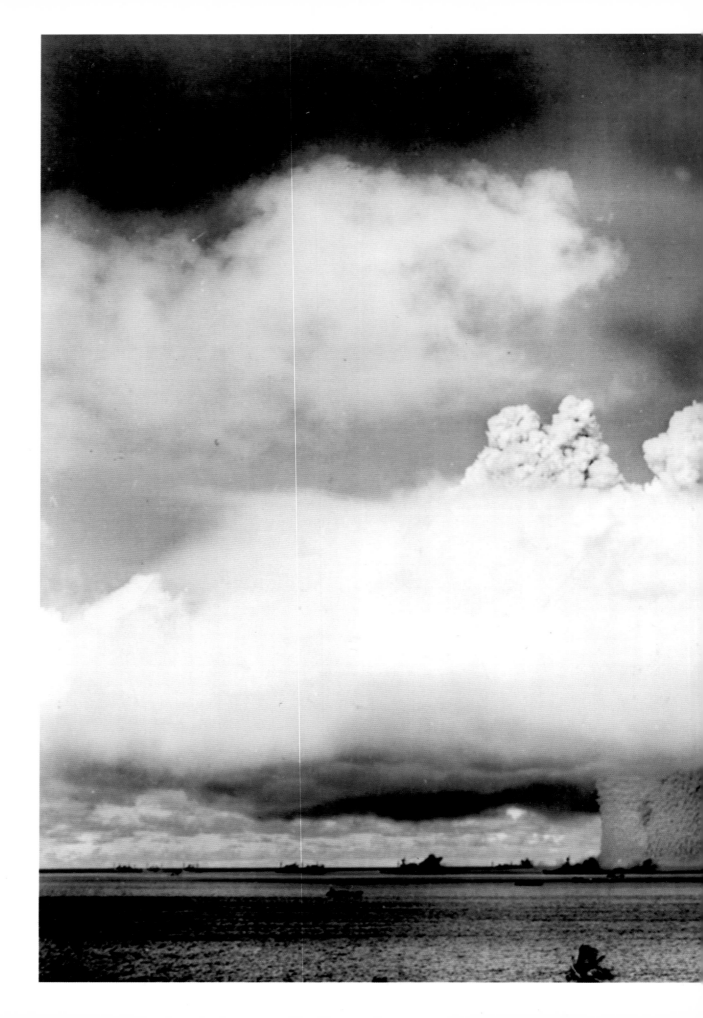

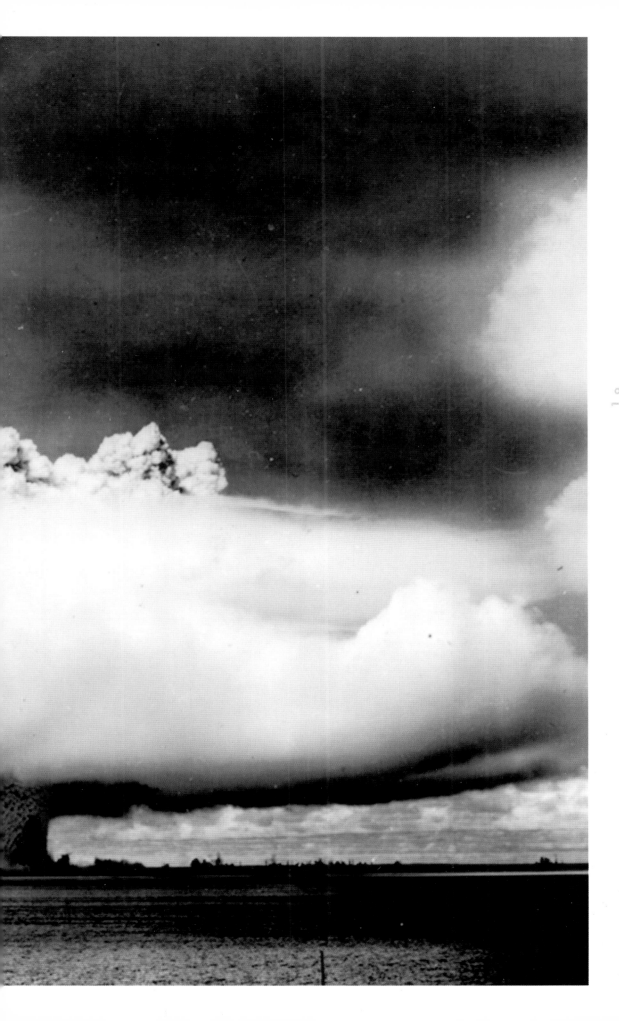

The atomic cloud put warfare under a new sign, natural and cataclysmic – a branch virtually of the weather. Henceforth the works of practical man, scattered along this horizon, would no longer count as they once had.

UNKNOWN PHOTOGRAPHER

Atomic cloud during Baker Day blast at Bikini

WAR **89**

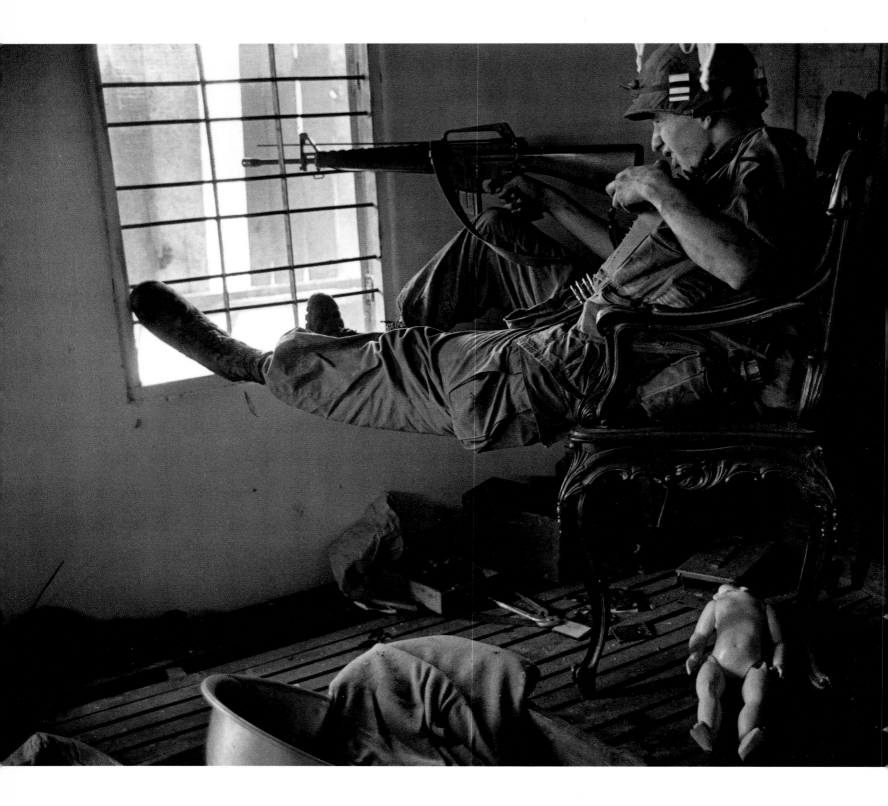

This notable picture from Vietnam
appears in Griffiths's *Vietnam Inc.* of
1971. The doll and carved chair
point to this as the affluent District 8
on the southern edge of Saigon, an
area infiltrated by Vietcong and
then subject to American firepower.

PHILIP JONES GRIFFITHS

**U.S. soldier during the Tet offensive
in Saigon**

1 9 6 5

Like all Vietnam pictures this
became a wire-photo. Transmission
lines gave such pictures an
expressive dimension quite apart
from the subject matter. Here, a
Vietnamese soldier immerses a
Vietcong suspect during questioning.
"She later was thrown into a
government prison," the caption
adds reassuringly. Vietnam pictures
were of a candor unprecedented in
the history of warfare. My died
in action in 1965.

HUYNH THANH MY

Mekong Delta, Vietnam

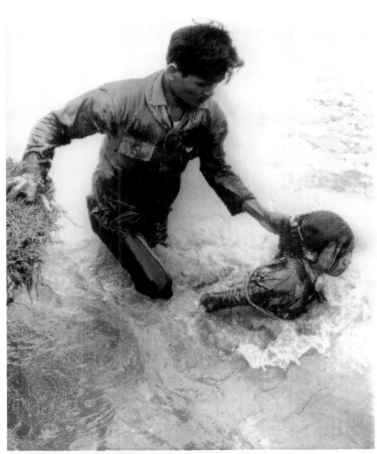

(FOR USE WITH "WOMEN IN WAR" NEWS-PICTURE PACKAGE)
(NY18-Aug. 27) WATER TREATMENT FOR VIET CONG SUSPECT — A Vietnamese
soldier pulls a suspected woman Viet Cong by the hair as he lifts her out
of a stream into which she was dunked during questioning after her capture
near Ap La Ghi. Her arms were bound behind her before the water torture.
The soldier sought information on the identity and whereabouts of guer-
rilla forces in the area. She later was thrown into a government prison.
(AP Wirephoto by Radio from Saigon)(f61322stf-htm) 1965

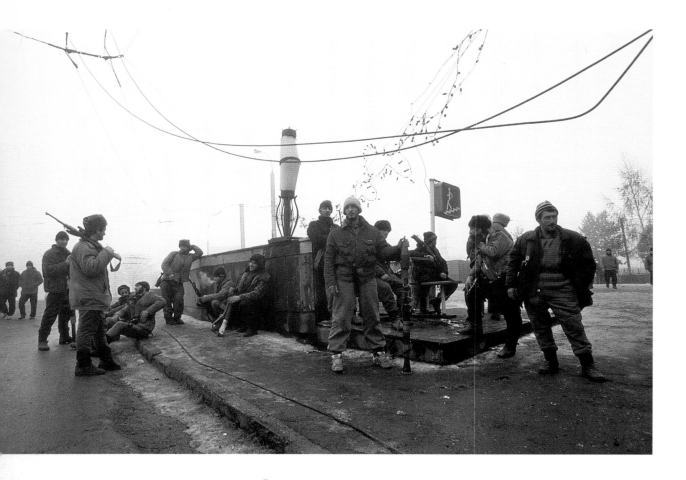

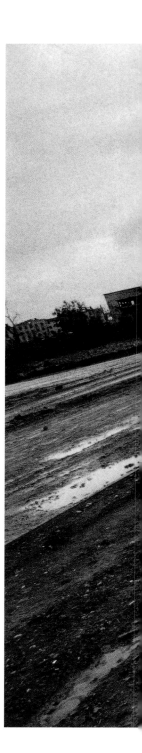

1995

Many of the participants in Postmodernism's small wars have been familiar with international style as mediated by television, and the wars themselves become events in fashion's history. Lowe is a member of Magnum Photos and known for his pictures from Chechnya and Bosnia.

PAUL LOWE

Chechen soldiers on the main road to the Palace, Grozny

1995

As a city in the former U.S.S.R., Grozny would have had futuristic, utopian aspects of the kind cited by the businesslike road and housing off to the left. Wylie's tactic has been to refer to that old utopia in the context of present ruination. His preoccupations are – like those of many of his contemporaries in the small wars of the 1990s – with the victims, or those forced to cope with the aftermath.

DONOVAN WYLIE

Grozny, Chechnya

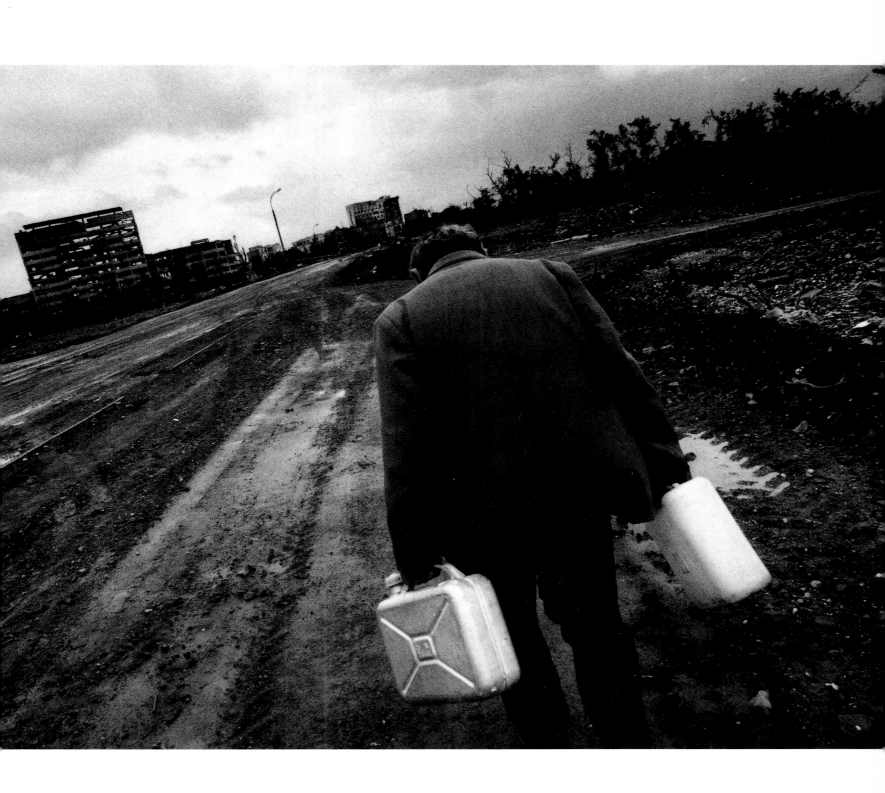

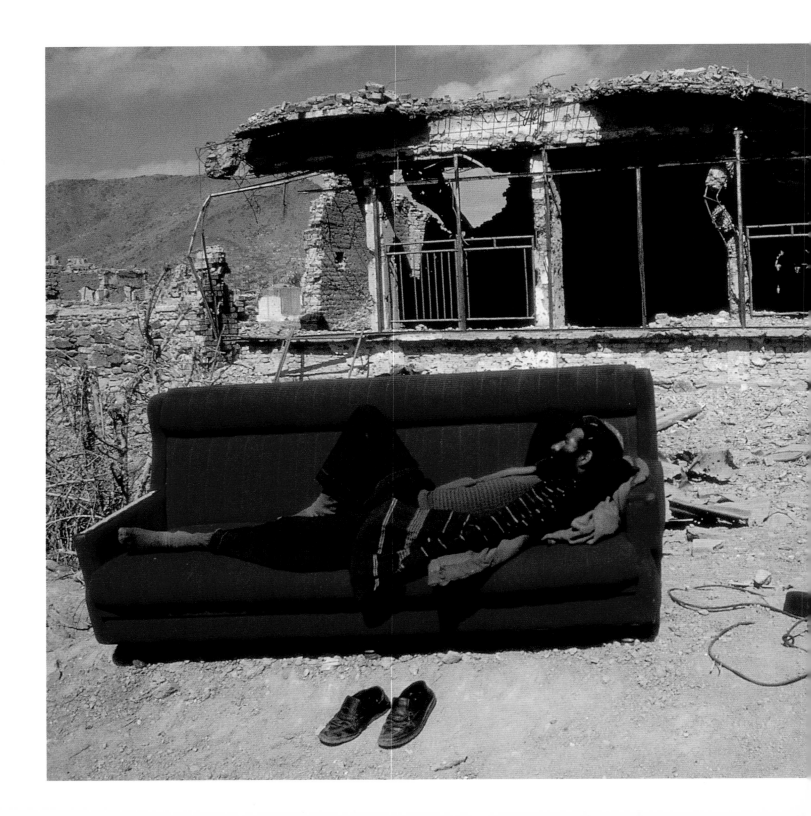

1997

African wars figured in reportage, from the 1960s on, as premonitions of an anarchic future in which liberation meant looting and new forms of oppression. Delahaye, one of the major war reporters of the 1990s, specializes in significant details: beer and wristwatches in this case.

LUC DELAHAYE

A column of AFDL soldiers in former Zaire

1995

Why, with so much destroyed, should he bother to remove his shoes to rest on what seems like an abandoned couch? Small but sustained wars, such as that in Afghanistan, can sometimes look like rehearsals for the collapse of Western culture and society. Their colors are often those of travelogs, decorated with abandoned consumer durables. McCurry, a member of Magnum Photos, has reported often from Afghanistan, the Yemen, and Sri Lanka.

STEVE MCCURRY

A bazaar in ruins, Kabul, Afghanistan

GOOD EARTH

Russian and German Modernists in the 1920s and 1930s imagined the earth as a resource to be managed for the good of the people by tractor-driving operatives. Ideas of being at home in landscapes were brushed aside because Nature was there to be subdued. This applied less in tradition-conscious France, which was imagined to be a nation of regions. This meant that French photographers in the 1930s were more aware of local contexts than their contemporaries in ambitious Russia and Germany. After World War II, the French example dominated as the postwar world cherished the notion of an international order of small cultures at peace with one another.

The ideology of the good earth culminated in the *Family of Man* exhibition, mounted by New York's Museum of Modern Art in 1955. Its motifs included children at play, the family circle, weekend leisure, handwork, and any number of bicycles and mules – especially in Italian neo-realist photography. Italian photographers, especially in Sicily and Friuli, devoted themselves to archaic good earth themes well into the 1970s, when their example was taken to heart by Arte Povera and Italian vanguard artists. Elsewhere, most notably in the work of Josef Koudelka in Czechoslovakia, the good earth survived as a memory only in contemporary dystopias.

c . 1 9 3 2

Traders interested Modernist photographers, perhaps because they existed in and managed limited spaces – like artists in their studios. Certainly they epitomized individuality and the liberal spirit, increasingly under threat from the collective ideologies of the 1930s.

WALTER SÜSSMANN

"When will the first customer come along? A market stall in Würzburg in the gray of the morning."

1 9 3 2

"The sewer workers, who have to wade through deep water, get ready with watertight waders." Borchert, a principal photographer for Pacific & Atlantic and then for Associated Press in Berlin, specialized in work topics of this kind, close to national material: the stones, soil, and water of Germany. Modernists in the 1920s had tried to look beyond the material base. Berlin's sewers were a favorite topic in the early 1930s.

ERICH BORCHERT

A Walk in Underground Berlin

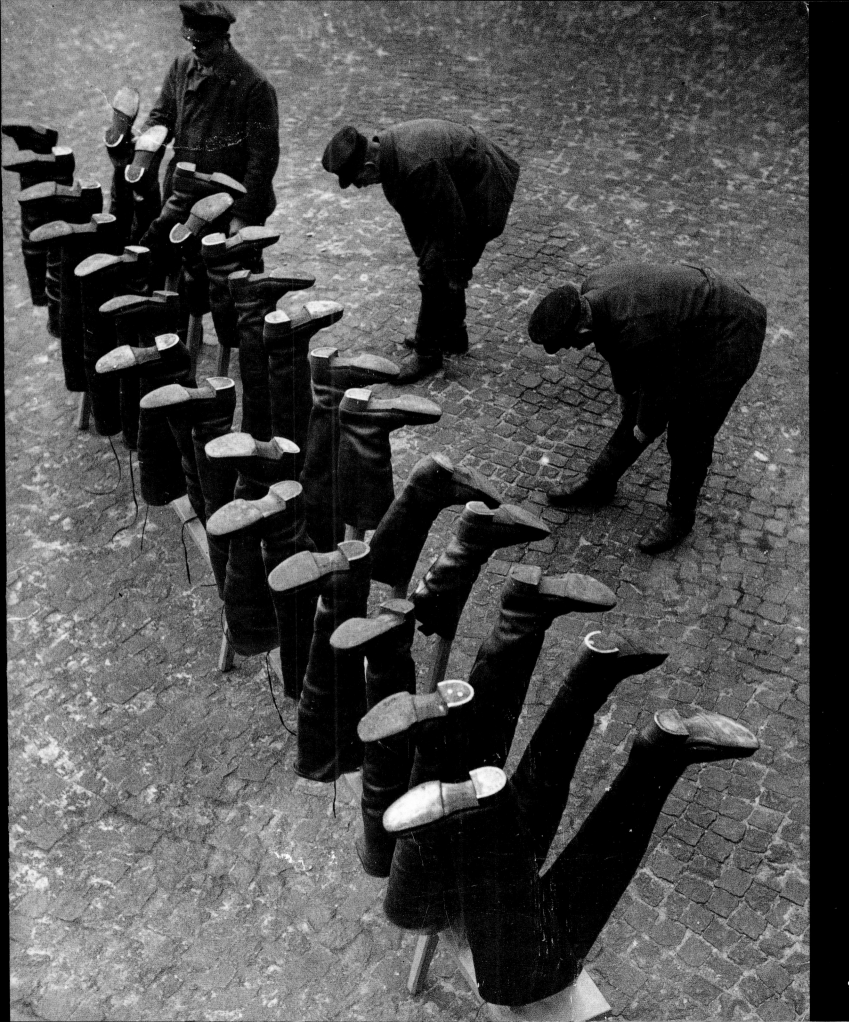

P aradise existed, but at a distance. From the 1840s photographers inspected the world for "treasures": valuable, discrete objects which might be owned or put on show back in London or Paris. Landscape was at best a resource or site to be clearly demarcated, for trade or ownership. During the Symbolist phase that followed, from around 1890 up until the start of World War I, artists assumed a symbiosis between places and specially sensitized observers. Both phases left their mark on popular aesthetics. Realism, or that respect for objects in the world, resulted in a materialism that held that we were or could become whatever we handled and ate. Thus the people of France might be understood in terms of wine and wheat, granite and limestone. The basic ingredients of a place shaped the nature of its people, and this accounts for the very high esteem in which coalmining and ironsmelting were held throughout the modern era, and far into the twentieth century. Both coal and iron were well and truly of the earth, and came to symbolize connections between a people and its place. Symbolism added a mystical element to the relationship in that it suggested that those in regular touch with the configuration of an area were likely to be imprinted spiritually as a consequence.

1902

Frechon toured France during the summer months, photographing in the country and in small towns. He represented the French as unselfconsciously engrossed in a way of life, working, trading, and very often conversing, always at home among familiar sounds.

EMILE FRECHON

A market on the ramparts, Dax

The French were the first to give shape to the idea of paradise – at least within the context of industrial and metropolitan culture. By the 1900s, Britain's industrial cities had already developed their own identities, and their immigrants came from far away in Ireland, Wales, and Scotland. No British city, however, maintained a close relationship with a well-defined region, whereas Paris represented the regions of France. Atget's Paris, for example, photographed from 1900 on, can look – with its regional food shops – like a version of the provinces. Of necessity the French had to consider the relationship between the capital and its provinces, whereas in Britain the die was already cast. Thus there grew up in France a photography of the regions that left a permanent mark on French and modern photographic aesthetics. It was still possible in

the modern era, according to French terms of reference, for there to be a harmony between inhabitants and a site, even in the otherwise unpromising city; and until the 1950s Parisians in particular continued to be photographed as if they remained provincials and even peasants.

THE U.S.S.R. AND THE WORLD

The good earth proper, however, emerged as a serious issue only after the Russian Revolution, and in particular in the 1930s. During the 1920s, Russian photographers had emphasized the newness of revolutionary culture, but that look was futuristic, and therefore anachronistic, in the agricultural communities that made up the U.S.S.R. In the 1930s photographs were obviously not intended just for local consumption. The Soviet authorities were bidding for world

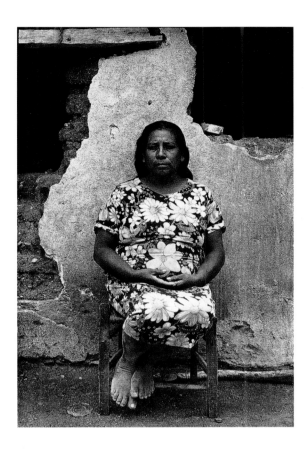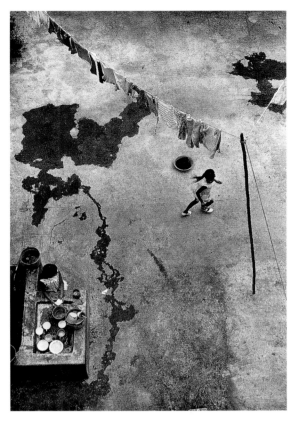

leadership, especially among subject peoples. It was in their interest to show that the U.S.S.R. respected regional and cultural differences while at the same time introducing the peoples of the earth to the new technologies that made life more efficient. It would have been absurd in that context to persevere with Modernist aesthetics that proposed nothing less than a total transformation of mankind. The Soviet response – very like the German response – was to show modern technology incorporated within traditional contexts. The Soviets were also lucky in that in Max Alpert they had an artist equal to the task. Alpert had begun to work as a photoreporter in 1924 after a spell in the Red Army. From 1928 he made documentary pictures for Pravda, and then in 1931 he began to contribute to the illustrated magazine *U.S.S.R. in Construction*

– set up by Maxim Gorky to present the U.S.S.R. abroad. Along with Arkady Shaikhet and Semjon Fridland, Alpert was a member of the Russian Association of Proletarian Photographers, and in the early 1930s he and his colleagues argued on behalf of human interest in Soviet documentary. They opposed the abstract, design-conscious approach of the October group of photographers headed by Rodchenko. Alpert specialized in images of labor-intensive enterprises, such as the laying of the Turkistan-Siberian Railway (1929) and the building of the Magnitogorsk Steelworks (1930). In 1937, Sovfot, the official news agency, distributed a study of local life in the Kirghiz Republic, pictured by Alpert as a romantic epic in which wild horsemen mingled with the classic tractor-driving citizens of the Soviet vision.

Both the abraded stucco wall and the water-stained courtyard resemble maps and positioned La Señora and the children as representative figures, monumental in one case, fleeting in the other. They stand for Mexico, and beyond that for life in the relationship to the elements: water and air, but also grit and that jagged metal lid by her right foot. Carrasco, from Oregon, is a documentarist specializing in rural life in Latin America, India, and Spain, and in the culture of Russia's Old Believers – from the 1960s on.

PRISCILLA CARRASCO

La Señora de el Rosario Micaltepec, Puebla, Mexico, 1973 and Por Que Corre? (Why Run?), Puebla, Mexico, 1976

Vogel, editor of *VU* magazine in Paris, toured the U.S.S.R. in 1931 with Dr. Leibovici and Countess Michel Karolyi. They used Rolleiflex cameras and Agfa Isochrome films, as Vogel pointed out in the special issue that ensued. The harvester is not intended as a symbol, although that is how she functions. It was a handy place to keep a sickle while making a straw rope. The special issue of 127 pages projected the U.S.S.R. in a very fraternal light.

LUCIEN VOGEL

In the fields

The advantage of the U.S.S.R. – from a photographic point of view – was that it housed autochthonous peoples dressed in traditional, non-European ways. They were authentic inhabitants of the good earth, and apparently unaffected by the great economic crisis of the late 1920s and early 1930s. By contrast, in Germany and the U.S., the countryside was a problematic zone that suffered badly in times of crisis and became associated with mendicancy. Country people in both cultures could only endure, waiting for better times, and the results were equivocal – charming and at the same time decrepit. American photographers did eventually make utopian pictures of worked landscape, but not until the late 1930s and 1940s, under the aegis of the Farm Security Administration and its successors at Standard Oil. American concepts of landscape were either of wilderness, with humanity nowhere in sight, or of successfully occupied arable land, where man was in total control.

Britain's vision of the good earth was altogether more complex, due less to innate sophistication than to a different ideological stance. With industrial processes in charge in the cities and across large tracts of the countryside, the British were unusually aware of malign encroachments, opposed, in the 1940s and 1950s, by visions of an archaic culture hospitable to individuals. The movement was called Neo-Romanticism and its leading photographer was Edwin Smith, one of the most determined documentarists and author of books on many aspects of British traditional life: landscape and architecture, sacred and secular. Smith's vision of Britain was of a place heavily worn, in use by countryfolk continuously present since the Stone and Bronze ages. Smith's pictures acted

mnemonically for being of architecture and of inhabited sites, they had to be explained, and the explanations kept the past in mind. Not only that, but it was the kind of past that served as a rejoinder to what one commentator called "squalid reminders of the present century."

The good earth never stood much of a chance in the face of technology. Germans of the national socialist era, who believed passionately in the closeness of blood and soil, made sure of their separation by the building of the first autobahns, from which the soil could be seen only at speed and at a fair remove. The British, despite their attachment to ancestral voices, opted for the suburbs and ribbon development. The *Family of Man* exhibition of 1955 used imagery from the good earth inventory, but the writing had been long on the wall. Nevertheless, the idea remained a potent one, and it survived, negatively, well into the postmodern era.

DYSTOPIAN VISIONS

One of photography's major exhibits is a book of 1975: *Gypsies*, by Josef Koudelka. The photographs were taken in separated gypsy settlements in East Slovakia during the period 1962–68. The pictures are introduced by Robert Delpire, the most influential of all late-modern editors. Delpire says of Koudelka's portraits that behind "these weather-beaten faces silently slides the ice of all fears." Several of the photographs, however, are of near-landscapes hosting cultural events: work, weddings, and a funeral. But in each case there seems to have been a slippage in pictures disproportionately arranged to show distances obscured by mist, and muddied foregrounds. It is as if the cultural program of *The Family of Man* has been subverted. Man may survive much as before, but in far fewer

numbers and in the ruins of civilization. Koudelka's *Gypsies* is the last homage in photography to the idea of a universal social order based on the soil and on the cultures to which it gives rise.

Photography is a vast collective enterprise, sustained by contradictions. Without Max Alpert and Edwin Smith it would be hard to see postmodern landscape for what it is. Alpert, Smith, and Koudelka assume a cyclical order inherent in agricultural life. Their chosen societies lie outside history considered in the long term – they represent little more than the passage of the seasons. Postmodernism, however, dispensed with that vision of the good earth in relation to the seasons, and proposed instead, and in direct contradiction, a reading of history oblivious to the agricultural year. Henceforth – from the 1970s on – there would be a new preoccupation with abandoned sites in postindustrial zones. Abandonment implied radical change at a structural level and independent of nature. Much of Postmodern and postindustrial landscape takes place in settings

from which all traces of weather have been excluded because weather occurs in natural time rather than in the longer span of manufactured history. One thing, though, that this newer photography does declare is standpoint. In the 1930s, photographers worked on behalf of society at large and took up their position accordingly at a distance that implied a public rather than a private viewpoint. New topographers, of the kind employed on the French DATAR project in the 1980s (*Délégation à l'Aménagement du Territoire et à l'Action Régionale*), chose instead – even when reporting on ostensibly regional and seasonal matters – to admit to standpoint. Not only were many of them using large-scale, earthbound cameras, but acknowledgement of the here and now (weather included) spoke of experience of landscape as something personal, as an act of individual witness rather than a social undertaking. Humankind, as represented by the photographer, is no longer able to feel integrated into nature's cycles as was once the case, as was still the case in Koudelka's Slovakia in the 1960s.

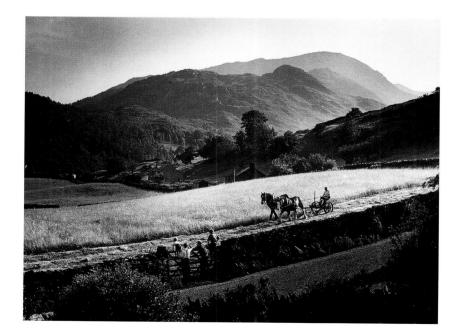

Smith, a neo-Romantic, related national monuments – castles, stately houses, and such landscape features as this – to the daily and practical life of the people: gardening, thatching, plowing, and in this instance, haymaking. His work was collected in a series of anthologies, e.g., *England*, 1971, with texts by Angus Wilson and Olive Cook.

EDWIN SMITH

England – Westmorland, Little Langdale (Lake District)

c. 1860

The picture is of Harriet Crawshay, the photographer's daughter, and a friend dressed up as fish girls; it is an albumen print from a wet collodion negative. Pioneer photographers often thought of the world as a stage and took it as second nature that parts should be taken. This tendency to act for the camera lasted well into the 1860s – after which people were expected to play their true parts.

ROBERT CRAWSHAY

Welsh fish girls

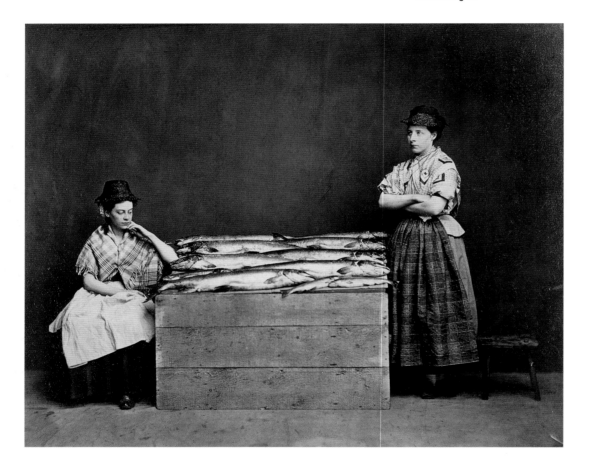

1906

Frechon toured and photographed widely in France during the first decade of the century. He made pictures of many aspects of folk life, but this was a favorite subject, perhaps because it was associated with talk and the sound of the river and of fabric on metal. Frechon's vision of France, wherever he went among sawyers, soldiers, drunks, or traders, was a culture in conversation, enacted – a quality of light and sound – an aura rather than an aggregate of items.

EMILE FRECHON

Washerwomen on the River Adour

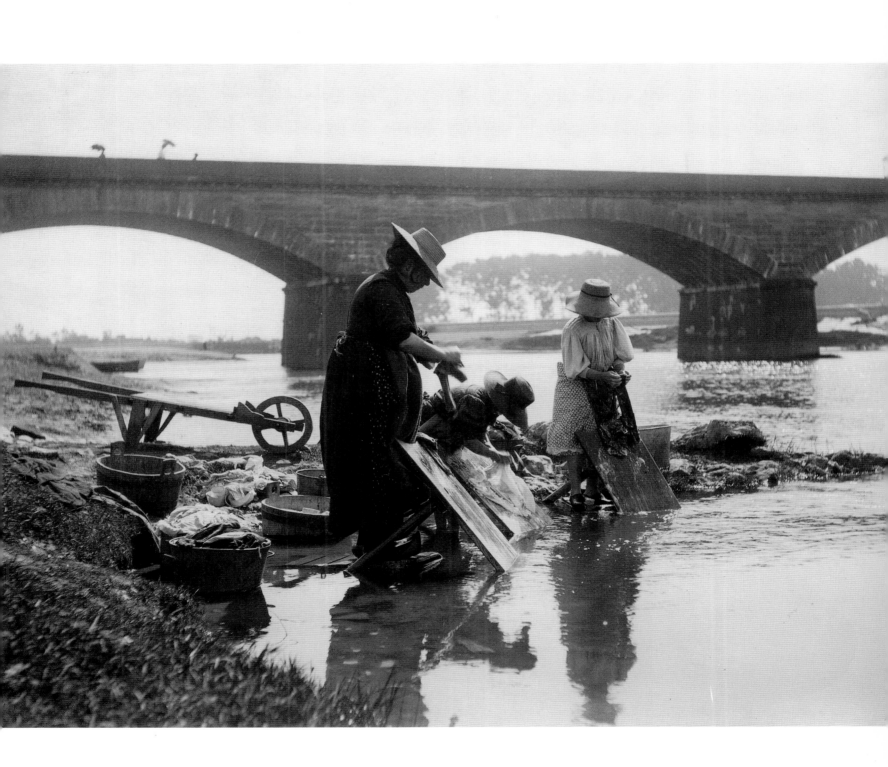

c.1932

Ruge, who was himself the agency Fotoaktuell, made a documentary study of indigent farmers in northern Germany, living in excavated homes with sod roofs. There was in the early 1930s, just before the Nazis came to power, a movement of sorts in Germany, but such actualities as this reflected badly on the new regime, and it was left to the American photographers of the Farm Security Administration to continue the kind of candid documentary undertaken by Ruge.

WILLI RUGE

The village under the earth; cooking in a cave dwelling

c.1933

Süssmann, who worked for the Berlin agency Presse-Photo, had an eye for cultural and folkloric subjects at odds with the brisk metropolitan matter that had interested photo-reporters in the 1920s. A Jewish photographer, Süssmann was under pressure in nationalist Germany, despite his penchant for traditional culture, and he became Lueders (his wife's maiden name) and finally Walter Sanders, when he emigrated to the United States, where he worked for *Life*.

WALTER SÜSSMANN

The Market Place at Tübingen

1948

"The Dakotas in winter were a revelation to me and became one of my favorite places in the world, like Paris, or the Italian Riviera, only different.... I loved the wide open emptiness, the fact that there was nothing whatever to photograph." In 1948, Vachon was working on documentary projects for Standard Oil and was often at his best in open countryside.

JOHN VACHON
Mail delivery, Ransom County, North Dakota

1946

Brooks took documentary pictures for Standard Oil in 1946–47, pictures of farming in upstate New York, life in New England towns, and in Vermont. A romantic, she liked "fog in the morning, or rain, and weather conditions." Her vision was of a culture still at one with nature.

CHARLOTTE BROOKS
Early morning fog, Williamstown, Massachusetts

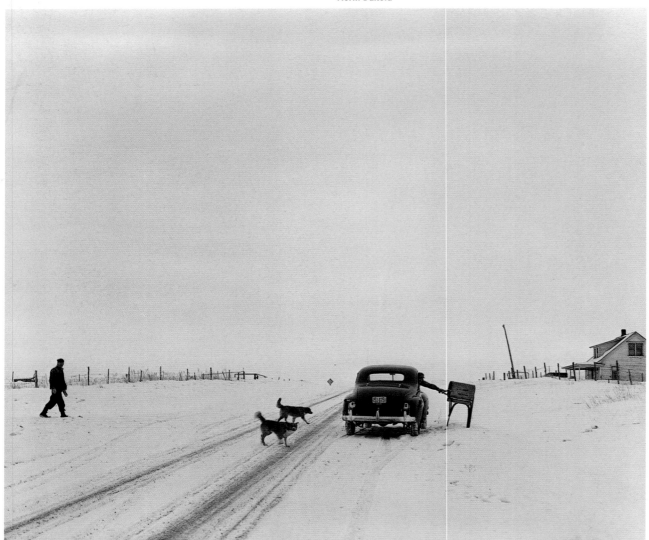

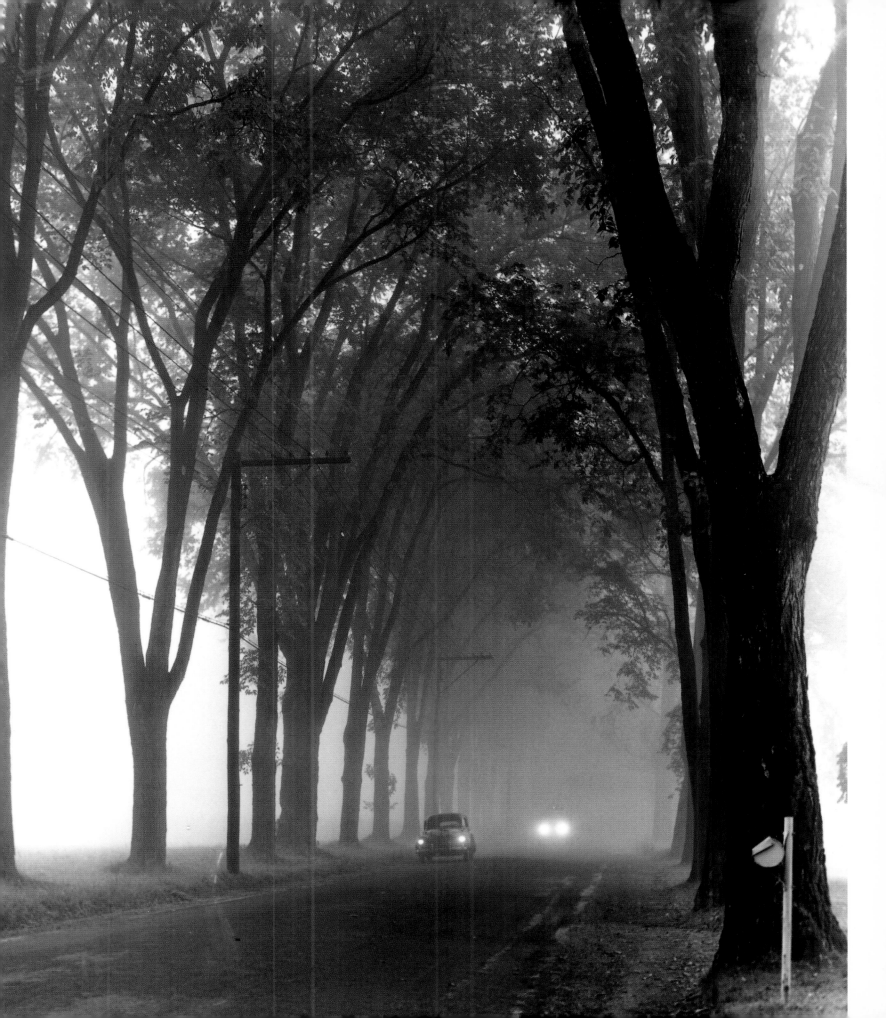

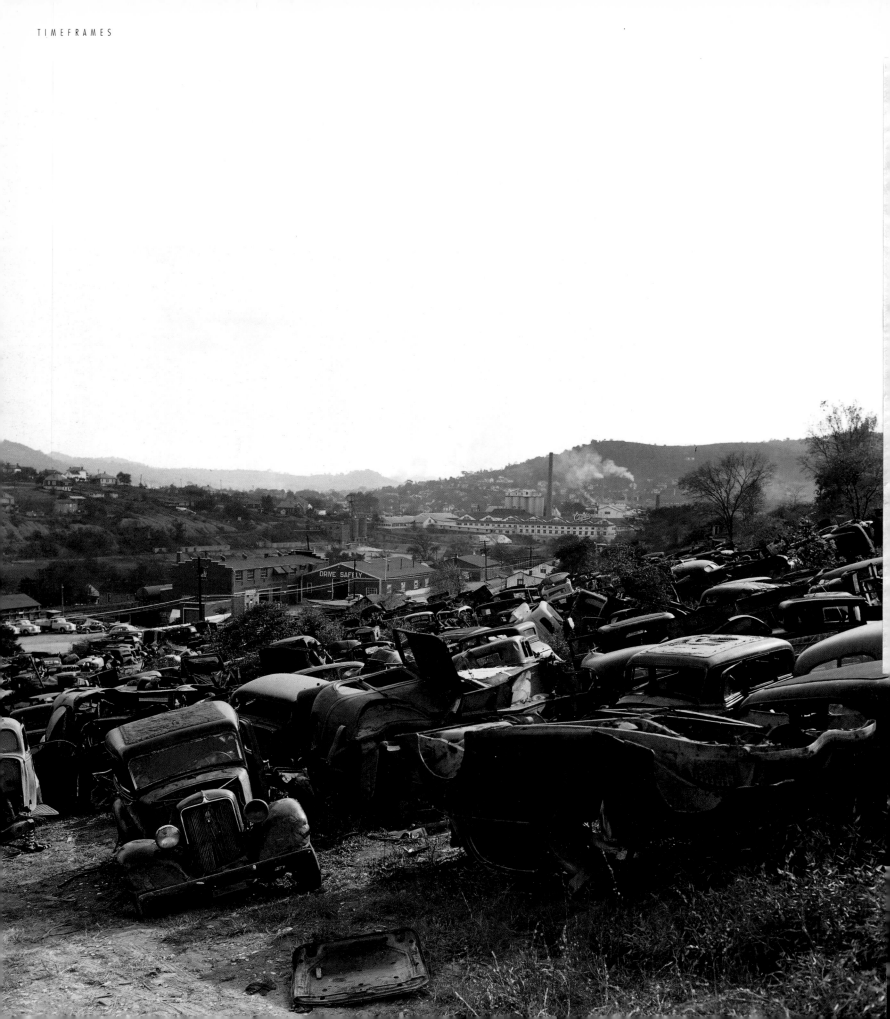

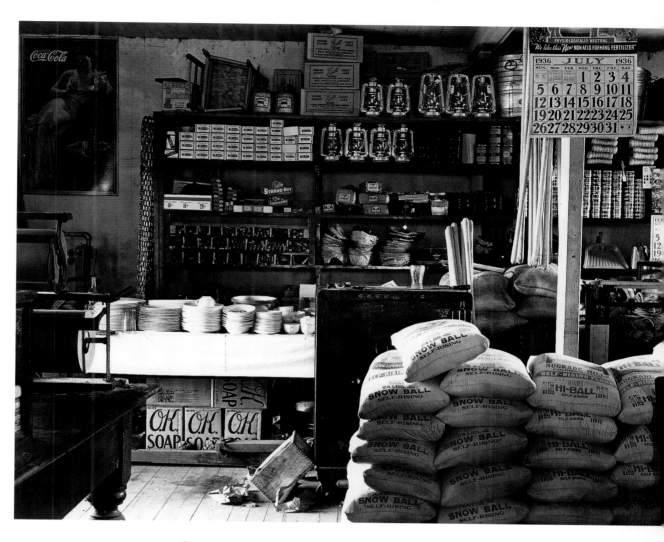

1936

Modernists, of whom Evans was an outstanding example, admired the constructive impulse and thought of the social world as a studio or workshop in which culture would be carefully put together from plain materials.

WALKER EVANS

General store interior, Moundville, Alabama

1947

Vachon, formerly of the Farm Security Administration, took into account the downside of industrial culture, and foretold the kind of ecologically aware photography that would come into being in the 1970s and after.

JOHN VACHON

Automobile junkyard, Clarksburg, West Virginia

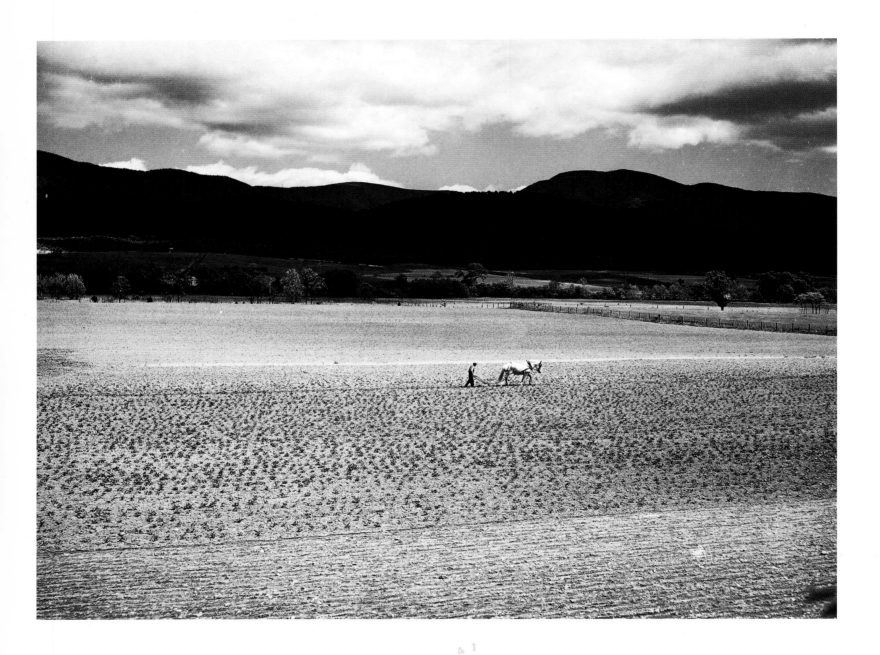

Farm Security Administration
photographers took relatively few
pictures of landscape for they were
more interested in the American people
as artisans and creators. This picture of
the romantic Shenandoah Valley is
comparable to the epic landscapes of
the Kirghiz Republic in the U.S.S.R.
taken by Max Alpert in 1938.

MARION POST WOLCOTT

Shenandoah Valley, Virginia

This is Soyuzphoto 4176, from May, 1938. It shows a brigade of Kirghiz collective farmers working on combines during the harvest campaign and belongs to a series *Soviet Kirghizia* by Max Alpert. An essay of 500 words attached to the series pictures Kirghizia as an upland paradise: "Apples, pears, grapes, quinces, pomegranates, figs, apricots, etc., grow in the gardens of the collective farms and farmers." Prior to the Revolution, the people of Kirghizia had lived in "The Epoch of Tears." Alpert was the most arcadian of all Soviet propagandists.

MAX ALPERT

Collective farm, Kirghizia

This is not just a Japanese icon but a symbol of postwar aspirations to return to nature and to respect tradition. From 1939 on, Hamaya took pictures in northern Japan, published in 1956 as *Snow Land*. His sympathies were always for people existing close to the elements in inhospitable environments.

HIROSHI HAMAYA

Woman planting rice, Toyama, Japan

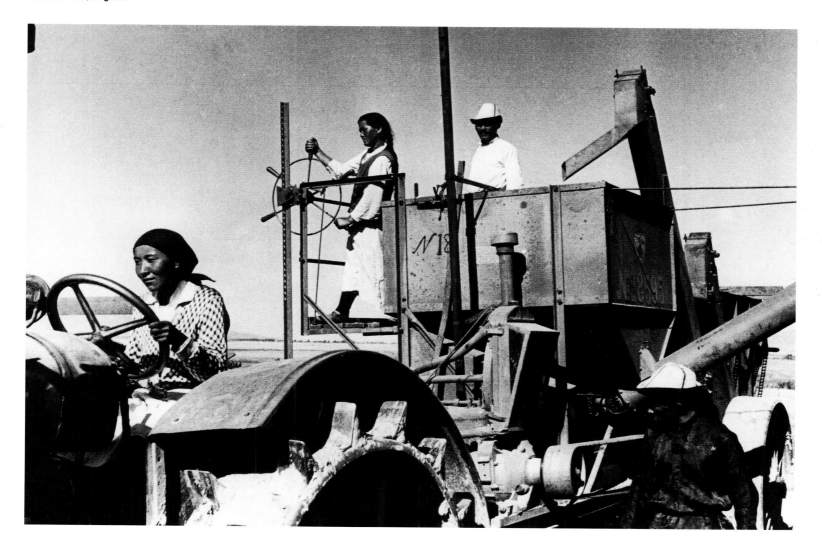

1946

This picture appears over two pages in *The Family of Man* (1955), in a section devoted to food and to family life under the inscription "Eat Bread and Salt and Speak the Truth," a Russian proverb. It is surely one of the most home-based pictures of its era, untouched by politics.

ROBERT CAPA

Russian family

1968

This is an introductory picture from *Gypsies*, Koudelka's greatly admired book of 1975. The pictures were taken in "the separated Gypsy settlements in East Slovakia during the period 1962–1968," and they show folk life carried out in such appalling conditions as these. *Gypsies* looks like a corrective to the optimism and geniality of *The Family of Man* (1955) – the good earth gone wrong, inhabited by survivors.

JOSEF KOUDELKA

Vinodol

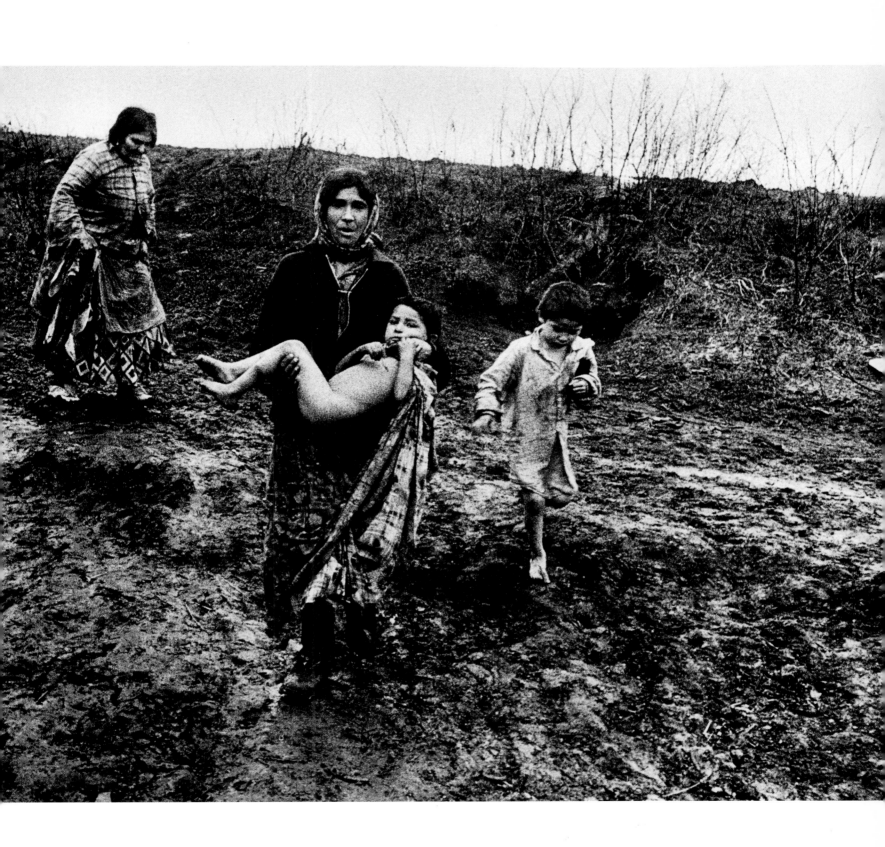

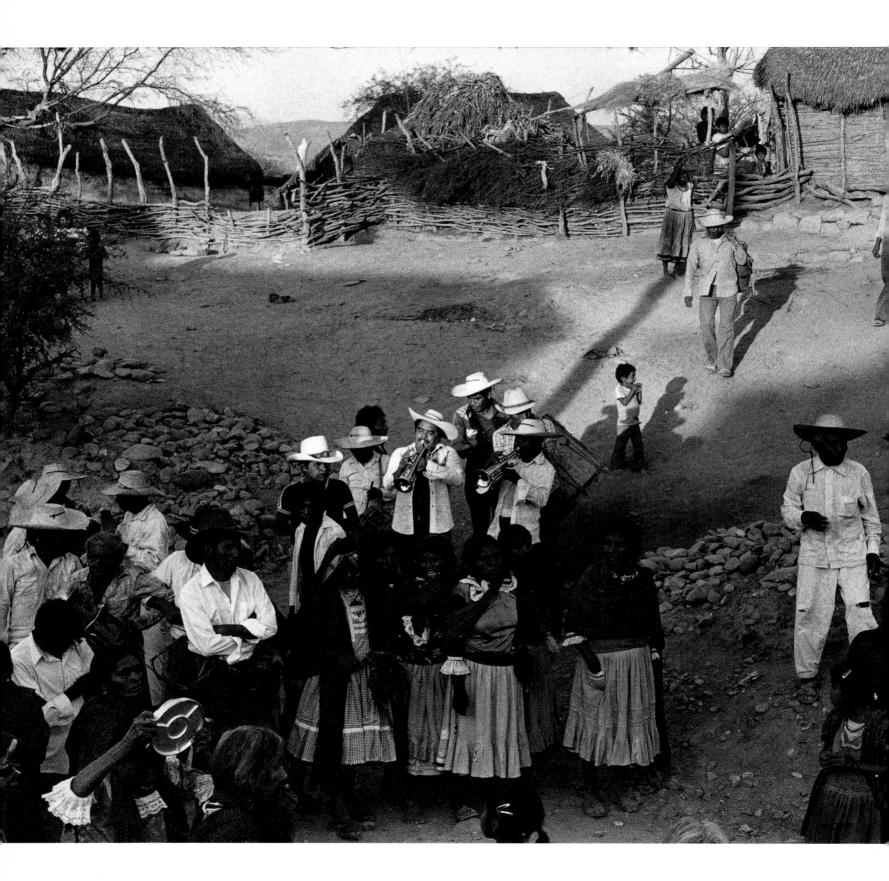

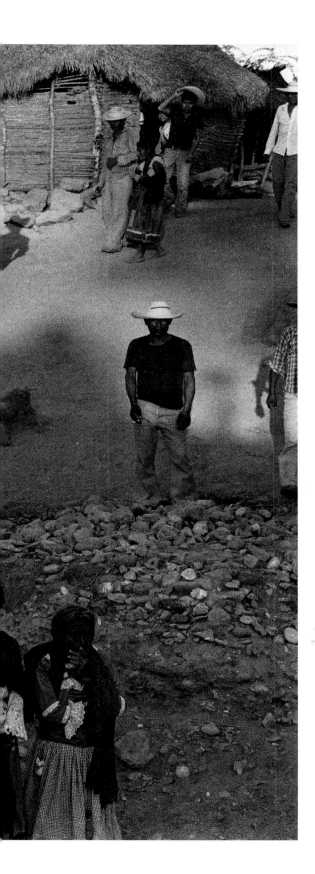

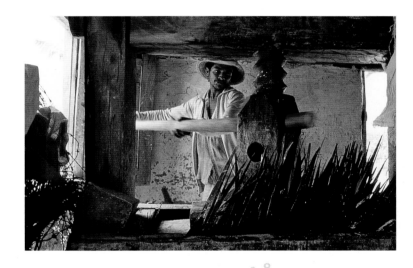

1984

This epic study of carnival
appeared in 1986 in *Retornos
a Oapan*, and then in *Return to
Mexico* (1992). Oapan represents
for Abbas an ideal community
and a counterexample to the
troubled cultures on which he has
usually reported. His first major
book was *Iran: La Revolution
Confisquée* (1980).

ABBAS

**Oapan, Mexico; a band playing for
a local wedding**

1989

Pushing on a lever he turns
a press, which is a simple
enough action. In the 1950s,
documentary photographers'
attitudes sympathized with their
subjects; in the 1980s though, they
lowered their sights, preferring to
remark on labor and on the basics
of making do and getting by.

MIGUEL RIO BRANCO

Satirio Dias – Brazil

REPORTAGE

Photojournalism was always difficult. Major events took place, but they were often impossible to predict. Nor was it easy to say what an event was: a stock-market collapse, for instance, or an international agreement. Thus, reportage became rhetoric: blurred, hasty pictures taken from film and surveillance came to stand for news unfolding, for the event itself. Reportage should have been a possibility from the 1920s on because of new cameras able to work in available light. What evolved instead, however, was documentary, a kind of photography that reported on conditions surrounding events: city streets rather than the crime associated with the metropolis, refugees rather than the act of war.

Reportage has its own story and dynamics. Photographers, from the 1920s on, worked hand in glove with editors and proprietors. From time to time the pressure became too great, and photographers tried to break away from the consensus to report on events as they saw them. Magnum Photos, set up in 1947, was one such sustained attempt to tell the truth and to dispense with cozy stereotypes. Other radicals, often thought of as art photographers, also explored the fringes of the social landscape and helped to keep reportage alive in the 1950s and beyond.

1880

The rifle and the camera had something in common, the power to take likenesses and take trophies. Both were premised on a culture of discrete objects that might be stilled and possessed – a culture of acquisition and collecting.

UNKNOWN PHOTOGRAPHER

Tiger study

1932

One of the best-known instants in photography – in which the relevant motifs appear to have been doubled and even quadrupled, in an elaborate countdown. The clock, too, signifies TIME. A picture in which no element appears to be superfluous.

HENRI CARTIER-BRESSON

Paris, Gare St. Lazare

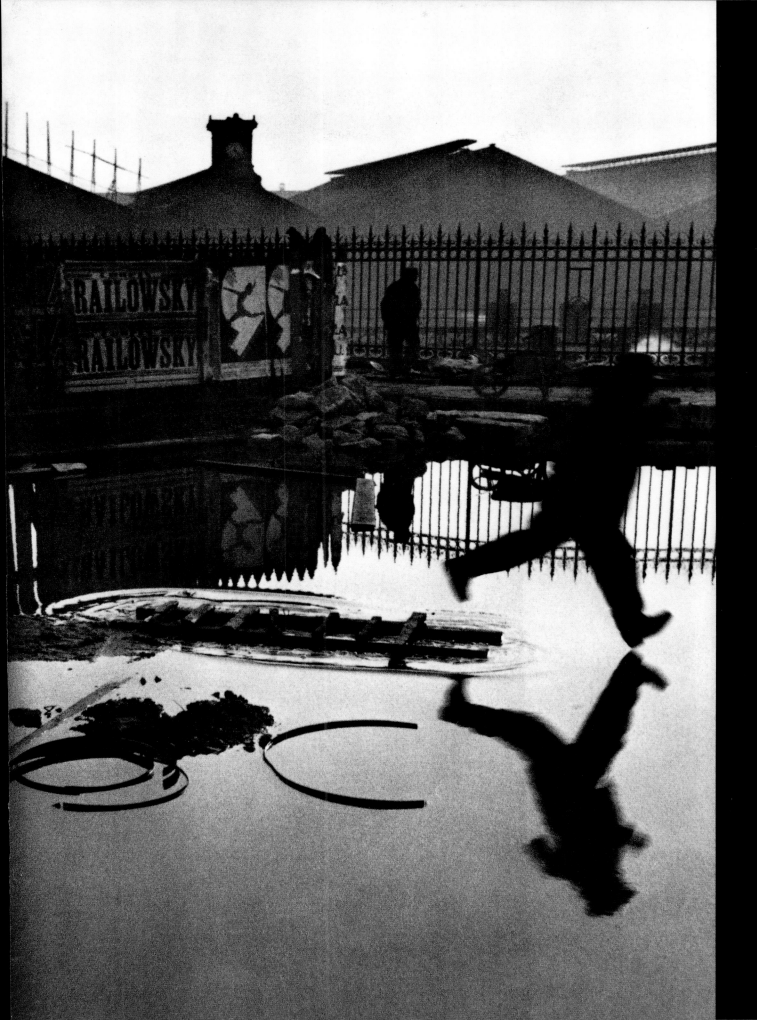

R eportage, or photojournalism, is a broadly inclusive category. At one pole it deals with events as they happen, almost any events in the daily round, and at the other it can be a branch of documentary with topical applications. Photojournalists have always been aware that the news, by its very nature, is unpredictable. There have, of course, always been staged and therefore predictable events – demonstrations, embarkations, inaugurations, arrivals, departures by scheduled flights – but these have never constituted anything other than quasi-news, unless, that is, things turn out unexpectedly. Sports photography might be thought of as an idealized miniature of reportage for it has everything that reportage has in terms of predictable entries and exits plus the events themselves: goals, touchdowns, home runs, hits, falls, and so on. In actuality, or on the streets, newsworthy events and spectacular accidents are scarce, and figure little in the history of the medium. When they do, they have been taken by amateurs or bystanders who just happened to be there. A well-made news picture would be a contradiction in terms. Nonetheless, once the appetite for actualities has been aroused, it has to be fed, and the results have been interesting.

Ideally, reportage goes to the heart of the matter, capturing the instant the blow was delivered or the trigger pulled. It is an impossible promise, yet one that is implicit in the practice of photojournalism. Cameras in the 1920s had, after decades of development, been perfected – especially by the Leitz Company in Germany – to a point where they were able to register events as and where they unfolded, and in imperfect available light. Theoretically, then, it should have been possible to photograph the news as it occurred; and some pivotal events, for example, the fatal shot at Sarajevo fired by Gavril Princip at the Archduke Ferdinand, the shot that triggered the Great War and rang around the world, had been captured on camera – the scene appears as a mêlée in slow motion. Even so, significant split seconds – on the international stage – remained

impossible to foresee; and when they were foreseen appeared quite disenchanting. The new technology of the 1920s was first put to use by Dr. Erich Salomon, often called "the father of photojournalism." Salomon was able to gain access to the major international conferences which were such a feature of the period. French, British, and German statesmen gathered on and off stage in what ought to have been significant encounters. They look, though, in Salomon's pictures like complacent horse traders from archaic bourgeois cultures. Salomon's candid photography merely confirmed an unfortunate impression of incapacity and helped to set the stage for the dynamic political styles of the 1930s.

Another response to the promise of the new technology, and one that was of the greatest importance in the art of photography, took the

1911

Grant reported for *The Daily Mirror* – published November 2 – that " one had to pass a huddled mass of some fifty men and boys, who were herded into a small space enclosed by three walls, and there fired upon until none was left alive. It must have been a veritable carnival of carnage." Tripoli, formerly under the Turkish administration, had been occupied by Italians, who were opposed by both the Turks and the Arab population. Grant and other European reporters came across massacres and executions by Italian forces. These were reported, by letter to Europe. Grant's pictures caused a stir, and by November 16, Grant had been expelled from Tripoli.

THOMAS GRANT

**Massacre in Tripoli,
October 27, 1911**

form of a displacement. It was difficult to capture the kind of incidents that mattered on the world stage, but it might be possible to satisfy the desire for originating instants much more simply – with the kind of commonplace material that had been so much relied on by Dadaist and Surrealist artists in the 1920s. Thus, there evolved – principally through the genius of the French photographer Henri Cartier-Bresson – an aesthetic of "the decisive moment," except that the moments involved were decisive only with respect to everyday predicaments. In the most famous of these, a very ordinary man leaps from a horizontal stepladder into a pool of water on a waste lot behind a Parisian railroad station. The narrative touches on wet feet rather than world wars, but it offered release from the impersonal oppression of history considered as epic.

NATIONAL PROPAGANDA

Cartier-Bresson's photography was a brilliant and subversive riposte to the consciousness of history. Most of his contemporaries by contrast didn't take up the challenge of the new technology at all, and preferred instead to contrive tableaux from typical events and situations. Thus, the bulk of photojournalism from the late 1920s and the 1930s looks more like theater photography than reportage. It was meant to inform the nation of its component parts, all those elements who featured in the body politic. The people cooperated and acknowledged the camera as an agent of the public at large, and cameramen under these terms of reference became impresarios and national propagandists.

During the 1930s, photojournalism took several forms. Much of it was normative and dedicated to picturing the nations of Europe at work and play, and to this end developed such formats as "a day in the life of a ..." – it might be a pastry cook, a jockey, a lighthouse keeper, or underground worker in the sewers of Berlin. The socially minded British thought in terms of traditional pursuits, such as horse racing, whereas the German tendency, in the early 1930s at least, was toward the soil and substance of the land. More self-consciously, ideological photographers chose other topics, especially the nightlife of London and Paris. Nightlife was significant; from the point of view of the collective regimes, such as those of Germany and Russia, it represented lack of control and social degeneration for its personnel included many outsiders not fully committed to the wellbeing of the nation; to photographers

DAILY NEWS
FUNERALS HELD For Gray, Mrs. Snyder

This was, according to the *New York Daily News* (January 14, 1928) "the most talked of feat in the history of journalism." Howard took the picture illicitly with a camera attached to his ankle. Ruth Snyder, the murderess, appears straightened within "confining gyves." Her head is helmeted and her face masked, and an electrode is taped to her right leg "with the stocking down." An autopsy table stands beside the electric chair. The report left little unsaid. In cahoots with a card salesman, Judd Gray, she had murdered her husband. Thanks to Tom Howard she entered popular history. At the same time, though, this is a fine example of documentary for it gives an account of the process, and brings it home.

TOM HOWARD
When Ruth paid her debt to the State

1956

The Stalin monument in Budapest was destroyed during the Hungarian Revolution of 1956, cut off overnight by the boot tops – an event that was witnessed by a number of photographers, and which became a leitmotif of that uprising. Such monuments were hostages to fortune and tokens of imperialism, and part of an old order about to pass away.

UNKNOWN PHOTOGRAPHER
Communism took on new forms and Stalin's statue was toppled from his pedestal in Budapest

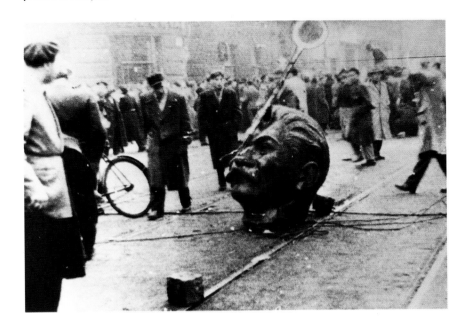

who had fled collective oppression, or just the tedium of the provinces, the city represented freedom, and moreover it sometimes reminded them of old Berlin in the 1920s, Europe's cultural lodestar, along with Paris. A typical cross-section of a city night, represented in the early 1930s in a British illustrated magazine – the *Weekly Illustrated*, in particular – was made up of 15 or so images of soup kitchens, night workers, and revelers on a two-page spread. The idea of the photo-story only developed later in the decade.

For a long time photojournalism had binary tendencies. There was the overwhelmingly normative mainstream, with its impresario photographers and acquiescent subjects, and on the other hand a subverted minority, maybe in need of soup kitchens and reform but symbolic at the same time of individual freedoms. It was the city that always volunteered this alternative cast: Paris and London in the 1930s, and thereafter New York intermittently from the 1950s. American photojournalism after 1945 developed a normative aesthetic very similar to that which had

dominated in Britain in the 1930s, except that the American cast was drawn from the service industries rather than the worlds of horse racing and deep-sea fishing. The duality first surfaced in Berlin around 1930 in photographs produced by the Pacific and Atlantic Agency, a two-man operation for which the subsequently very famous Alfred Eisenstaedt concentrated on urban affairs and high society, in hotels and ski resorts, while the folk life of Berlin and its environs was covered by Erich Borchert, who became an outstanding war photographer. The agency dissolved soon after the Nazi takeover, and Eisenstaedt settled in the U.S., where he helped to develop the American mainstream, principally for *Life* magazine, established in 1936.

NEW YORK AS METROPOLIS

New York's first appearance as the alternative city was in 1945 in Weegee's *The Naked City*. Weegee, born in Poland as Usher Fellig, served as a passport photographer, darkroom technician, and then as a photo-reporter, between 1940 and 1945 for the New York tabloid *PM*. Weegee tracked the police and took many pictures at or near the scenes of crimes, and the most spectacular of these appeared in *The Naked City*. Weegee's, like that of Cartier-Bresson, was an art of displacement. Crime, like sport, was a miniature of the world at large, rich in set pieces and significant events: accidents, robberies, and murders. As with politics and international events, however, the decisive moment was always elusive, having happened perhaps five or ten minutes ago. Thus, Weegee's is also an art of near misses, worked around the idea of an absent center. Weegee's only successor was the Magnum photographer Leonard Freed, author of *Police Work*, 1980.

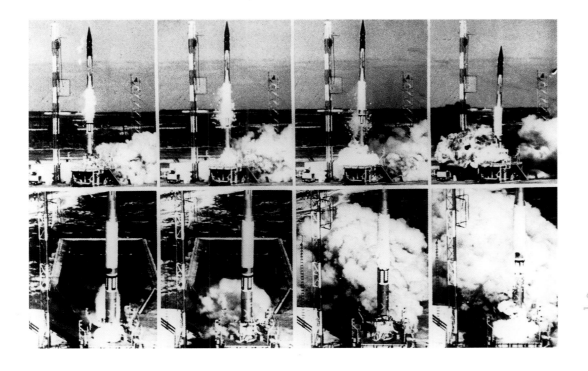

1957

A sequence taken from official
movie footage of the death throes
of *Vanguard*, a three-stage rocket
launched from Cape Canaveral,
Florida, December 10, 1957.
It was designed to put an Earth
satellite into orbit, and exploded
shortly after takeoff – as seen here.
Sequences taken from moving
pictures became part of the visual
rhetoric of the Space Age,
signifying crucial moments and
bated breath.

CINE PICTURE

***Vanguard* explodes**

Reportage was never able to redeem the pledges extended by the new technology of the 1920s. There were never enough photographers to stake out the ground, that is until the 1970s and after, when camera ownership became so commonplace that almost every catastrophe had its witness. Cartier-Bresson and Weegee responded by evolving their own versions of the decisive moment – the one displaced and the other delayed. Nor did technology stand still, and the onset of television from the 1950s made a great difference to reportage. Hard news, of the kind relayed by Weegee, began to look archaic enough to be remarked on by Andy Warhol in his car-crash silkscreens of the 1960s. Television also defined the newsworthy as difficult, as happening across screened time. Television often caught the event in question, but as an impoverished representation.

The role of the photo-reporter henceforth was to find icons that would stand for a chain of events or a state of affairs previously and simultaneously reported on television. The totality of news also began to be considered differently. In the 1930s, events were likely to come to a head or to be resolved by negotiation or conflict. There would be winners, losers, and a new order. In the 1960s, however, especially in the U.S. with the Civil Rights Movement and opposition to the war in Vietnam, a belief evolved that lifestyle itself could amount to significant political opposition. What counted now as news was open to question. Events were no longer valued as circumstances seemed to emerge, to endure, and then to fade away, or at least to leave public consciousness. The heroes and heroines of this new order were citizens and victims who merely persevered and waited for the pressure to lessen. Thus, although events might be fatal, they remained insignificant in themselves, and the task of reportage became to find embodiments of endurance, victimhood, mere being.

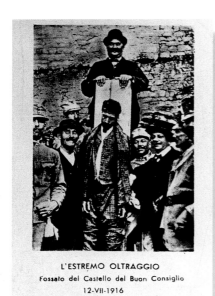

L'ESTREMO OLTRAGGIO
Fossato del Castello del Buon Consiglio
12-VII-1916

c.1918

Cesare Battisti, although an Austrian subject, fought on the Italian side in the war, and on his capture was executed as a traitor. The authorities made postcards of the event and its cast of self-satisfied witnesses. The picture appeared as the frontispiece to Karl Kraus's famous satire, *The Last Days of Mankind* (1922).

UNKNOWN AUSTRIAN ARMY
PHOTOGRAPHER
Execution of Cesare Battisti

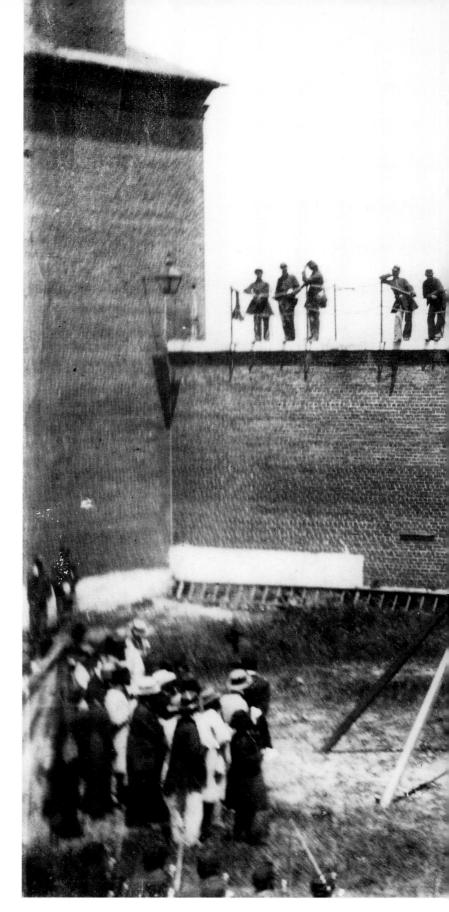

1865

Four conspirators were guilty of the assassination of President Lincoln. At this point they are seated on the scaffold receiving counsel from priests. The figure to the left under a parasol is Mary Surratt, the first woman to be hanged in the U.S. Several soldiers secure the vertical beams that support the trapdoors above. Gardner, who had documented the Civil War, had privileged access to the accused, but in the event his pictures found no market until the 1880s, when they were bought by collectors of Civil War memorabilia.

ALEXANDER GARDNER
**Execution of the Conspirators,
July 7, 1865**

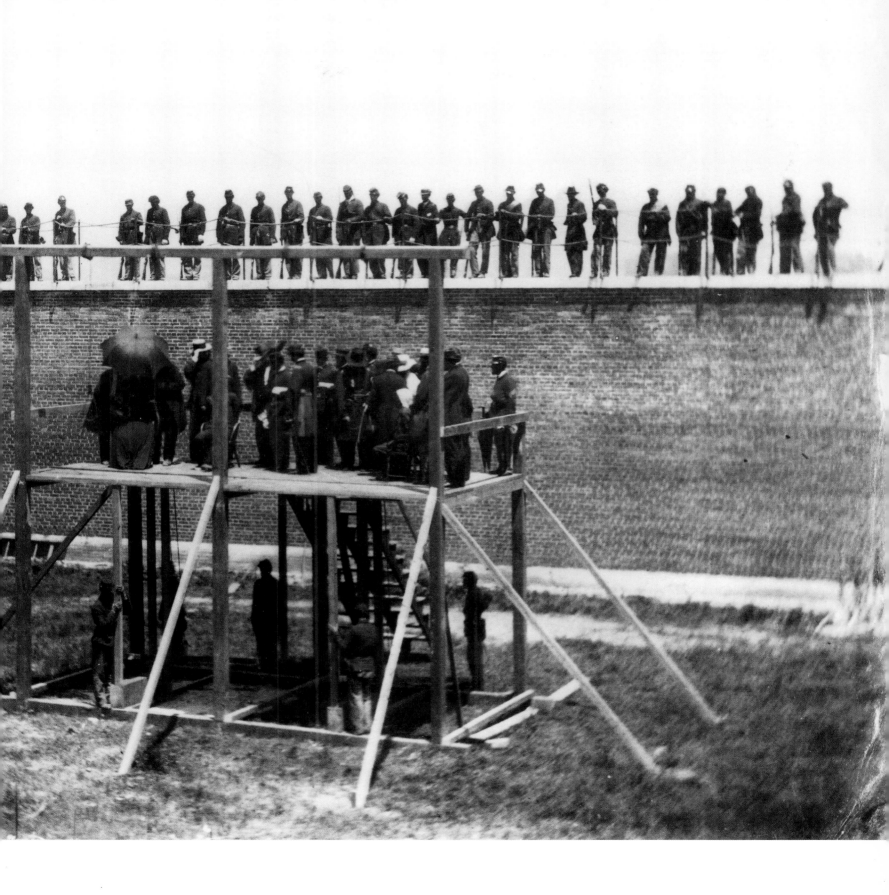

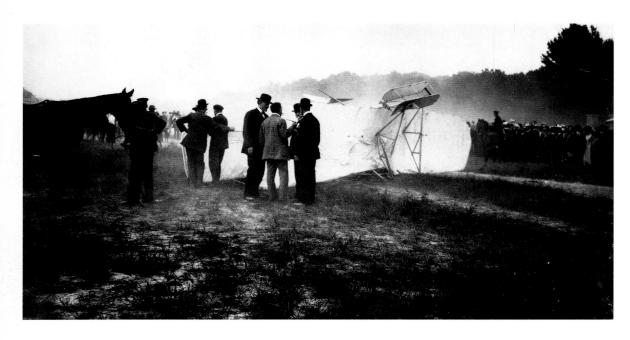

September 17, 1908, and the scene of the first airplane fatality: Orville Wright's passenger. Photo-reportage would be rich in such pictures in which the cameraman came late to the scene to find it peopled by onlookers and investigators. Hare was a pioneering photojournalist, and from 1895 a staff news photographer for the *Illustrated American*. He recorded many early public flights by the Wright brothers.

JAMES H. HARE

Crash of Orville Wright's airplane, Fort Meyer, Virginia

This lightweight, single-seater aircraft, with one propeller behind the wings, was used for exhibition purposes. The earliest public demonstration flights took place in 1908, and they were widely photographed. In 1910 Mayfield made the first photograph from an aircraft. Like the Wright brothers he was from Dayton, Ohio, and he became a staff photographer for the *Dayton Daily News*. Flying exhibitions were fine examples of staged news events, to rank with parades and state funerals.

WILLIAM MAYFIELD

Orville Wright at the controls of a Wright Model E

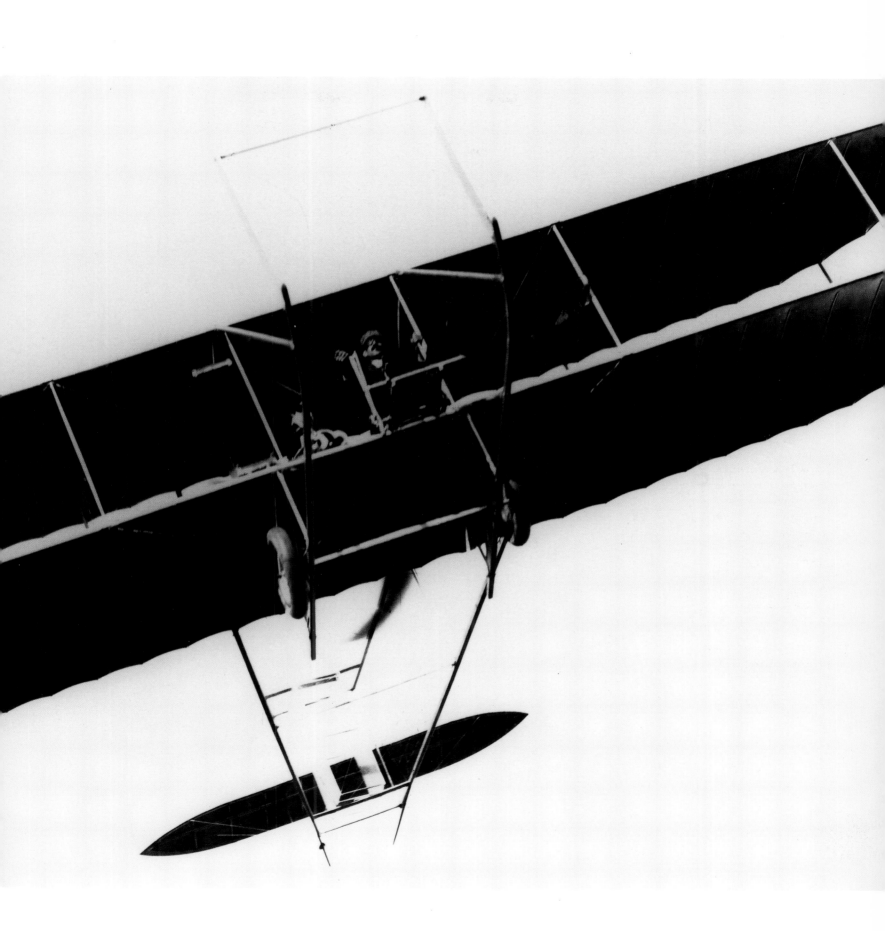

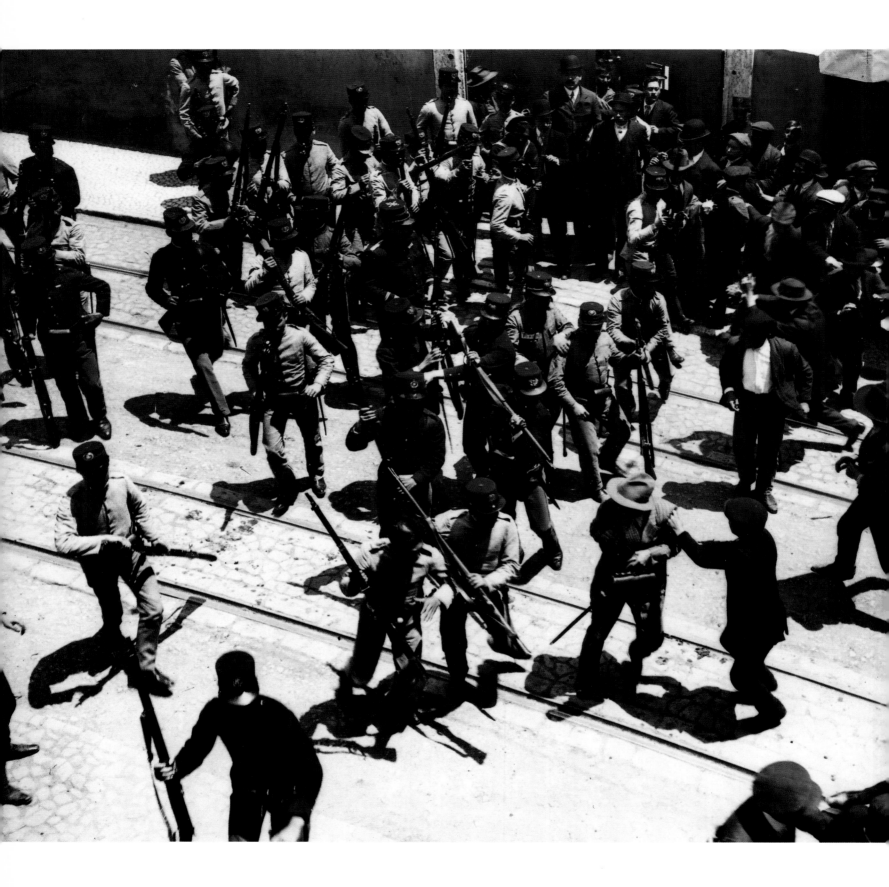

1930

Salomon was a pioneer of candid reportage, and one of the first to take pictures in available light using the new Ermanox camera. He took pictures at the League of Nations in Geneva and at the many political conferences that took place around 1930. His image of politics was of horse-trading among Edwardians or members of the old haute bourgeoisie, shortly to be upstaged by Hitler and the dictators.

ERICH SALOMON
Round-Table Talks

c. 1908

Benoliel was a pioneer photo-reporter who worked for the Lisbon weekly illustrated magazine, *Illustracão Portugueza*, from its first appearance in 1906. Riots, assassinations, and revolution were features of Lisbon life from 1908 on, and the press was at relative liberty to report on events as they took place. No other city at the time left such a remarkable account of itself, and Benoliel was without equal among early photojournalists.

JOSHUA BENOLIEL
Riots in Lisbon

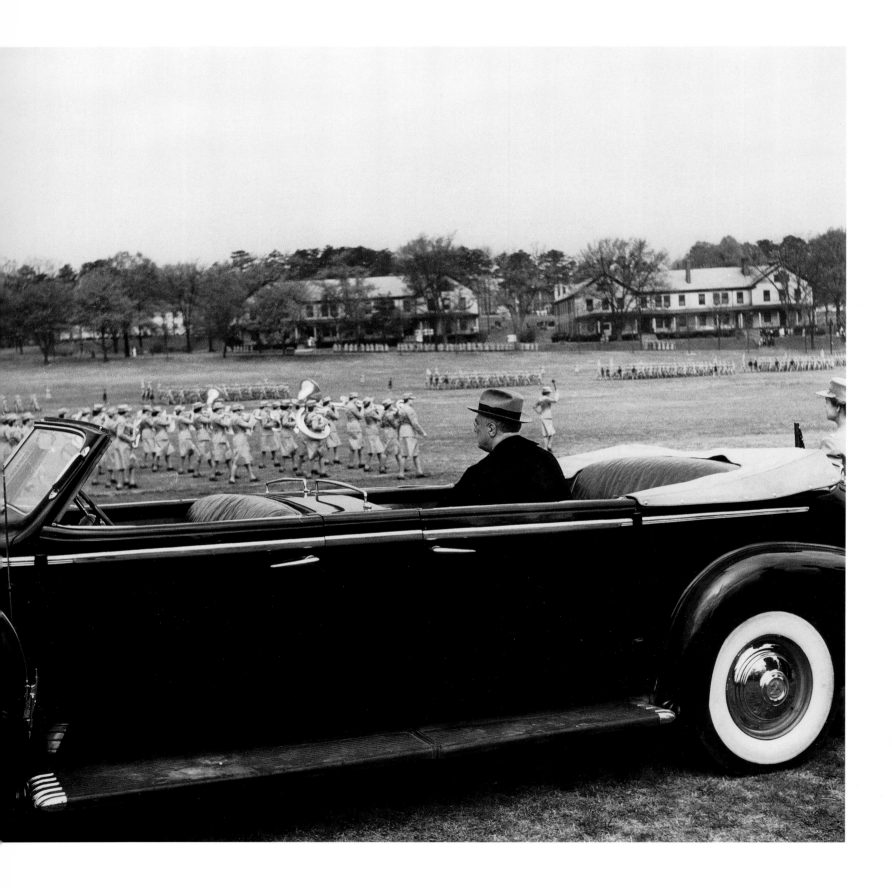

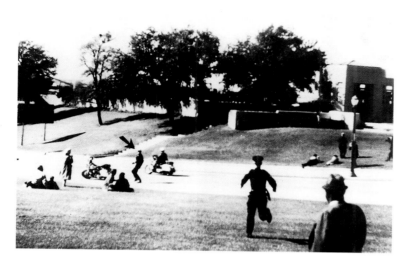

1963

The picture was distributed by cable in November, 1963, with this caption: "New York: in support of his contention that three gunmen were involved in the assassination of President John F. Kennedy, author Dr. Josiah Thompson published this photo showing Officer Bobby W. Hargis (arrow), who, after being hit by a shower of the President's blood, dismounts from his motorcycle and looks towards the grassy knoll in the background from where he thought the shot had come." News pictures from the scene were often as mysterious as this and taken by operatives who happened to be there. Transcribed from movie film and then wired, they were sometimes of such poor quality that they had to be retouched, which added to their mystery.

UNKNOWN PHOTOGRAPHER

Assassination of John F. Kennedy, President of the U.S., November 22, 1963

1963

Both this picture and the one above were taken by the same unnamed passerby, as puzzled as any of the other witnesses on show in what looks like a subverted pastorale.

UNKNOWN PHOTOGRAPHER

"John Fitzgerald Kennedy assassinated. People hug the ground as the motorcade rushes JFK to hospital."

1943

Frissell, usually known for her fashion pictures, also reported on American High Society – in which she was at home. This odd picture is explained by the President's polio. Frissell's pictures are often marked by a practical interest in coping and making arrangements.

TONI FRISSELL

President Franklin D. Roosevelt, Camp Oglethorpe, Chattanooga, Tennessee

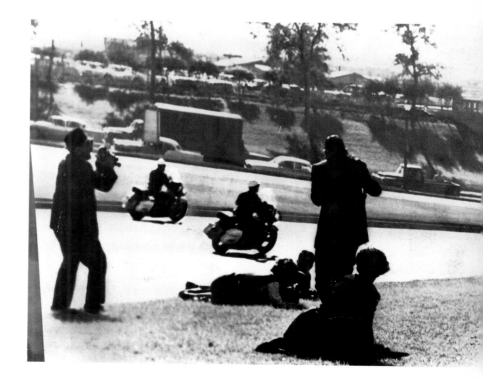

1964

Winogrand must have had his camera ready while driving – probably on the grounds that a photographic subject would crop up at any time and anywhere. In the 1960s, Winogrand helped develop an idea of the social landscape as a theatre of incident. His fondness for unpredictable incidents such as this helped to undermine the idea of the well-planned documentary picture that held sway in the 1950s.

GARRY WINOGRAND

Utah

1979

This is number 46 of 54 pictures published in Sternfeld's *American Prospects*, published in 1987. In the 1970s and 1980s, Sternfeld specialized in small phenomena sometimes at odds with nature and the weather. It is an anti-Modernist vision of America, or one prepared to be captivated by intriguing details and bits of affable narrative.

JOEL STERNFELD

Exhausted renegade elephant, Washington State

The tramcar seems to have been delayed by great events happening off stage, but daily life has its own priorities. Pinkhassov's ideas, and his recurring subject, are of life beyond the headlines or of "history" as no more than an element in the whole. Pinkhassov is one of the most innovative of the new reporters of the 1990s – and a member of Magnum Photos.

GUEORGUI PINKHASSOV
Moscow putsch, August 2, 1991

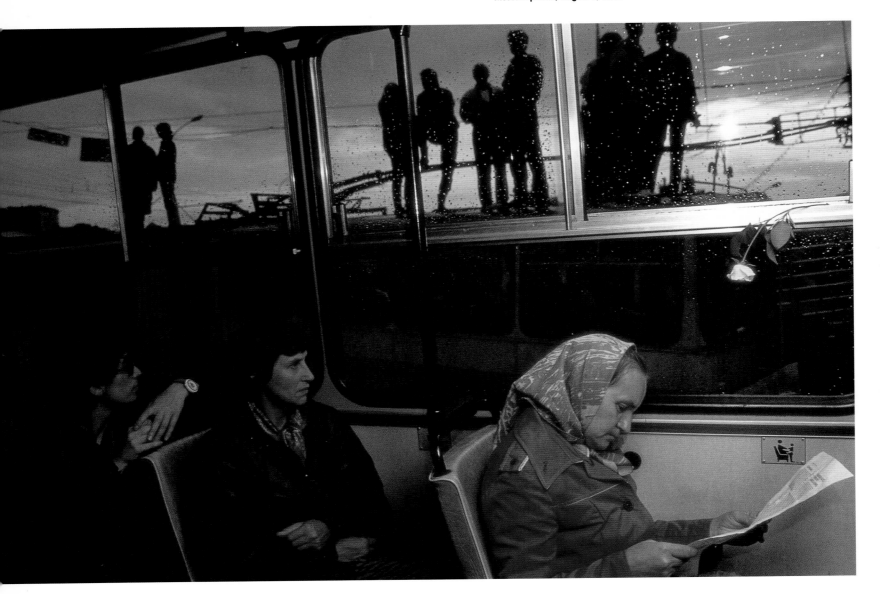

1996

Pictures of Russia's rusting
heavy industry in the 1990s
provided Western audiences
with premonitions of
post-industrial culture.

LISE SARFATI

**Russia, Siberia Naiejda,
metal factory**

1993

Petlyura runs a center for lost souls, and here she is accompanied by Pani Bronya and by her husband, who thinks he is Lenin. Typically, Pinkhassov's post-communist Russians are shown distracted in what looks more continuum than place. Pinkhassov's new Russia in the 1990s is the converse of old "modern" Russia as projected by Max Alpert, for example.

GUEORGUI PINKHASSOV

Petlyura's Place, Moscow

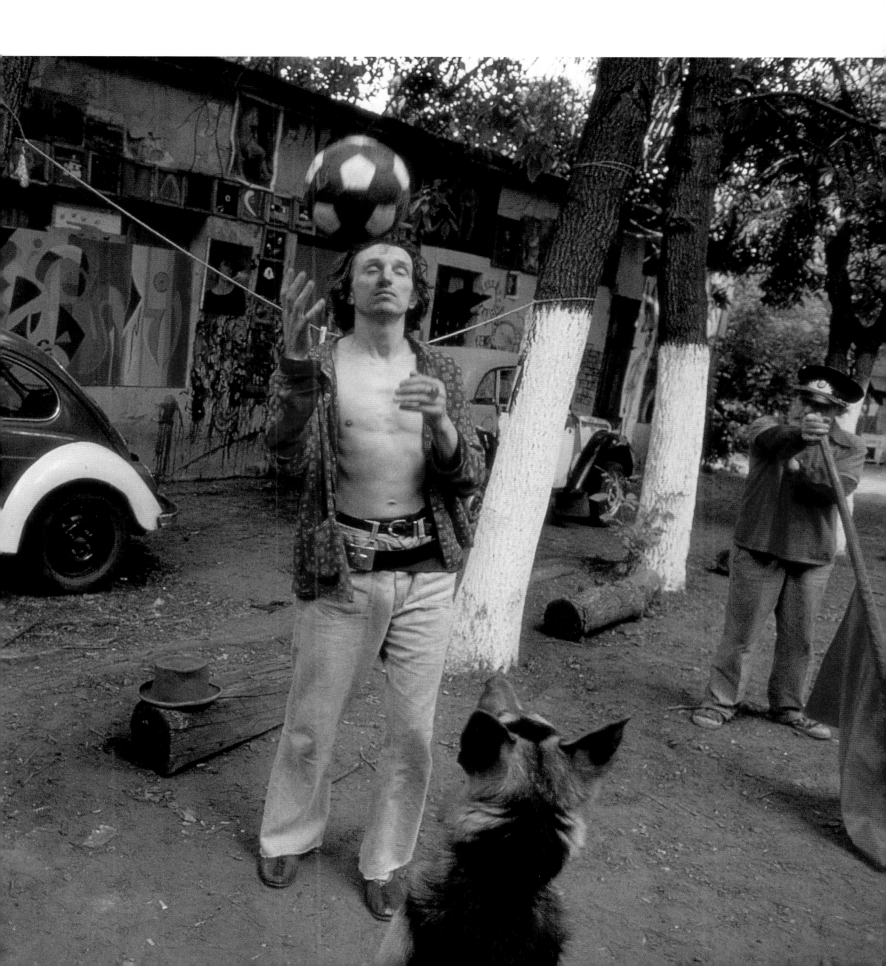

FASHION

c.1933

Bing moved to Paris from Frankfurt in 1930. Her subject in the early 1930s was Paris as the surviving stage for that sprightly, individualistic Modernism that had surfaced in the late 1920s, and which had been abetted by available light photography and the arrival of the Leica in 1925 – Bing was a Leica user, "Queen of the Leica," according to the photographer Emmanuel Sougez.

ILSE BING

Dancer, Paris

Photographers give an account of fashion as it arises from season to season – or at least they did so during the 1920s and into the 1930s. In the 1930s, though, a generation emerged which took fashion as no more than an occasion for a new hybrid art, "fashion photography." Henceforth, the best couture houses associated themselves with talented auteur photographers, and took credit from the association.

Fashion photography was never a world apart. In the 1930s it took its tone from reportage and sports photography, and in the 1940s and 1950s it was humanist or in touch with the *Family of Man*. Modernists in the 1930s looked forward to a better world, even to utopia, and fashion photographers remained true to that idea well into the 1960s. They were the last major group of artists to put their trust in imagination or fantasy, and to show the everyday world vividly reconfigured: the streets of Paris, London, and New York as a stage. They believed, like Pop artists who were their contemporaries, that exuberance and wit would make all the difference or at least enough to dissolve the tedium of real life. This was the last collective moment in the history of the medium.

1962

A picture from the April, 1962, edition of *Vogue*. "Top of the Sixes – in other words, levitated silently up thirty-nine stories of Waldorf Astoria (666 Fifth Avenue)...." The trip took a week, and featured Jean Shrimpton and a "neurosis bear." It was an invitation to enter Bailey's world, which was that of a documentarist at ease in the street culture of New York.

DAVID BAILEY

New York: Young Idea Goes West

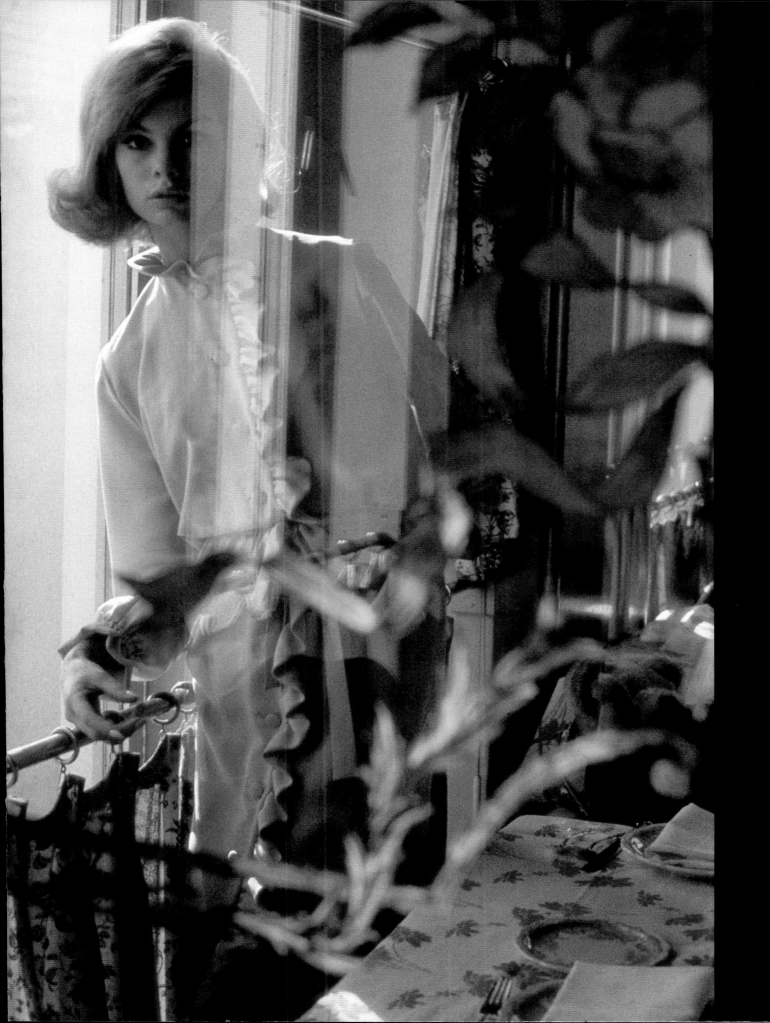

Fashion photography has always had haute couture as its ostensible subject. It served to document collections by, for example, the House of Worth and the House of Paquin in 1900, Paul Poiret in 1910, Myrbor in 1920, Jean Patou and Elsa Schiaparelli in 1930, and after a break in 1935–45, for an avalanche of names. Fashion photographs were published in *Vogue*, a periodical bought and revitalized by Condé Nast in 1909; in *Vanity Fair*, another Condé Nast publication set up in 1914; and in the rival magazine *Harper's Bazaar*. The empirical history of the genre is complicated for it is a history of brilliant artists hired and fired by brilliant editors, often threatened in their turn by restive management obsessed by the fear of missing the boat. But what shape should a history of fashion photography take? It could begin with its first major artist, Baron Adolph de Meyer. Originally de Meyer Watson, he married an illegitimate daughter of King Edward VII, thereafter becoming a Baron in Saxony, his native province. De Meyer traveled and kept contact with such artist-photographers as Alvin Langdon Coburn and Edward Steichen. In 1914 de Meyer was asked by Condé Nast to be his first staff photographer on *Vogue*, and although he quit in 1923 to move to Hollywood, his reputation held until well into the 1930s. Early fashion photography, as epitomized by de Meyer, was a Symbolist art form.

c. 1919

Baron Adolph de Meyer more or less invented the genre, first at *Vogue* from 1914 to 1923 and thereafter, until 1935, at *Harper's Bazaar*. His was an aesthetic in which light functioned as a metaphor for the sensorium. It might almost be touched and tasted, air and aroma both, all pervading. His successors, however, like to take a more instrumental view of the world, one based on handling rather than mere sensing.

BARON DE MEYER

Fashion picture

According to that aesthetic it was possible to sense a spirit underlying appearances, and although that sensing was best done with landscape as a backdrop, it could be carried out anywhere at all. De Meyer's tactic was to show fabric dissolved in light – virtually as light – and at the same time invoking touch and smell. Synesthesia, the name for that interrelating of the senses, results in a general impression or idea about appearances. De Meyer's pictures look very much more like visions inwardly arrived at than anything imprinted by the facts of the matter. Many of the clothes worn by his models were, of course, contrived with just such aesthetics in mind for they were of materials elusive to the touch, visible but barely present: chiffon, fur, ostrich features, and pearls. In de Meyer's era,

fashion and photography shared the same preconceptions and values – a state of affairs that would never be repeated.

De Meyer's aesthetics, enjoyed by the equally important Edward Steichen – who both influenced him and then replaced him at Condé Nast in 1923 – were markedly individualistic. They assumed a self-engrossed consciousness in touch with the world around, mediated via the senses working together. Society could play no part because it was various and distracting, entirely other. Society, though, couldn't be denied for long after the Great War. Modernism, as it evolved in the 1920s, became preoccupied by personal reinvention, and that had far-reaching consequences in fashion. If reinvention could be achieved once by someone newly arrived in the

metropolis, it could be achieved over and over again. It took place, inevitably, with respect to whatever was most topical – and topicality was valued in the modern era in part because of photography. Developments in camera technology and in printing led to a spate of new weekly illustrated magazines in the late 1920s, and these accustomed the public to an idea of turnover of news and styles – pure news, in the sense of major accidents and events, was never sufficient in itself. Sport figured in this new economy as a kind of artificial news, and it was to sport that fashion turned for an example. Fashion photography in the 1930s moved outdoors and into the available light, which could now be exploited via the Erneman and the Leica.

The first of the modern fashion photographers was George Hoyningen Huene, also a Baron. He began to work for *Vogue* in Paris in 1925, and by 1927 was its principal photographer. He was probably the first to move fashion photography out of the studio and into an exquisite version of real life: hotels, beaches, bars, spas, resorts, and shops. It was only late in the 1930s and then again in the postwar era that Huene's successors took an interest in the streets themselves. Early Modernism had a taste for controlled environments, such as ski resorts and swimming pools, undisturbed by fallout from the trenches. Huene's successor at *Vogue* was Horst, another German who had moved to Paris in 1932 to serve in Le Corbusier's studio. Horst took over at *Vogue* in 1934 on Huene's departure for *Harper's Bazaar*.

AVAILABLE LIGHT

The 1930s was a decade of firsts: the first fashion pictures to be taken underwater or in modern architecture or in a zoo. All photographers worked outdoors and in available light, and most of their biographies claim that they were the first to do so. The most successful photographers, who were also the most up to date, were able to earn what were, for the period, astronomical fees. It was around this time that the myth of the fashion photographer came into being – someone able through sheer creativity to show the whole fashion enterprise in a glamorous light. Photography itself – largely because of new technology that could be used without prolonged training – became a career wide open to both the talented and the ambitious in the early 1930s. It was possible, as Horst's career demonstrates, to become an established name almost immediately.

Advertising photography at the beginning of the century featured objects and materials that could be consumed, but were inessential, making no fundamental difference to the life of the consumer. By the 1930s, advertising, fashion in particular, implied that objects and lifestyles were integrated, and that the choice of one meant the choice of the other – a hopeful and naive view that was temporarily knocked on the head by the war of 1939–45. Fashion photographers responded, inevitably, by introducing fashion into the new ambiences of the 1940s and 1950s. War-torn Europe was inhabited by survivors who had been subjected to bitter experiences, and that was perfectly represented by such weathered cultural notables as Samuel Beckett and Alberto Giacometti. Fashion's models could no longer be decorative or aristocratic; they were required to look like character actresses, and photographers thought in terms of situations borrowed either from B-movies or existential dramas. Fashion took to the archaic and sometimes ruined streets, where it remained into the 1960s, at first in response to wartime experience, and then with reference to a myth of the city as a source of threat and spectacle.

 1958

A picture from the October, 1958, edition of *Vogue*. The original article featured the cast of *Irma la Douce*, a hit French musical about the underworld, then at the Lyric in London. Armstrong-Jones reanimated fashion by placing it within a context of London life and popular culture. The jukebox was a new and potent icon in the late 1950s, and contemporaries were beginning to imagine themselves in B-movie terms or as stars and starlets in the making, willingly mediated by the movies.

TONY ARMSTRONG-JONES
Events with Irma

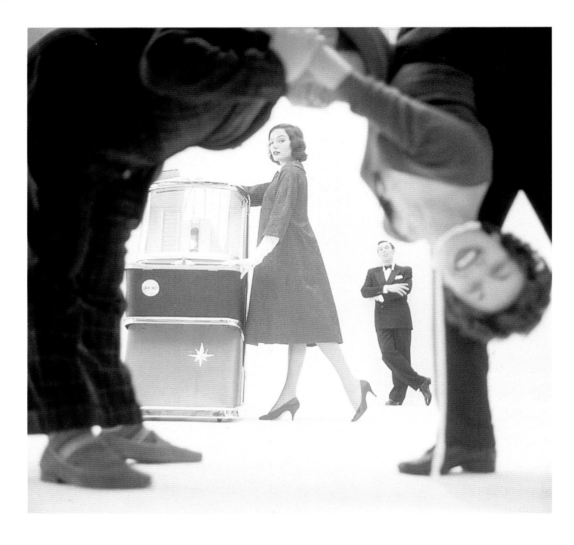

GLOBAL CULTURE

It seemed that society mutated, and even decomposed. In the 1930s it was tightly structured around a few well-known differences, between the working class, for instance, and the independently wealthy, who could indulge itself in books and haute couture. Following World War II, there was to be one great *Family of Man* – as the photography show of 1955 put it – which would share an overall culture, broadcast by the media and television in particular.

This view of world culture was a persuasive, but flawed, ideal. It lacked a center of gravity. It demanded global management and patronized subcultures, and even as *The Family of Man* was taking shape in the 1950s, contemporaries were interesting themselves in Dada and Surrealism, art movements of the 1920s that epitomized exclusivity. It became possible to opt for a collective life apart, in enclaves dedicated to art or jazz or fashion. Membership of the new coteries entailed cultural knowledge of the past – of Marcel Duchamp, the exponent of Dada, in art, for instance, or Eugène Atget in photography. This meant that fashion photography, tailor made to become a practice in its own right, began to look like an independent art fronted by a series of major artists: Richard Avedon, David Bailey, Irving Penn, being three of the most celebrated names. Under the old terms of reference, photography had been at the service of fashion, but in the second half of the twentieth century proportions were readjusted to the point where fashion became a vehicle for photographers.

Why, in that case, didn't they leave fashion for a wider world in which they would be quite unconstrained? Because fashion was the topic in a postmodern culture. The moderns might have believed in reinvention and in the power of clothes and makeup, but they didn't believe that it did any harm. Somewhere behind the mask individuality still survived sufficiently to allow choices to be made. From the 1960s on, though, it became possible to imagine humanity as consisting solely of appearances, and capable of change but not of choice. Thus, fashion photographers were confronted by a sublime subject: the possibility of transformation in society. All the best fashion pictures in this era – from as early as the 1950s through to the 1980s – touch on the difference made by clothing and, beyond that, by picturing itself. In Helmut Newton's art, for instance, appearances are shown to be contrived in relation to nakedness at one pole and imagery at the other. If not, you find that the naked act is clothed, and the clothed act naked.

POLYMORPHOUS PERVERSITY

There was always overlap in fashion photography, and in the 1980s the artful style was supplemented and negated by a new objectivity in fashion pictures: fragile and vulnerable, it was more a branch of portraiture than fashion had traditionally conceived. Vernacular styles had always made some contribution to haute couture, but in the 1980s branded sportswear and leisurewear began to establish an alternative universe of fashion in mass culture. Formerly, in the 1930s, it was assumed that the people everywhere were a force for good, but by the 1980s they had become virtually indecipherable in moral and ethical terms. This made them more intriguing than ever before because it meant that

they were capable of anything or nothing. Mass fashion wear became a sign of this new perverse order in society, for its signifiers were all misused: sporting goods associated with idleness, for instance, and work styles appropriated by leisure. Mass culture had become, as it were, artful and secretive in its turn, defining those in its service and in its thrall as victims or representatives of a moment on the point of disappearance. Hence the anxiety of fashion in the 1980s and 1990s and its sense of vulnerability.

A picture from the May, 1961, edition of *Vogue*. "The valley of the Dead Sea is strange, hot and fierce, with salty sand-dunes...." Klein's trip to the Lebanon was a culminating moment in fashion-travel, so extravagantly sited as to cast doubt on "supple chiffon" and shoes by Charles Jourdan.

WILLIAM KLEIN
The Lebanon

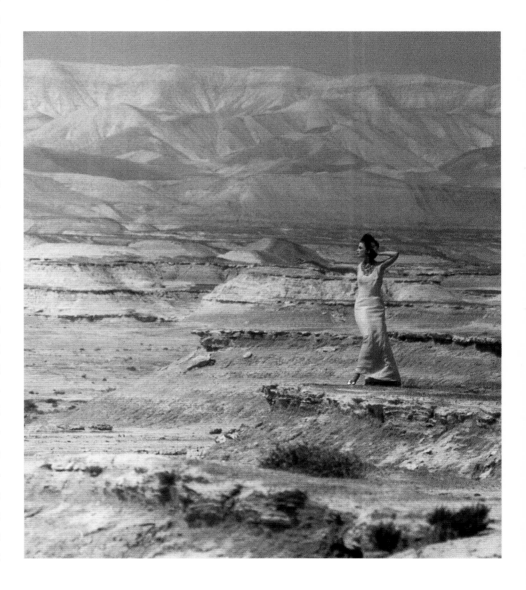

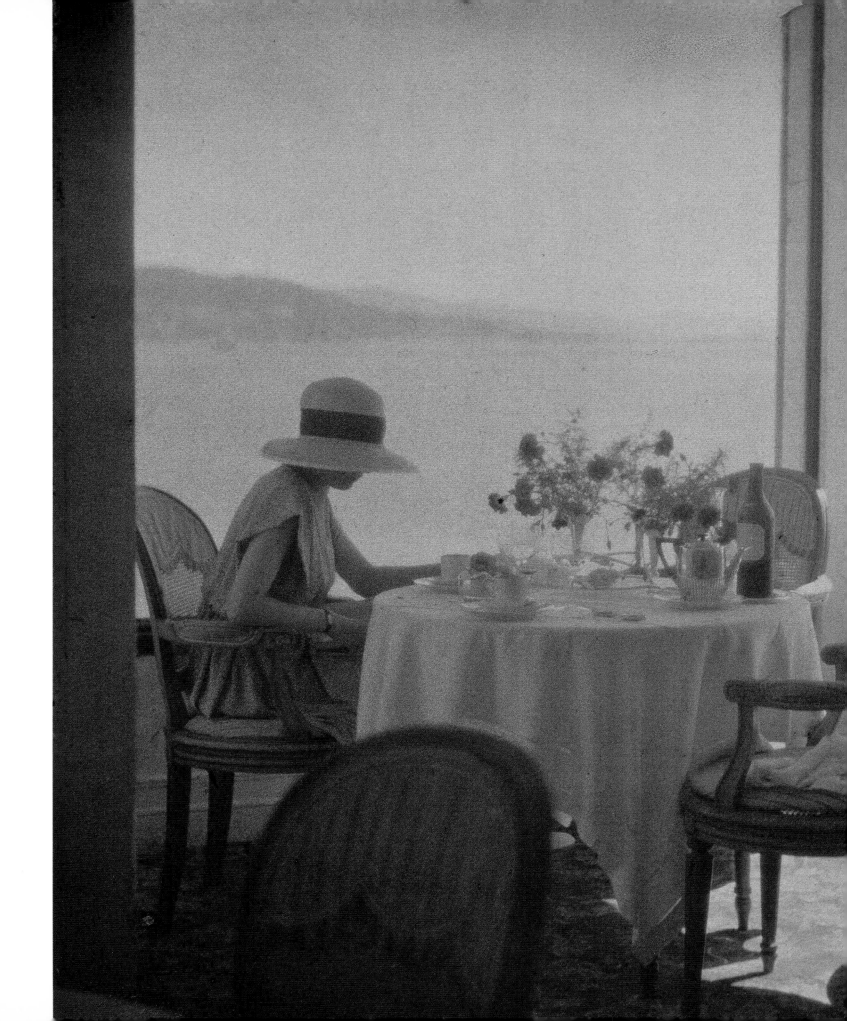

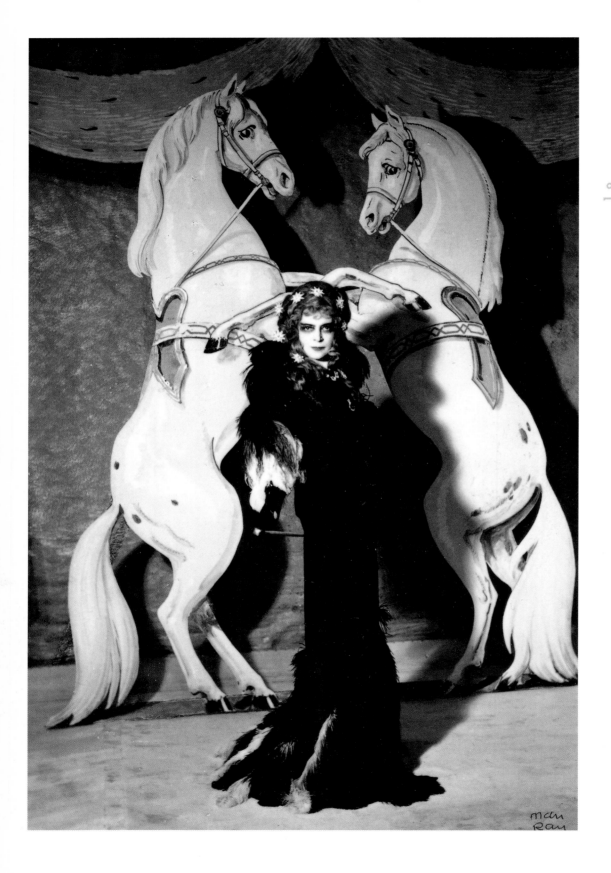

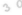

1930

She acts the part of a vamp in silent movies, in a context of circus decor. Modernists were drawn to exotic, small worlds of that sort – and art itself was one of them. Man Ray worked as a fashion photographer in the 1920s for Paul Poiret and was the first to associate fashion with the new vanguard culture that had grown up in Paris during the 1920s.

MAN RAY

La Marquise Casati

1930

Her sideways glance stands for energy in an activist age, just as the sailcloth overalls signify the world of work. Miller herself became a professional photographer in the 1930s, and was a war correspondent in 1939–45.

GEORGE HOYNINGEN-HUENE

Lee Miller wearing Yraide sailcloth overalls

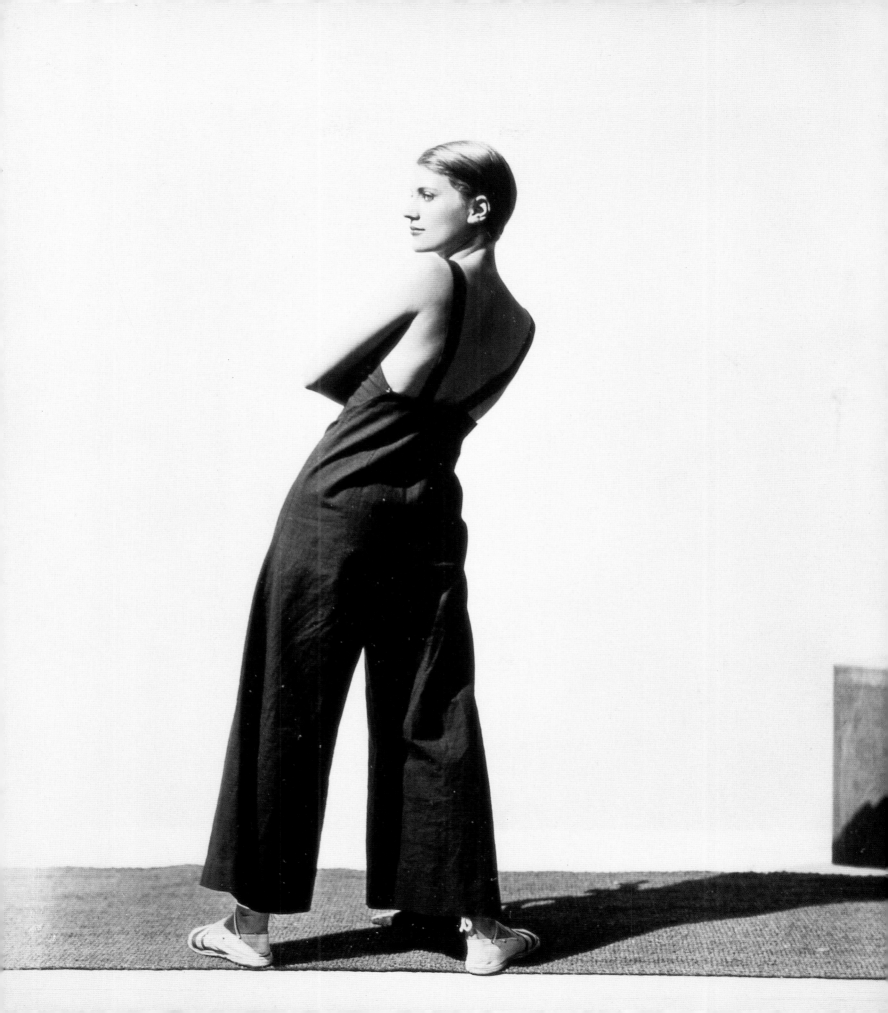

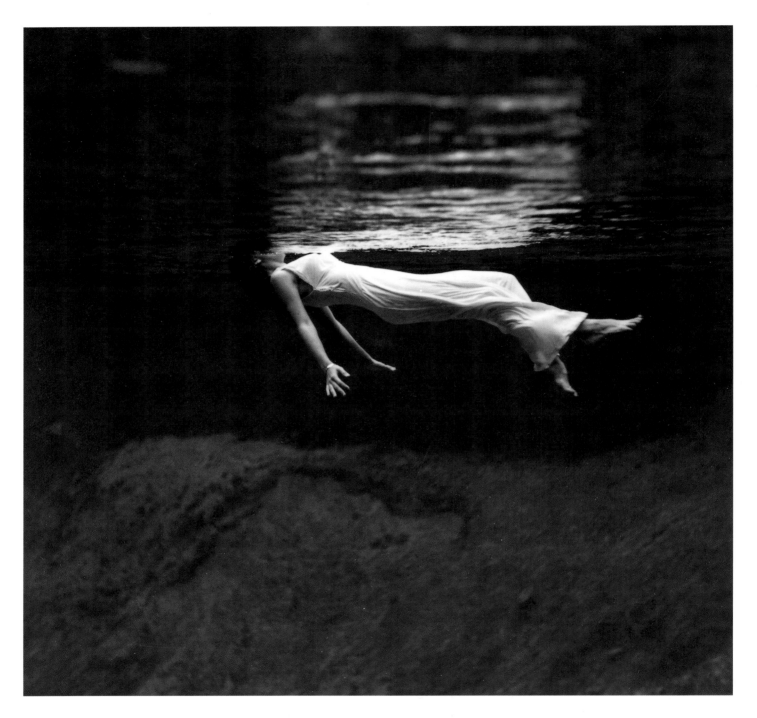

Frissell took her first underwater fashion pictures in
1939 in the dolphin tank at Marineland, Florida.
She took her first fashion photograph in 1931 and
continued into the 1950s to favor natural settings
in available light. This photograph was published
in *Harper's Bazaar*, December, 1947, and in
Sports Illustrated, 1955.

TONI FRISSELL

Weeki Wachee Spring, Florida

A picture from the October, 1946, edition of *Vogue*. Coffin, an American who often worked for London *Vogue*, experimented with context. The difference between this and settings of the 1930s is that it is more workmanlike. Coffin and his successors would play on the gap between fashion and everyday life.

CLIFFORD COFFIN

Elephant grays appropriately set against a circus background

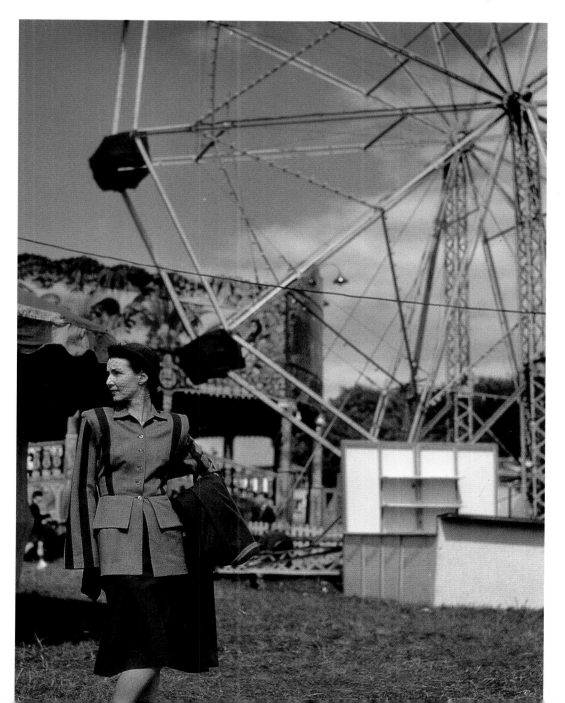

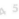

1945

A picture from the November, 1945, edition of *Vogue*. Beaton was always able to identify the tone of his times, and in 1945 it was a tone expressed in the abraded wall beyond – a suggestive neo-Romantic surface.

CECIL BEATON

Pierre Balmain's new Coolie Coat

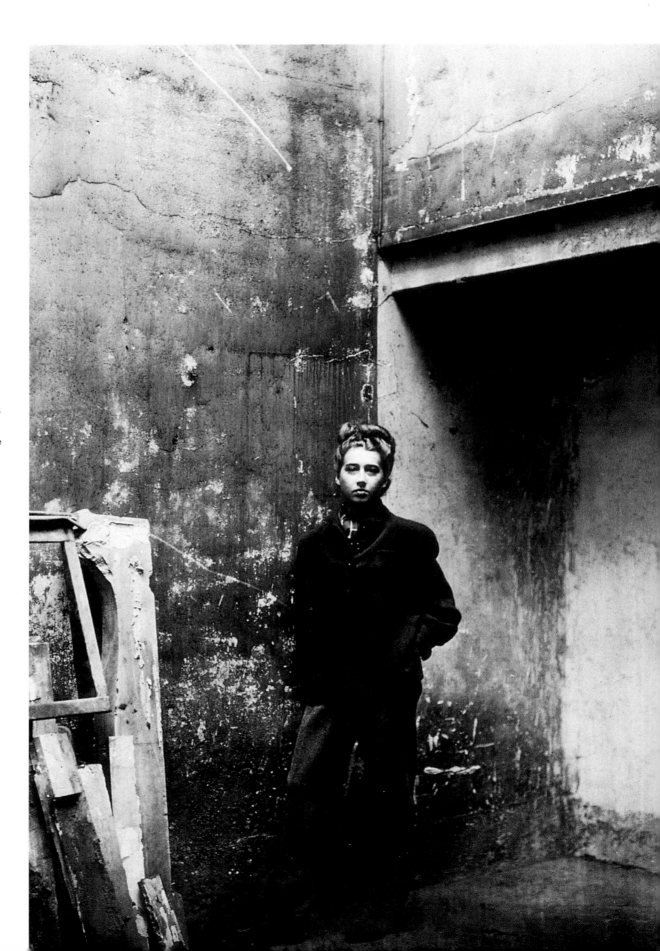

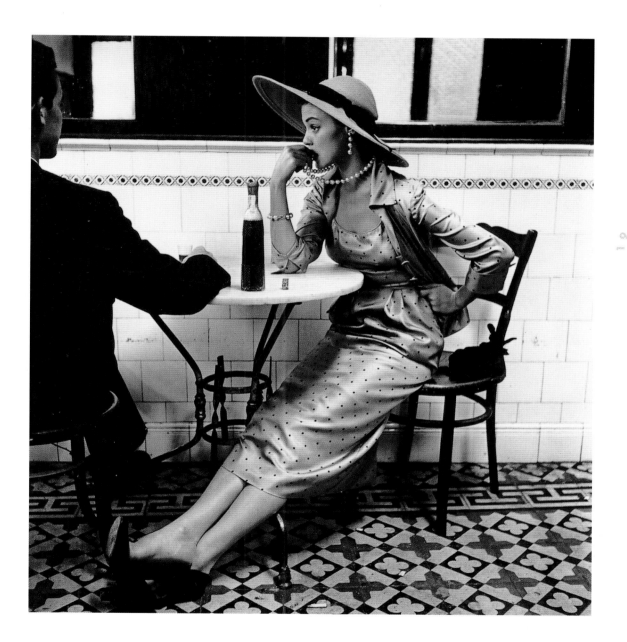

A picture from the April, 1949, edition of *Vogue*. Traveling to Lima, Peru, in this instance. She wears "scooped out back-and-front decolletage and semi-tailored jacket. Pattern No. S-4967." Penn made a difference in fashion photography in the 1940s, with an iconography of the senses: flowers, pearls, liqueurs – whatever might be touched and tasted. It was a way of bringing fashion home and mitigating its visionary elements.

IRVING PENN

Vogue patterns go traveling

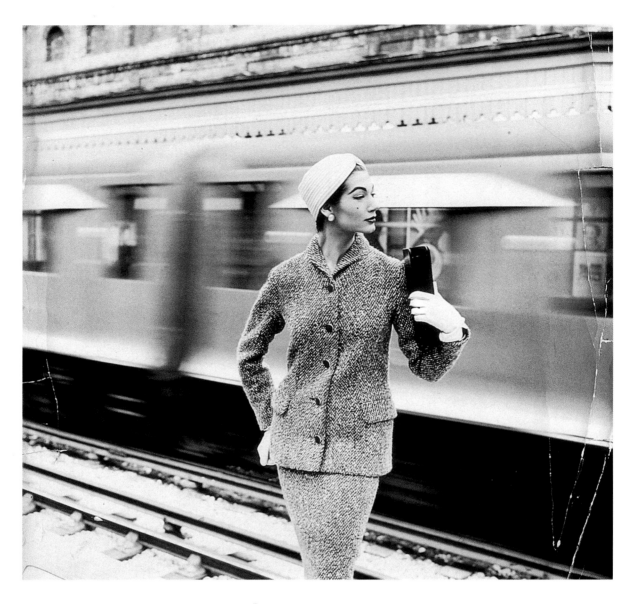

1955

From the October, 1955, edition of
Vogue, with London's underground
in motion blur beyond.
Hammarskiold, a vanguard
photographer and member of the
Swedish group "De Unga," placed
fashion in a businesslike
contemporary ambience, one no
longer imbued with postwar
melancholy. He worked for the
Vogue studio in London, 1955–56.

HANS HAMMARSKIOLD

A winter suit

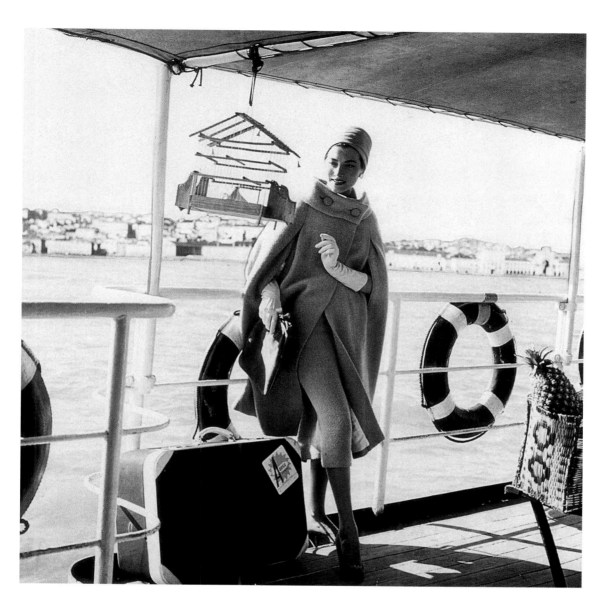

A picture from the February, 1957, edition of *Vogue*. She wears a cape and skirt in pale blue tweed, by Jacqmar Town and Country, and other noted and priced items, and features in an article on Portugal. Fashion began to go on tour from the late 1940s, placing its stylized gestures in all sorts of documentary contexts. Clarke's was an aristocratic concept of fashion removed from, but graciously intrigued by, real life.

HENRY CLARKE

The Tagus at Lisbon is two miles wide...

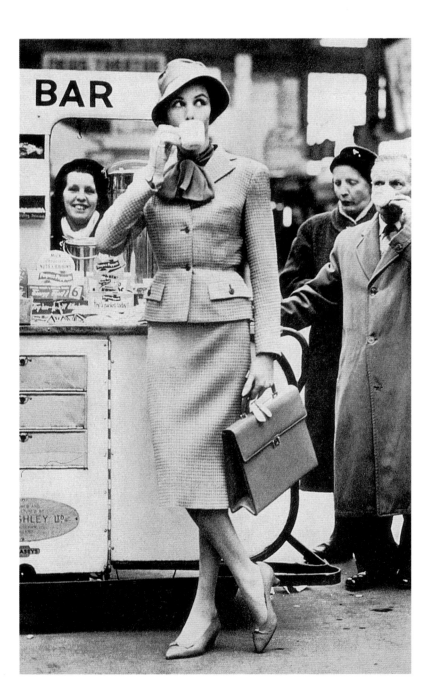

1961

A picture from the September,
1961, edition of *Vogue*. She wears
a Fabiani coat and has just
dismantled a bunch of flowers.
The world goes on around her,
though, because by 1961 "fashion"
no longer presented itself as a
world apart or especially superior
to the rest. The Pop spirit, then
collecting itself, admired business
as usual and the spontaneous
life of the streets.

BRIAN DUFFY

Italy: fashion with brio

1958

A picture from the April, 1958,
edition of *Vogue*. Newton
developed his own subject matter
while working in fashion. In this
instance he is "*Vogue*'s roving
camera," remarking on well and
badly worn clothes, but his other
topic is desire and yearning on
the part of those excluded – a
deconstruction or analysis of
fashion and its charms.

HELMUT NEWTON

Accessories: their power in fashion

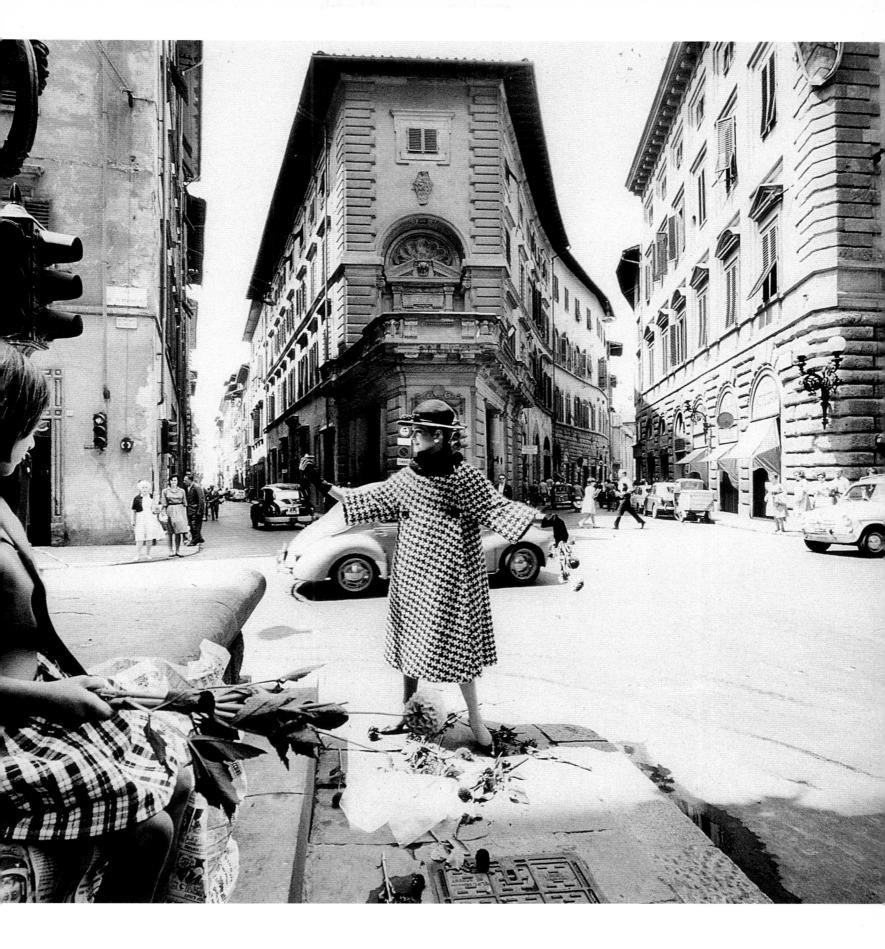

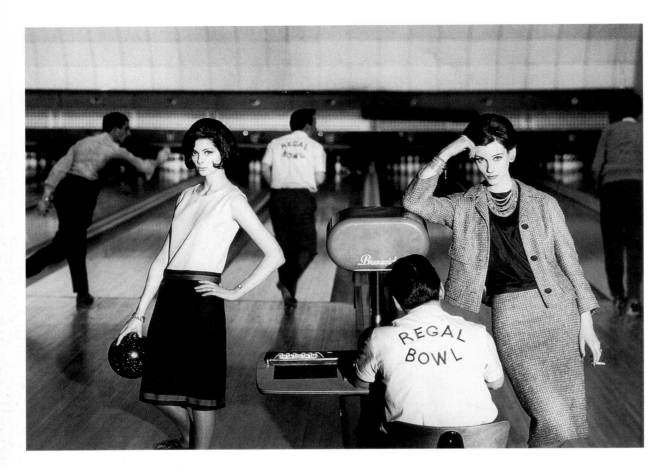

1961

A picture from the February, 1961, edition of *Vogue*. The beginnings of the street-style movement that would be all important by the 1970s. Vernier took this in London in "a sometime local cinema, the Regal Bowl in Golders Green... lush, showy, with the star attraction of Ten Pin Bowling." In the 1940s and 1950s vanguard culture had the upper hand, but from the 1960s on the vernacular began to make the running – an all-pervading avant-garde of brand name goods and mutating lifestyles.

EUGENE VERNIER

London revisited

1996

Fashion photography of the 1990s was objectivist, interested in unmasking the pretense – although appreciating it at the same time. As an aesthetic it was the converse of that of the 1960s that dealt in worlds of the imagination – tourism, New York, Italy, the metropolis – all seen through in the 1990s to fundamental flesh.

GUEORGUI PINKHASSOV

Moscow Fashion Show – backstage

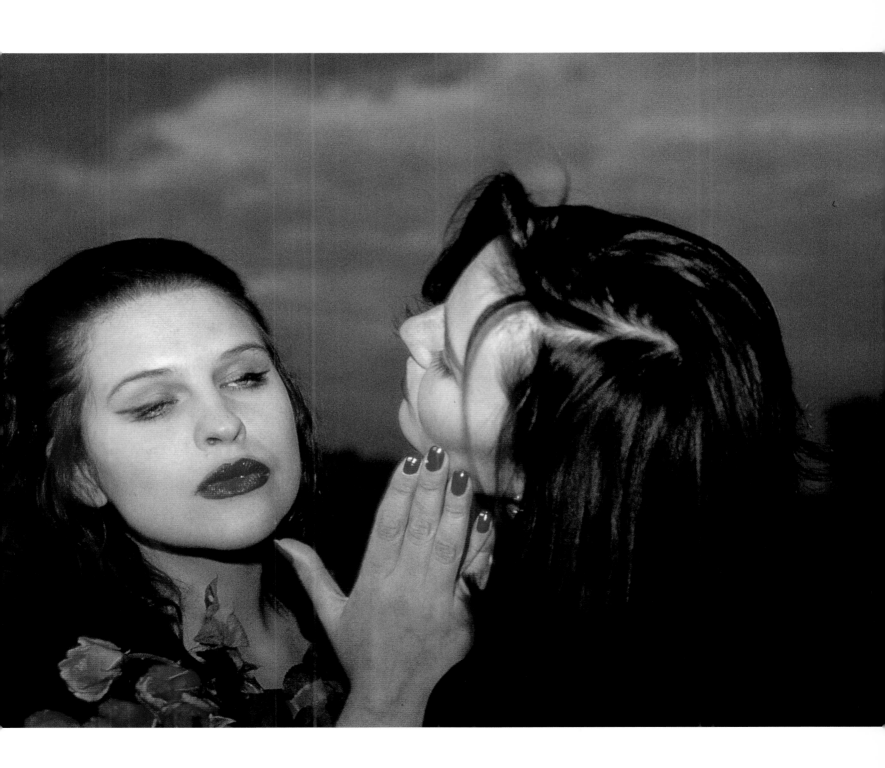

SPORTS

Photography might have been developed to service sports. Photography in available light, refined in the 1920s, made it possible to report on boxing, athletics, and soccer. The great thing about sports was that they were predictable. Athletics particularly attracted photographers because athletes were drilled and perfected examples of modern mankind – and high-divers were the most exemplary of all athletes. Athletics stood for the future, and its greatest staging was at the Berlin Olympics in 1936. Traditional sports, soccer in particular, were tainted by mud, dirt, and industrial origins.

Boxing took pride of place in the U.S., where the efficient, scientific Joe Louis became a national icon in the late 1930s. From the 1950s on television popularized sports and reclassified them as spectacle. Photographers became interested in what sports looked like "as seen on TV." In the 1930s, fights were witnessed by fans in the arena, but from the 1950s they were seen by the public in millions at one remove. Huge unseen audiences and massive prize money made sports into a mystery, and the sports star into a disembodied figure, subject to "pressure" and other intangibles – fascinating, that is, as Everyman in abnormal conditions.

1930

The modern world, as envisioned in the 1920s, was supposed to proceed like clockwork: well-drilled athletes and soldiers often provided the evidence. In this case the maneuver is less than perfectly accomplished. Remarkable for his vivacity and inventiveness, Rodchenko was a Modernist *par excellence* – at home in the 1920s when he was known for his photomontages, and then again on his rediscovery in the 1960s, another age of carnival.

ALEXANDER RODCHENKO
Dynamo Club

1936

Diving mattered in the 1930s because it showed the human form to advantage and as an ideal representation. And divers, like orators, held attention, captivating audiences. Eisenhart was an active photoreporter through the 1930s, picturing modern subjects, such as the construction of airships.

THEO EISENHART
**Wayne, U.S., wins the high-diving gold medal
at the Berlin Olympics**

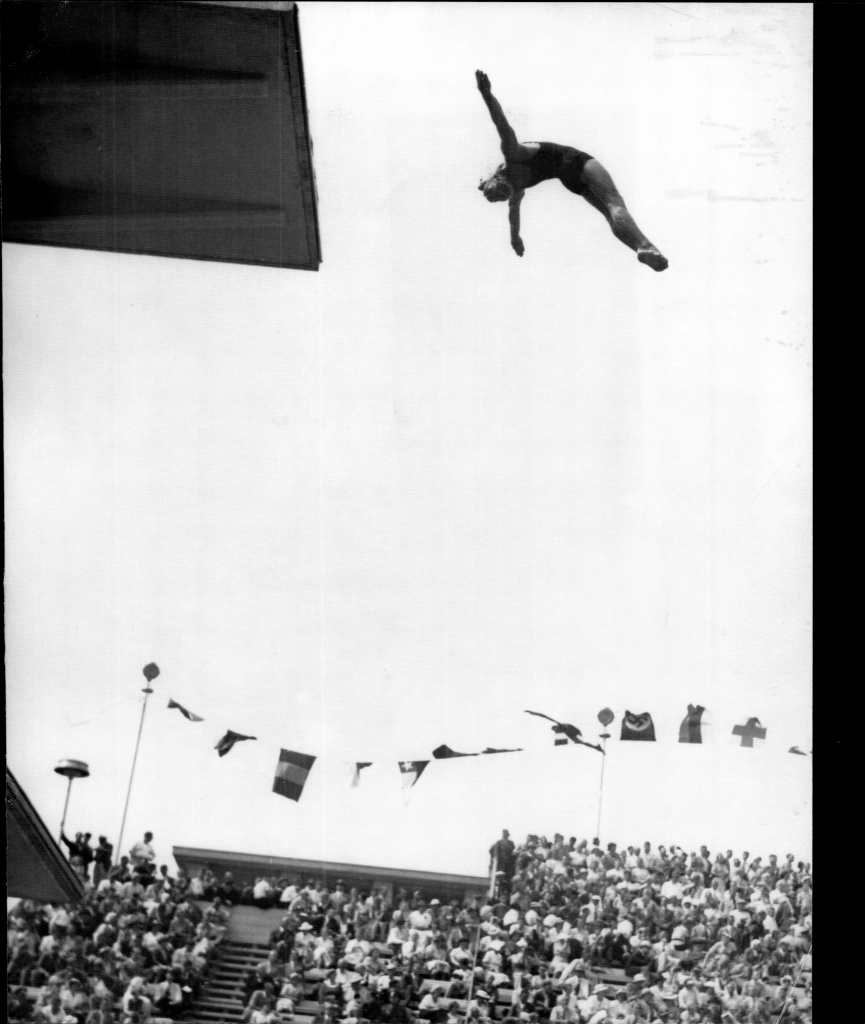

Although sports began to be organized on a systematic basis in the late-nineteenth century, they only became a serious subject for photography in the 1930s. It was practically impossible to do justice to any sporting event in the early 1920s and before. Equipment was too cumbersome to catch action in informal circumstances and in moderate light. Sports photographers in the early 1920s favored the 4 x 5 inch Graflex camera that, with a 12 inch lens, could be used in available light; but it was slow and at its best during pauses in the action. Then the German Erneman camera, in the 1930s, made it possible to work at speed in available light, but only if the subject could be kept in focus. Strobe lighting, developed by the American scientist Harold Edgerton in the 1930s – originally to examine and to picture car engines in operation – finally brought sports' decisive actions within range of almost any operator. It is as if chronophotography had been evolved specially with sports in mind, although in actuality sports were unintended beneficiaries.

There was, however, much more at stake in sports photography than access to the instant, to the knockout blow or the winning hit. In the course of the 1930s, sports became a metaphor, bearing on the fabric of society itself. Early sporting pictures, from the era of the Great War and before, show participants at work on muddied fields against fog-shrouded backgrounds. Sports were an extension of average social life, only slightly less earthbound. Soccer stars, for example, looked as if they belonged to the industrial masses who constituted their audiences. The Modernists, or new stylists of the 1920s and 1930s, hoped to put the smoke-stained world of industry behind them – to them it appeared as an industrial version of the terrible trench warfare of 1914 and, moreover, it was grinding to a halt in the slumps and depressions of the period. Although, anthropologically speaking, industrial man was a tribesman who merely inherited his father's place and look, the Modernists hoped to reinvent themselves. Many of them were newcomers, displaced provincials and first-generation city-dwellers, and were well aware of what it meant to construct a new persona in Paris or Berlin. Modern architecture was composed with this kind of experience in mind; it was thought of principally as a stage on which reinvented men and women could watch themselves in action, and learn in the process.

The Modernists were very conscious that the masses, who were about to be transformed for the better, looked toward exemplars. Sports provided just the kind of controlled environment in which these futuristic scenarios could be tested. Team games were out of the question because they took place at ground level, and they also belonged to archaic industrial cultures in ill repute. The archetype to which modern man and woman aspired was idealized and unruffled, and was represented by the figure of the athlete, most especially the gymnast or the high-diver.

1937

This shows a four-nations meeting – Germany, Austria, Norway, and Czechoslovakia – under 26 floodlights on the Small Olympic Jump at the Gudi Mountain, in front of 3,000 spectators. Sports as spectacle developed in the 1930s – magical events drawing on high technology in the place of the old field sports that were still the norm in many countries. Boesig worked for Presse-Photo in Berlin.

BOESIG

An unforgettable experience: night ski-jumping at Garmisch Partenkirchen

If the period is epitomized by a single type it is that of the diver perfectly realized against a flawless sky in the presence of a distant audience.

Sports photography was also important to the Moderns because it embodied the idea of control. It wasn't that cultures in the 1930s were necessarily ripe for dictatorship so much as impatient with the raggedness to which the economic slump gave rise. Reformist photographers, for example, toured widely in Europe's depressed areas in the early 1930s and returned to the major illustrated magazines of the period – *Vu* in Paris was the best known – with pictures of idleness in industrial landscapes and in the coalfields. In this decrepit context, virtuoso athletes looked like inhabitants of utopia. In particular they were admired for the effortlessness of their accomplishment – and effortless virtuosity had been high on Europe's agenda since the era of the fighter aces of 1914–18, many of whom became cult figures in the 1930s.

SPORTS AS SYMBOL

Sports' major showcase in the modern era was the Berlin Olympics of 1936, photographed by Dr. Paul Wolff, a pioneering photographer closely associated with the development of the 35mm Leica camera. Wolff took care to present the Olympics as an event mediated, filmed, photographed, commentated on, and consumed by readers of the weekly illustrated papers that were then such a feature of German culture. Wolff's book *Was ich bei den Olympischen Spielen 1936 sah (What I saw at the 1936 Olympics)*, is important, but not just because these were Hitler's Olympics. Wolff's is the first comprehensive admission in the history of the medium of a circularity in culture, or of culture simultaneously acting and checking on the outcome of its actions. His is a premonition that society can be carried along as much by the production of images and commentaries as through primary labor in heavy industry.

Sports the world over in the 1930s were enrolled in symbolic work, although nowhere to the degree that this was true of Germany. In the U.S., a prime sufferer from industrial and agricultural depression, boxing adopted the position held by athletics in Germany. The American drama centered on Joe Louis, known for his association with Detroit, then the center of the American automobile industry. Louis was

This photograph was taken by an unknown photographer for Associated Press. The victim was Tony Zale, and the winner Rocky Graziano. From l. to r. (1) Zale sags into the ropes; (2) Graziano waits to deliver the K.O.; (3) the referee pulls Graziano away. Zale, Graziano, Fullmer, Gavilan, Basilio, and Robinson brought spectacle to boxing as never before in the 1940s and 1950s. They were all-action fighters who fought return after return, each bout an existential drama. Audiences preferred their vividness to the science that had characterized boxing in the 1930s.

UNKNOWN PHOTOGRAPHER
The end of the middleweight champion under hammer blows

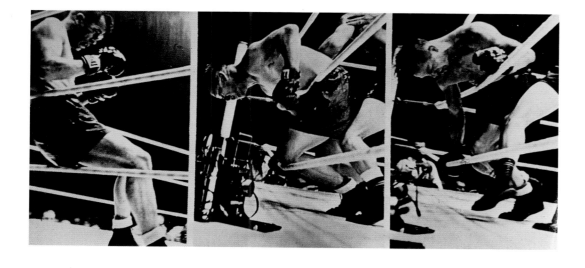

c.1975

Haas was one of the first to recognize that relevant pictures might be taken from TV screens. Sports were, of course, increasingly transmitted and mediated by TV, but pictures like this also served as emblems, signifying "American football" rather than this or that match.

ERNST HAAS

66 6 55: American footballers

a remarkable national star, for he was unemotional and businesslike. He entered boxing around 1935 and soon succeeded in bringing sense to a disorderly house in which there were several disputed and even disreputable champions. His career was closely connected with the Magic Eye camera, a device introduced by International News in 1935 and capable of taking fifteen pictures per second. The Magic Eye was used in many of Louis's fights but in few others, and this was because the unemotional and deadly fighter was especially linked with the skill of boxing rather than the raw emotion of the fight. He embodied a craft professionally and exactly carried out, and stood as an example to the nation of what was possible with concentration – as opposed to the showboating indulged in by some of his contemporaries. Louis was to the United States what the high-diver and gymnast were to modern Europe.

Sports could always be seen as a miniature of society in which the issues of the day might be identified. Louis, for instance, stood for a Modernist functionalism, and continued to do so during the war of 1939–45. However, after the war, American society, and probably the world at large, underwent significant cultural changes that were easily identifiable in boxing. Louis had been an undisputed and deserving champion, and living proof of a theory of just deserts. He was admired as such, but his successors in the 1950s were admired in their turn as providers of spectacle. By the 1950s, strobe lighting had made it possible to record boxing with almost any kind of camera and film. This coincided with a new taste for "slam-bang brawls," which didn't necessarily have to be tests of skill between likely world champions. Photography reflected this new taste for boxing as mere violence, and it increasingly featured lighter

boxers – middleweights especially – under severe pressure, faces grotesquely distorted by right crosses. The new style had less to do with a decline in standards than with declining historical consciousness, and a tendency to live in and for the moment. Boxing, certainly during the 1930s, was one way in which Americans kept count of the recent history of the nation, and all its racial and regional differences. But the advent of television in the 1950s brought with it a sense of an overall culture and undermined the old culture of long-standing communities.

THE VANISHING PAST

Boxing photography in the 1950s needed to keep pace with reportage that was preoccupied at the time with movement, an antidote to the monumentalism of the 1930s. Louis was a monument, as were the gymnasts and diving champions. Their successors – boxers like Rocky Graziano and Kid Gavilan – expended themselves spectacularly, occupying the instant, and then occupying it again in a return.

Boxing gave advance notice of what would happen in society at large. Culture didn't necessarily take a turn for the worse, but traditions ceased to matter as they once had, and the present expanded disproportionately. In an essay written in the 1980s, *The Dimension of the Present Moment*, the Czech poet and scientist Miroslav Holub remarked that, judging from phrase lengths in music and poetry, the present moment lasted for around three seconds. It might well be argued in larger cultural terms that the present moment now lasts only for the time it takes to move from one Grand Slam or Grand Prix site to another. If humanity in developed societies is to live in the moment, then that moment has to be packed full of spectacle of the kind delivered by sports.

In the 1950s, sports promised excitement – thrills and spills in the ring, on racetracks, and on football fields. High-speed chronophotographs could make instantaneous images to fit the bill or to deliver on the promise of action extended by TV. However, pure action soon ceased to be enough in itself as the culture of the present moment developed. There may be many adepts in sports, but very few able to withstand the kind of pressure that resulted from the thought of countless millions watching a crucial putt in a major tournament. While Paul Wolff's Olympians in 1936 were refined examples of humanity in general, and the brawling boxers of the 1950s, although tough to excess, representatives of local communities – mainly African- or Italian-American – the sports stars of the 1980s and 1990s were different altogether. Even if they came from ordinary backgrounds, they were marked by a transcendental ability to withstand "pressure."

Thus, the Postmodern sports star was necessarily an athlete, but athleticism was not sufficient in itself as it once had been. It was no longer enough to capture highlights of a contest or performance. What really mattered was an immanent quality that enabled the virtuoso to continue to concentrate under the gaze of half the known world. This was a hidden ability, a secret that it was hoped would reveal itself through the face or via portraiture, which had always been credited with insight. The Postmodern sports reporter is, therefore, above all a portraitist – although portraiture has its limits for its promise of insight doesn't always deliver. Finally, as the myth of "pressure" and its transcendental dimension grew, photographers turned, for relief, to the idea of sports as a way of life. If the essence of stardom was ineffable, an alternative was to document the fabric of the game as a demystification.

A long exposure has meant that the boxers appear as blurs or apparitions in action, in an impassive setting. Earlier experimenters with time in sports wanted always to catch and to transfix the instant, whereas here it is dissolved or exhaled, like a breath of air. Rio Branco's tendency is to show humanity assimilated into the colors of the world.

MIGUEL RIO BRANCO
Rio's Academia Santa Rosa Boxing Club

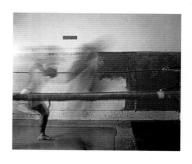

1912

Lartigue's pictures were meant as entries in a scrapbook or diary of his own leisurely life. He was interested in events taken on the wing. Mainstream photography only caught up with Lartigue in the 1930s, and it was only in the 1960s and after that it would be satisfied with such fleeting effects.

JACQUES-HENRI LARTIGUE

The Grand Prix of the Automobile Club de France

c. 1923

Around 1923 Munkacsi was taking sports pictures for the magazine *Az Est* in Budapest. In 1927 he moved to Berlin to work as a photojournalist for the Ullstein organization; and in 1934 immigrated to New York, under contract to *Harper's Bazaar*. Munkacsi applied the brisk, open-air style he had learned in sports and reportage to fashion photography, which he helped to transform – or to move from the studio to the streets and beaches.

MARTIN MUNKACSI

Motorcycle rider

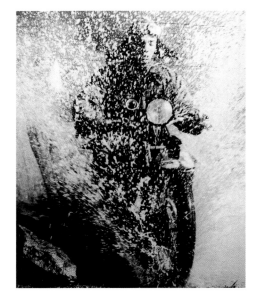

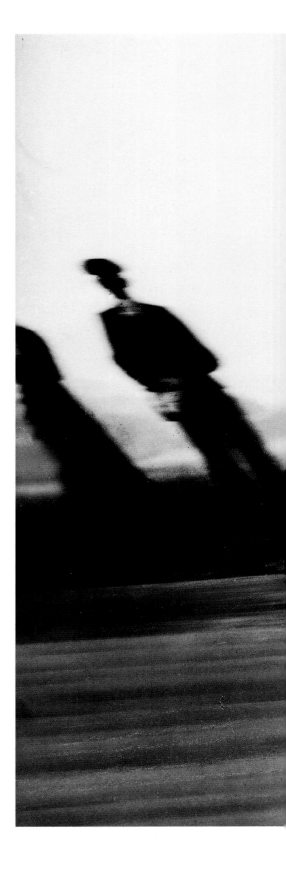

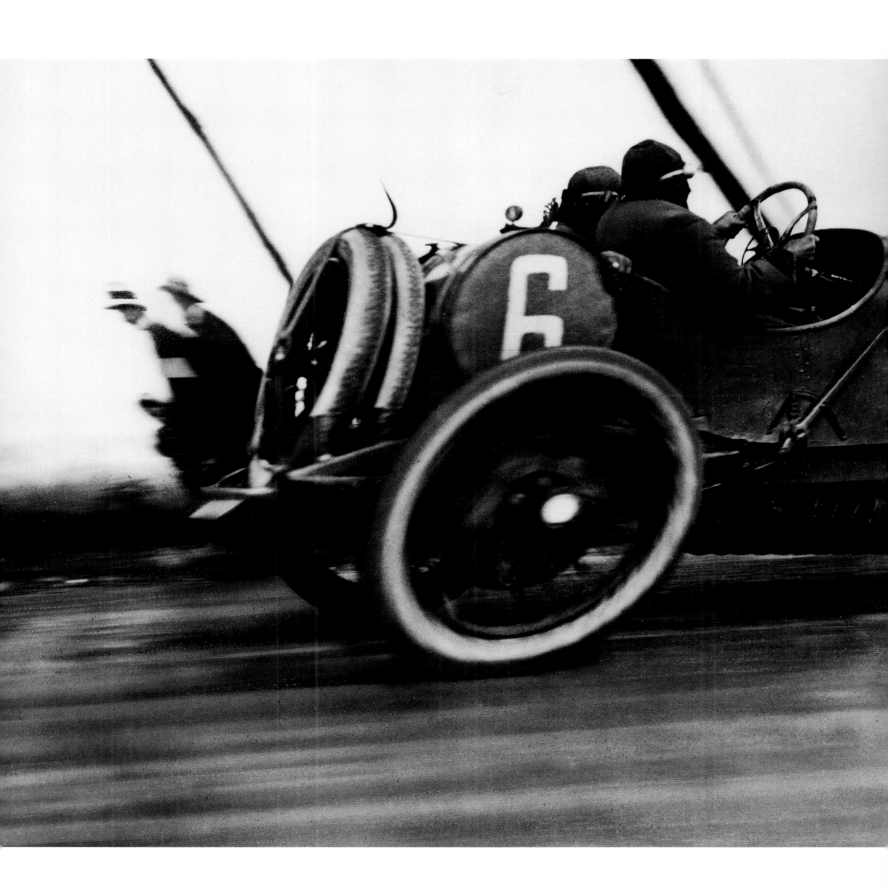

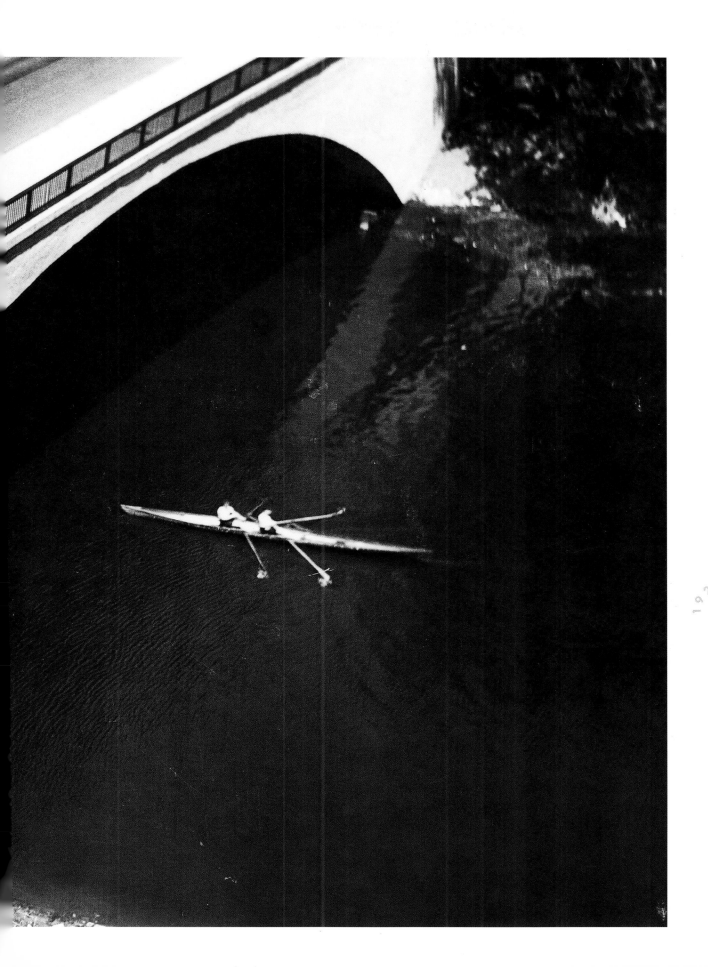

1929

Bridge and boat help to describe the river and each other. Modernists, of whom Finsler is a shining example, liked to work with a few finite elements that might be read through to a conclusion. In 1932, Finsler founded a photography class in the School of Arts and Crafts in Zurich – the first such professional class to be established in Switzerland – which was very influential.

HANS FINSLER
Bridge and boat

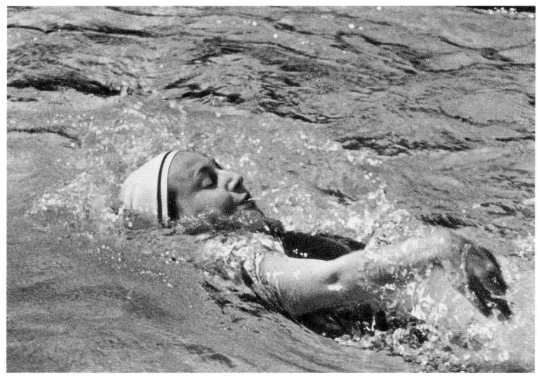

1936

Wolff was one of the first to use a Leica, on every imaginable subject. His reading of the Olympics was as a spectacular and transmissible event rather than as a series of sporting contests.

DR. PAUL WOLFF

Facing illustrations from *Was ich bei den Olympischen Spielen 1936 sah*

1937

After being floored himself, Joe Louis came back to knock Jim Braddock out in the eighth. The sequence, by an unknown photographer working for International News, was taken by the Magic Eye camera, able to take 15 frames per second, and it enabled viewers to appreciate the science and the decisive moments of boxing. It is especially associated with Joe Louis, the epitome of "science" and a "Modernist"' icon in the U.S. The Magic Eye was introduced in 1935 and used for the next ten years.

UNKNOWN PHOTOGRAPHER

How Joe Louis knocked out Jim Braddock, the story inch by inch, Comiskey Park, Chicago

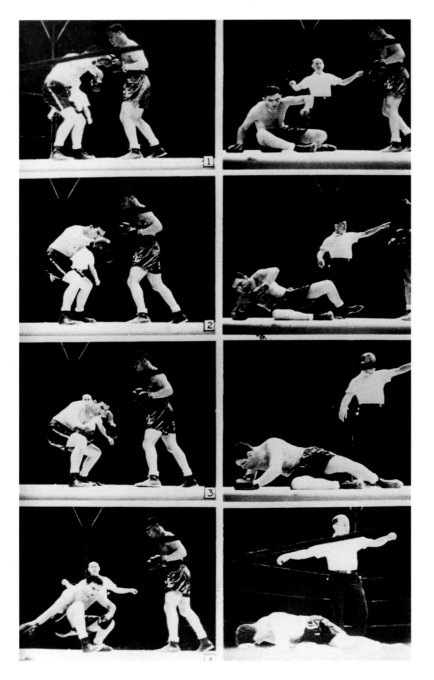

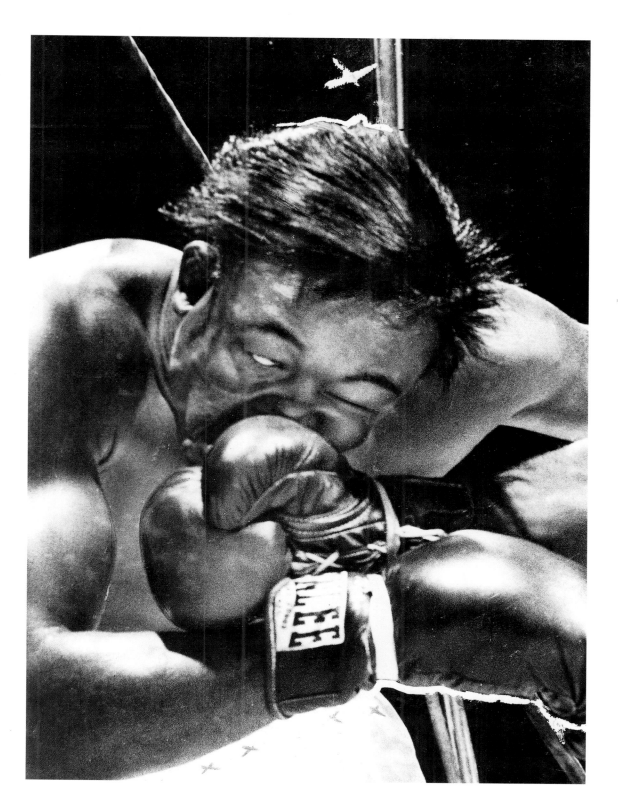

1954

Scharfman, who worked for International News Photos, called the picture "Smear Tactics." It won first prize in the Speedlite sports class of the New York Photographers Association contest. Gavilan, a leading light in boxing in the 1950s, had the most malleable face in the business, a face which became – partly through this picture – an emblem of boxing as spectacle.

HERB SCHARFMAN

Ralph "Tiger" Jones flattened the features of Kid Gavilan as if they were made of putty, June 14, 1954

1975

Implicit in Pop aesthetics in the 1960s was the worry that imagery distributed by commerce and TV simply ran to waste, as part of a great continuum. One of art's functions was to call a halt and to make a figure from the flow – these images, selected and enhanced, had that end in mind.

ERNST HAAS

3 16 – blue and yellow:
American football: Rams – L.A.

Diving was a great topic for
Modernists in the 1930s, when
the human figure, outlined against
the sky, represented perfectibility.
Color, though, is distracting and
gives the background an allure of
its own. Nor would a Modernist
ever have thought of looking
down on a diver.

ERNST HAAS

Diver at the Los Angeles Olympics

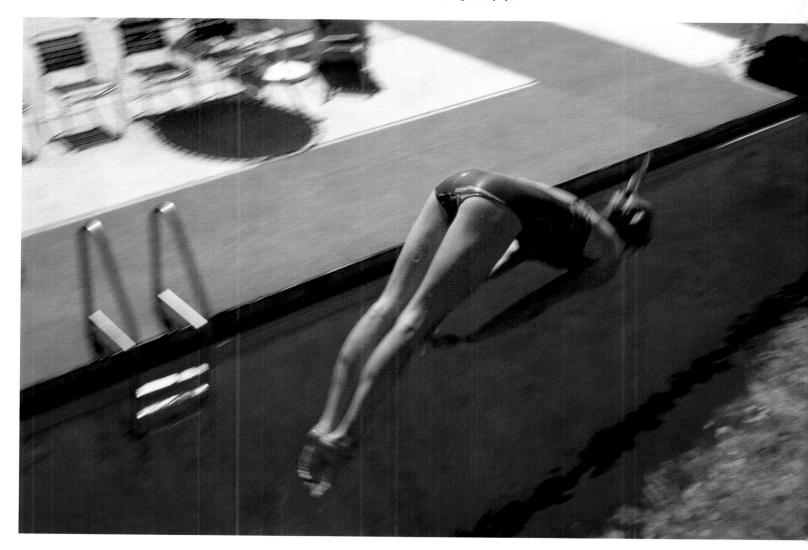

1991

Classic competition is supposed to be legible and calculable, but this scene in Hawaii seems unfathomable – mere activity. Sports as culture became a feature of the 1980s because of a diversification of leisure. In the old "Modernist" world it was, by contrast, a matter of winners and losers in a limited list of sports.

GARY NEWKIRK

Ironman Triathlon in Hawaii

1989

Exactly organized, the picture expresses the business of racing, while the two jockeys – even off-duty – embody the kind of style that is fundamental to the sport. Cutting is a British photographer who has specialized in the ambience and aesthetics of racing, as an epitome of art in general.

LAURENCE CUTTING

Evansville, Kentucky – behind the scenes

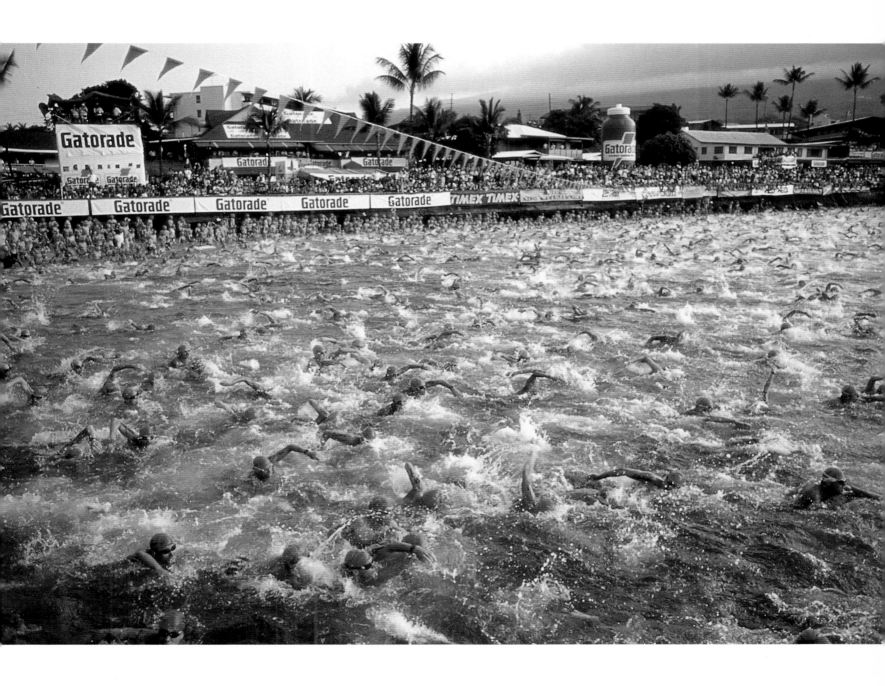

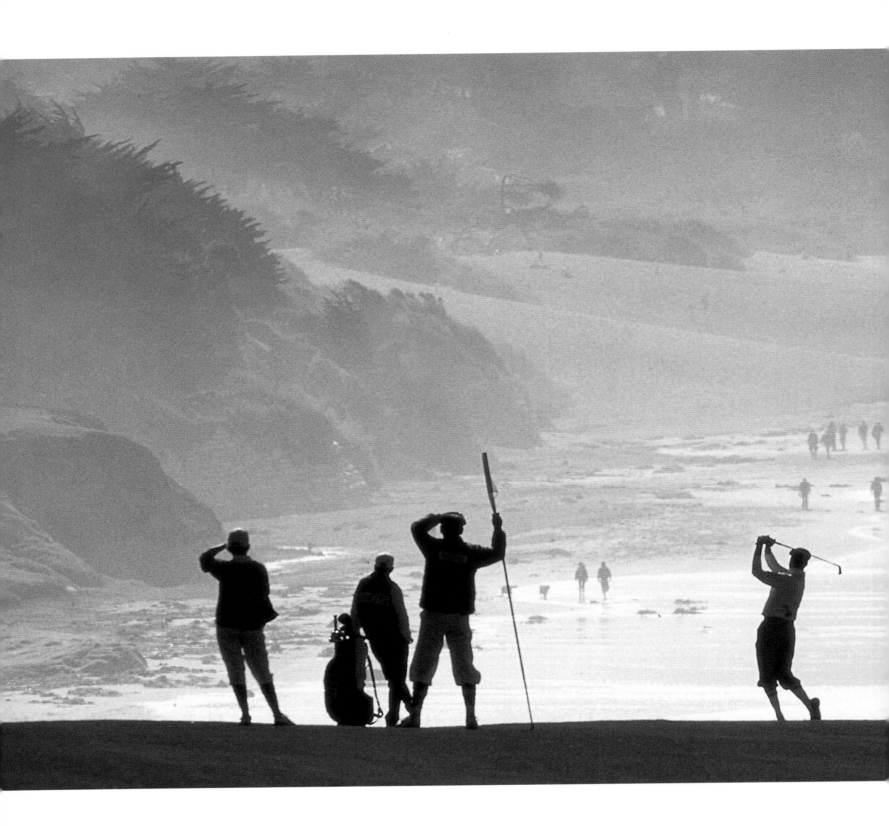

The bullfighter prepares himself. Precursors would have made it a portrait of Higures, but Rio Branco's interest is in physical sensation, what it might be like to be there in that light among those things. Modernist documentarists in the 1930s also wanted you to empathize with the subject, but usually as an artisan rather than as a sentient being. Rio Branco, a Brazilian and member of Magnum Photos, engages more thoroughly with color than any documentary photographer hitherto.

MIGUEL RIO BRANCO

Oscar Higures, toreador, Madrid

The golfers, in monochrome, seem to belong to an old "Modernist" state of mind, acting and paying attention, while the great beyond, delicately tinted, stands for leisure and lotus-eating, fatally attractive.

STEPHEN DUNN

Payne Stewart at the Pebble Beach Open, California, U.S.

LANDSCAPE

Originally it was difficult to register space and recession in landscape, and the sky often appeared as undifferentiated brightness. Photographers relied on various space-creating devices – rivers, roads, and figures diminishing into the distance – which gives some early landscape photography a conceptual look, attractive and interesting to audiences in the 1970s and after. Symbolist artists in the 1880s and 1890s imagined themselves at one with landscape or imprinted by its rhythms, and they devised a near-abstract art to answer this state. Surfaces and incidents were beside the point, and landscape was best seen in a half-light which gave no more than an impression of masses and proportions. This was an introverted concept of landscape which became clichéd by around 1910.

After the moody Symbolist years, new artists turned with relief to an objective understanding of landscape in the 1920s. It was now thought of as a resource, as something to be mapped, cultivated, and even exploited, and at best to be seen as spectacle from a newly completed autobahn. Landscape never regained the prestige in which it stood around 1900, but in the postmodern era it achieved a new status as victim or as the ground on which human misdeeds were most perceptibly inscribed.

1854

Llewelyn achieved momentary exposures in natural daylight. Tides and coastal subjects enabled him to reflect on the idea that the earth was in a state of constant flux or oceanic movement. This was at odds with the biblical claim that at the Creation distinct materials had been set in place one by one. Thus, the seacoast in the 1850s was a troubling motif. Llewelyn was one of photography's pioneers and related by marriage to Fox Talbot, the inventor of the negative–positive process.

JOHN DILLWYN LLEWELYN

Kenneth Howard, May 24, 1854, in Brandy Cove

c. 1950

Sudek took pictures in Prague from the 1920s on, and became increasingly interested in pedestrian points of view – or the city with its major monuments in the background seen from such and such a position on a riverbank, road, or pathway. His earlier "modern" pictures in the 1920s were often of the city seen from the high vantage points above the throng. He made a famous series of panoramic pictures of the city.

JOSEF SUDEK

The Opera House, Prague

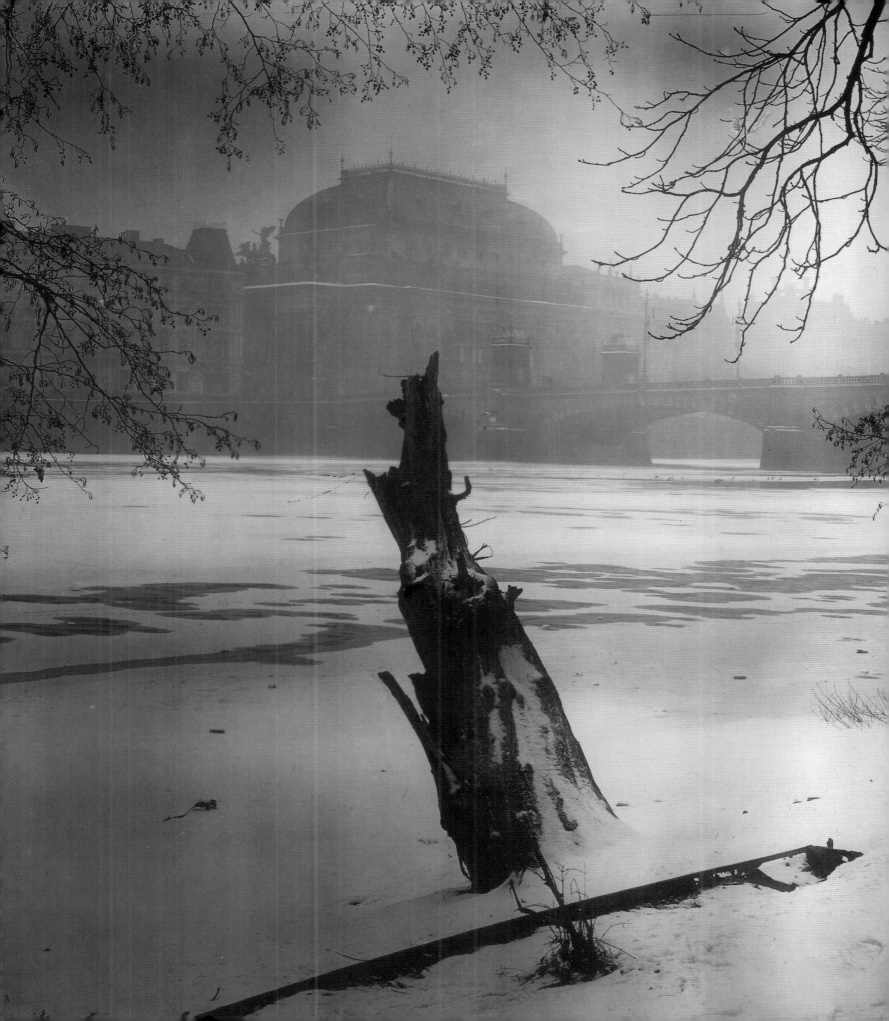

andscape is a necessary background. Humanity may be important, but not to the degree that it can exist nowhere. Landscape emerged as a subject in photography as we became less confident in our God-given priority, and began to recognize a dependence on environment. At one extreme, landscape made us what we are and had generally benevolent effects, and at the other, it merely tolerated our presence as inconsiderate guests. As the twentieth century progressed, our relationship with landscape became more troubled, and it is the history of this relationship that photography expresses. At the outset, in the 1840s and 1850s, photography was in a poor position to do justice to landscape. Exposure times were slow, from several seconds to minutes, and this meant that shadows – at least in variable northern lights – were evened out, resulting in pictures that looked like abstracted versions of landscapes. Prolonged exposures also produced bleached skies, as well as smeared water surfaces. Later audiences, in the 1980s, found these shortcomings rather to their taste for they gave rise to a kind of conceptual art composed of discrete zones: a white flat area identifiable as "sky," a shadowy stillness with reflections as "water," and a pockmarked, textured "earth." None of this was very satisfactory to contemporaries, however, because it implied that the world was made up of separate parts, at a time when landscape was required to convey the idea of a harmonious unifying whole. Technical developments, especially the introduction of collodion and glass plates, speeded up the taking of pictures, but photographed landscapes remained disjointed until well into the 1870s.

1910–12

Ponting accompanied Captain Scott on his expeditions to the Antarctic and brought back such evidence as this of the Great White South. Polar exploration was both a supreme test and an escape from the day-to-day world, laden with the kind of trade goods which were the subject of so much nineteenth-century photography.

HERBERT PONTING

Hut, iceberg, and mountain, Antarctica

Americans were very active photographers in the nineteenth century. After the traumas of the Civil War in the early 1860s, they turned their attention to the West, in California in particular. Photographers who had learned their trade during the Civil War participated in geological and geographical surveys, such as the U.S. Geological Exploration of the 40th Parallel, directed by Clarence King (1867–69 and 1872) and Lieutenant George Wheeler's U.S. Geographical Survey of the Territory West of the 100th Meridian (1873–74). The Survey pictures are startling and even alien, and only entered the public imagination a century later. They offered evidence of irrepressible adventurers in disproportionate terrains. What was jolting to audiences from the 1960s on was the sight of a primal landscape as resource or obstruction, or as anything but domicile.

The Survey photographers were activists, representatives of a civilization that looked on landscape with an eye to development: agriculture, ore extraction, and railroads. Landscape's next phase hardly even acknowledged such values. Where the surveyors had represented

society at large and governments interested in settlement, their successors thought of themselves principally as individuals acted on by powers inherent in landscape. Rivers, lakes, and mountains could, if seen correctly, result in motifs that answered to a feeling – often of graceful melancholy. This newly devised Symbolist art sought the shadows, in part because obscurity blocked out social minutiae. A row of fence posts and rails seen in the gloaming might develop a suggestive rhythm and look like music inscribed, where in daylight it would entail nothing more than boundaries and farming. Symbolist photography eschewed documentation and anything tainted by the small change of the world; it was an artist's art tending toward abstraction and musicality.

MODERN LANDSCAPES

The problem with Symbolist photography, as carried out through the 1890s and up to the Great War, was that its patterns became predictable. It became an international style whose adepts showed together regularly in exhibitions all over the world. Its landscapes belonged nowhere in particular, or anywhere at all, given a screen of trees fronting a pale river and a fluctuating line of hills in the distance. And, of course, Symbolist art had a great deal to do with inwardness. A self-denying artist might allow a scene's configurations to make their own mark, but others were just as likely to arrive on site with their minds made up. In the end, Symbolist art died of self-regard.

The war of 1914–18 made a major difference. It was not only the carnage, but on a practical level a whole generation was introduced to a new understanding of terrain. The war familiarized its participants with map reading, or with the idea of landscape seen from above and transformed by inscriptions. The use of artillery was central to the war, and entailed a very careful scanning and measurement of landscape. This could be carried out only from above, and increasingly from aircraft. Aerial photography became commonplace: pictures of fields stippled and trenched, often with a name and map coordinates in white ink. An interest in aerial surveying continued long after the war for it was noticed that it made valuable contributions to archaeology in particular.

The war exhausted those involved, but ended oddly with a promise of major technological developments ahead. The men and horses who opened hostilities in 1914 were replaced by tanks and aircraft by 1918, and futuristically minded participants dreamed of new wars that would be fought at a remove, across landscapes remotely sensed through bomb- and gun-sights. This habit

This is from a salted-paper print, printed by Louis Desire Blanquart-Evrard, the "Gutenberg of photography," the first publisher to specialize in printing from negatives. Greene, a Bostonian, photographed extensively in Egypt and in North Africa in the 1850s. In his pictures of archaeological sites he paid more attention than was usual at the time to landscape settings.

JOHN BEASLEY GREENE

Lighthouse under construction, Algeria

1867

An albumen print. This was taken on a geological survey of the 40th parallel, under the leadership of Clarence White. O'Sullivan continued to take survey pictures through the 1870s. In this, one of his most celebrated pictures, he has included traces of the surveyor's work: the photographer's wagon, and footprints in the (previously undisturbed) sand.

TIMOTHY H. O'SULLIVAN
Desert Sand Hills near Sink of Carson, Nevada

of imagining landscape from a bird's-eye viewpoint influenced landscape aesthetics in the 1920s and after. Wearied nations were also driven to think of the land as resource, as rich or otherwise in lumber, coal, and crops. Landscape was there to be measured and counted as never before, and the (literally) pedestrian aesthetics of the surveyors and Symbolists looked archaic in this purposeful context.

Aerial photography, however, was no more than one important element in a new aesthetic that was also a rejection of the old. While the Symbolists looked beyond surfaces to configurations that chimed with mood, their successors, by contrast, seemed to want to rely on evidence of the primary senses alone and to represent terrain that could be accessed only by sight and touch. A typical modern or interwar landscape shows a section of the earth's surface in daylight rather than penumbrally as was the case in 1900. It is indifferent to breadth of

"effect" and instead attentive to minute and crisply registered gradations. Imagine, for example, a shallow box evenly lit and containing overlapping flakes of rock. It is as if you could trace each element in the composition with your fingertips in an experience where sight and touch coalesce – seeing as touching. Modernists took pleasure in this kind of prospecting, and they meant to reassess the sort of ordinary material that their precursors had idealized and abstracted.

The new style as practiced most successfully in the U.S. and in Germany was described as Purist or Objective. It functioned most effectively when portraying undisturbed ground, among sand and rocks, in monochrome settings that fitted the monochrome photography of the time. It was also an exclusive aesthetic easily disrupted by the effects of weather and by

reminders of culture, and as limiting in its own way as Symbolism had been. The wider world which this aesthetic denied continued to exist and to make demands. Humanity, even though chastened by World War I, was unable to put its house in order, and the great subject of the 1930s became the settled and mismanaged landscape of societies subject to economic and agricultural depression. What was always interesting in the new emergency terms of reference was what happened to landscape following settlement. Photographers, especially those employed by the Farm Security Administration in the late 1930s, didn't take the view that mankind had simply ruined the land, but rather that the relationship should be studied.

NEW TOPOGRAPHY

Walker Evans, one of the major photographers of that era, took the Purist manner of the late 1920s and applied it to urban landscape, disclosing urban sites in enough detail to invite inspection. Evans, who was also a portraitist and architectural photographer of note, developed a kind of hybrid landscape that kept its credibility and retained a following. Its example lies behind what was called the New Topography of the 1970s and 1980s. In this forensic style devised by Evans and by contemporary documentary photographers, the main streets of small towns are shown in as much detail as possible, but without implying any foregone conclusions. This is landscape based on equable, democratic premises, although it, too, is as aesthetic or objective as anything subscribed to by the Symbolists and Purists. This new art identified the people at large as artists of a sort, or as artisans and improvisers, making the most of prosaic materials. If the inhabitants are to be taken seriously, it would be as well to pay attention to their buildings and arrangements, and not merely to read them as defacements to the landscape.

Exclusive landscape never re-established itself after the 1930s. The Great War had been an offense but primarily against humanity. Thereafter, there developed an awareness that the whole system was at risk. American terrain had been destroyed by poor farming practices and polluted by the development of the atomic bomb in 1945; both pointed to humanity's potentially disastrous interventions in the whole. Landscape could no longer be represented without reference to ecology, at least not without running the risk of irrelevance. Drawing sustenance from Evans's example, artists from the 1940s on chose to cite the earth inhabited, sometimes polluted, but always marked by settlement: roads, bridges, factory chimneys, all manner of standing structures. A crucial element in this developing aesthetic, which was also an ethic, was to disclose culture's interventions across the face of the earth. Conventional formats were inadequate for they showed the landscape compartmentalized. To project images of intersecting systems, or of the social and cultural in relation to the natural, photographers turned more and more to inclusive formats, the panorama especially. As in Evans's case, however, what was meant to function as document developed aesthetic aspects as audiences and photographers found that these intersecting systems were engrossing in themselves.

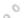

Lubken was a working photographer, a documentarist, whose pictures were brought back into the public eye by the New Topography of the 1970s and after. This, with its various angles and levels, amounts to an exercise in surveying – a kind of land art.

W. J. LUBKEN

Gates at the newly completed Truckee canal diversion dam, Nevada

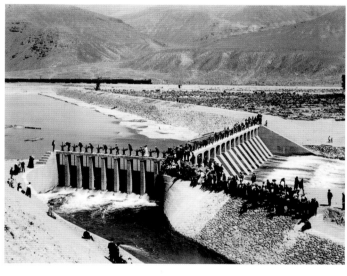

1926

In modern landscape, of which this a prime example, the earth is subject to calibration and control, of the kind expressed here in the uprights of the jetty and that distant plume of smoke. Hoppé was active in every branch of photography during the modern period, although he is best known as a portraitist, reporter, and devotee of "modern" subjects: industry and factory dynamics.

EMIL OTTO HOPPÉ

Key West, Florida

1857

Murray made albumen paper prints from waxed paper negatives. Pioneers, like Murray, represented space in a way that allowed it to be reconstructed or even calculated. The cannonballs are a unit of measurement, in what is one of the most stately of all early pictures.

DR. JOHN MURRAY

The Arsenal and Pearl Mosque, Agra, India

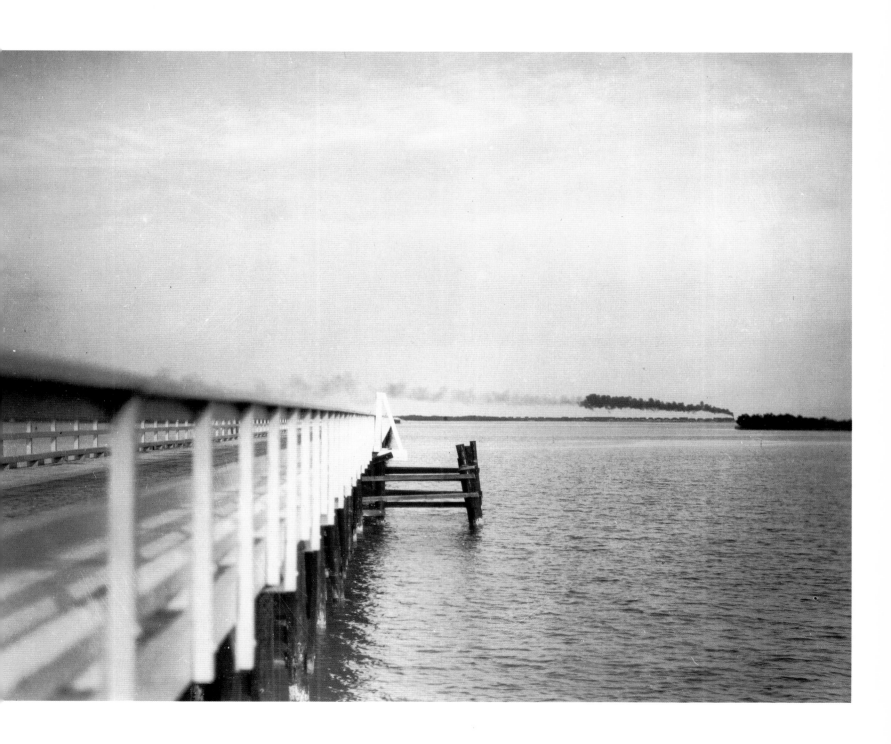

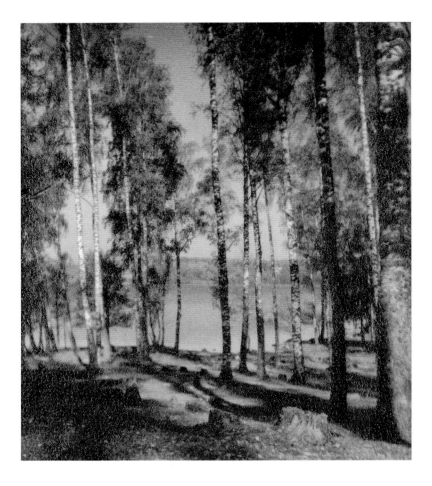

1927

A three-color carbro print. Warburg (b.1870) was a Symbolist or Pictorial photographer before the Great War, and some of the harmonies of that era survive in this picture of 1927 – when the new aesthetics (of the New Objectivity) were clear and businesslike.

AGNES WARBURG

Autumn by the lake

1900

A platinum print made from a negative of 1899. Seeley identified patterns in landscape, or mental figures half-discovered and half-imposed. He is a representative landscapist of the Symbolist era.

GEORGE SEELEY

Edge of the woods, Milwaukee

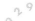
1929

A sapling outlined against a
landscape with melting snow
promises springtime. Every
element in the composition is clear
and legible. This is, in fact, a fine
example of the New Objectivity,
a movement in German art to
which Renger-Patzsch contributed.
He is known above all for a book
of 1928, *Die Welt ist schön
(The World is Beautiful)*.

ALBERT RENGER-PATZSCH

Das Baumchen

c. 1930

Petschow surveyed Germany from
a balloon, taking pictures of all
aspects of the German landscape,
published in 1933 in Eugen
Diesel's *Das Land der Deutschen*.
This was a comprehensive
survey, amounting to an inventory
of agricultural, mineral, and
picturesque resources.

ROBERT PETSCHOW

A clear-cut area in a pine forest

1948

Webb, who used large-format cameras with "slow" lenses, took pictures in Pittsburgh, then undergoing a clean-up campaign. He was there to reflect on before and after, but admitted that the "atmospheric quality of the pollution was really kind of wonderful for photography." His interest in "what man has done to the landscape" was always more important than the landscape itself – and it marks him out as an important precursor of many landscapists in the ecologically conscious 1980s and after.

TODD WEBB

Looking toward Pittsburgh, Pennsylvania

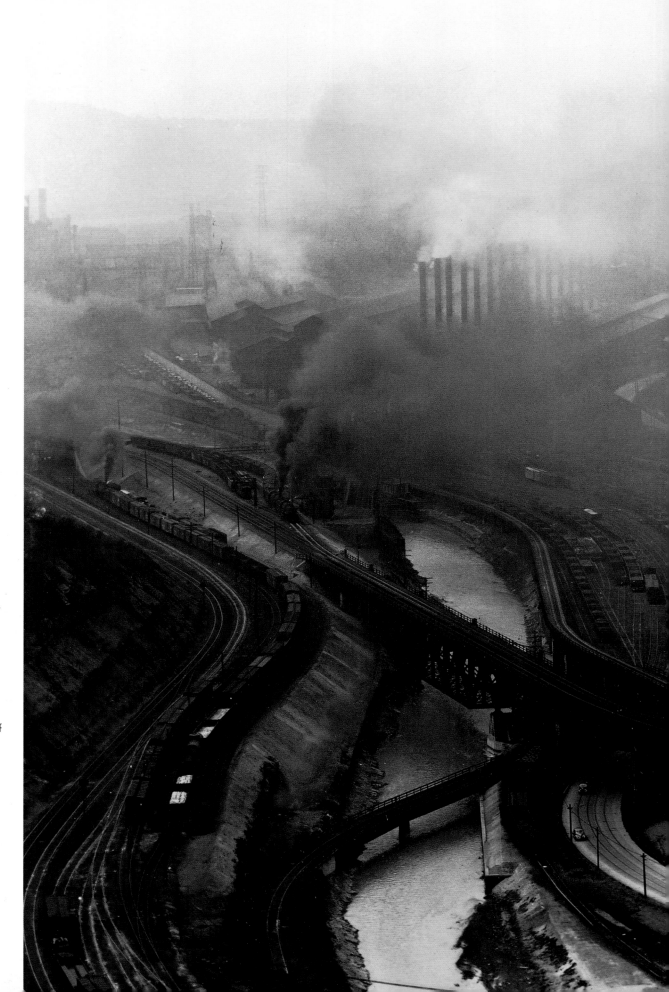

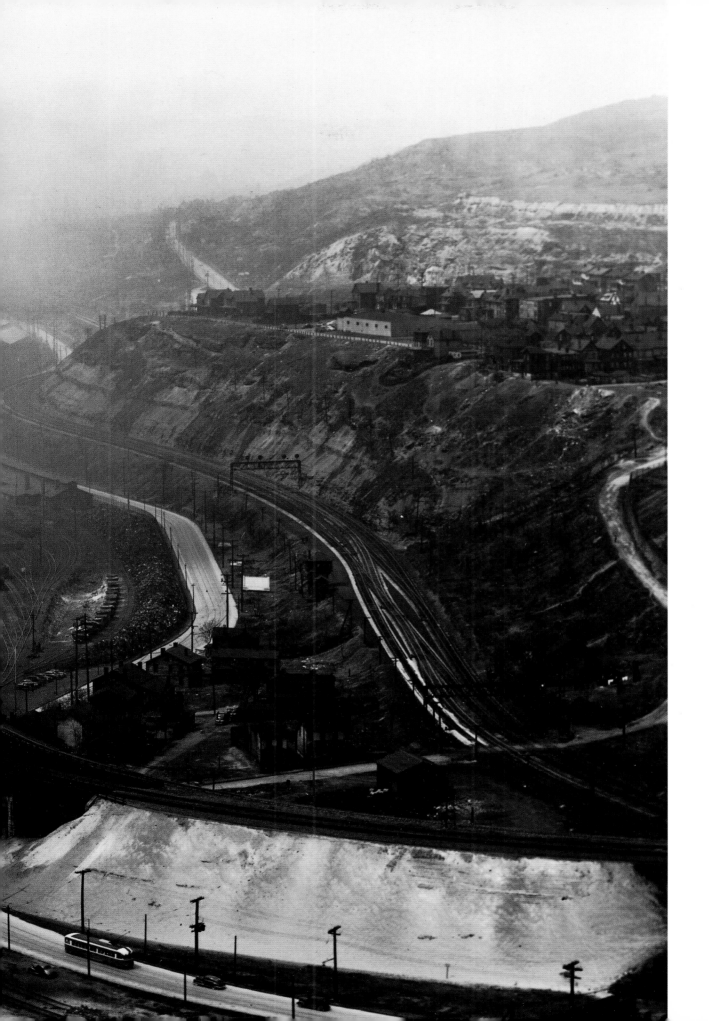

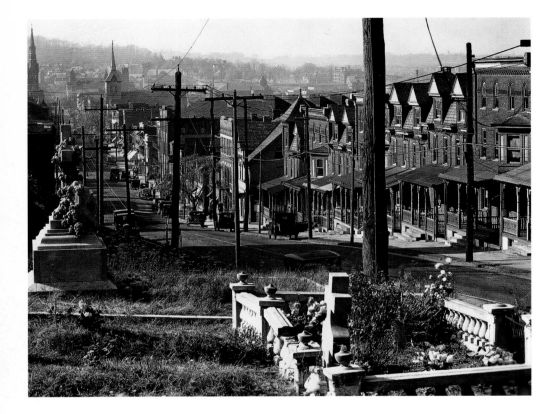

c . 1 9 8 5

This is published in *Los Angeles Spring* (1988), a book of 50 pictures by Adams, whose name is closely associated with the development of the New Topography. Long Beach looks like nowhere-in-particular, or a tract of land provisionally settled by vehicle owners. Adams remarks on the unworthiness of our response to landscape, and on surviving "intimations of mercy" – trees mainly, part of the organic order surviving with difficulty.

ROBERT ADAMS

Long Beach

1 9 3 5

This urban landscape, taken on an 8 x10 inch negative for the Farm Security Administration, asks to be worked out and its spaces assessed from available evidence. Such obstructed "difficult" spaces only became commonplace in photography in the 1970s, in the New Topography.

WALKER EVANS

Street scene, Bethlehem, Pennsylvania

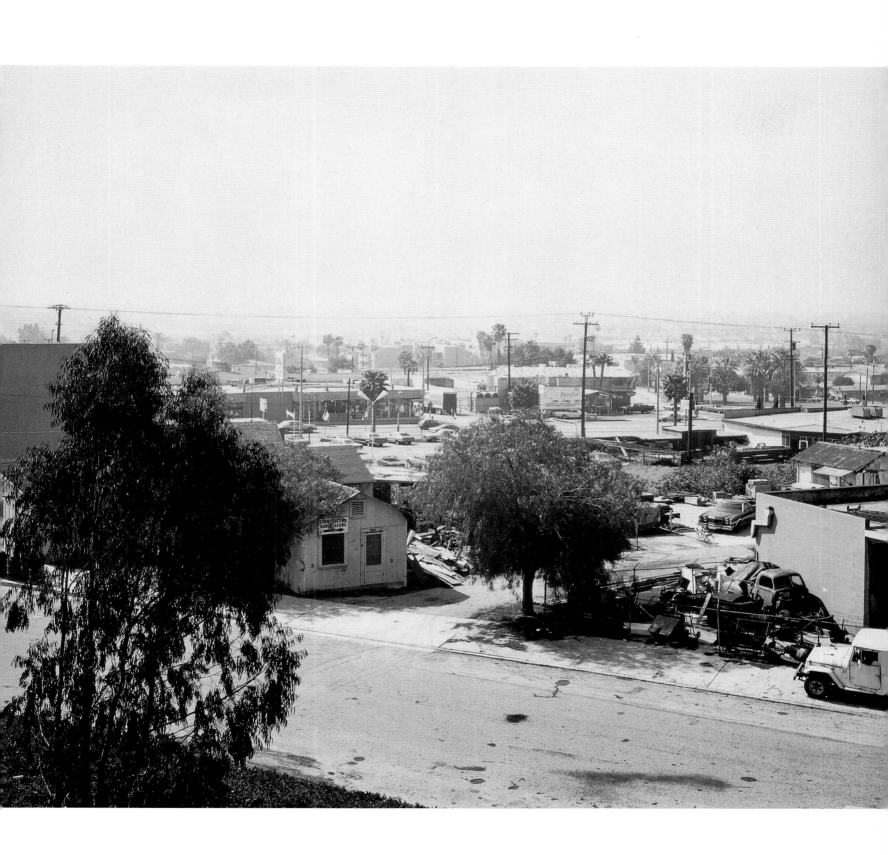

1997

The New Topography, made on large-format cameras, is an even-handed aesthetic, prepared to consider landscape forensically or as full of evidence relevant to inquiries not yet undertaken. It proposes a fresh start and a new look at topography dismissed by precursors as marginal or merely functional. Catrica is a Portuguese survey photographer who has toured Britain on behalf of the Siemens organization.

PAULO CATRICA
Manchester Ship Canal

1993

Ciol's is a romantic landscape
involved with space and time –
two aspects of infinity. Space
might be marked out, up to a
point, and time registered by
cast shadows – minimal
maneuvers that preserve
consciousness of infinity. Ciol,
from Pordenone in north Italy,
has worked principally with
landscape since the 1950s.

ELIO CIOL

**The Temple of the Queen
of Sheba, North Yemen**

The stems of *Verbascum thapsus*
survive the winter and stand
rather as rivals to the landscape
at large. Postmodern landscapists
like to remark on instances of
time, place, and position, or on
the "taking" of the landscape
rather than on the view itself. The
pictures were taken in Greece by
Attali, an archaeological and
wilderness photographer.

ERIETA ATTALI

Verbascum Thapsus, I & II

PORTRAITS

Photography made all the world into a stage. The camera with its operative made up an audience, but beyond them there was another audience, difficult to gauge. Many nineteenth-century subjects present themselves as if for a house party, and very often they were the photographer's associates included for the sake of scale. There was little sense, however, in the nineteenth century of a collective audience of Britons, French, or Americans – even if some Americans from the Civil War period look as if they might have national audiences in mind.

It was only in the 1920s and after that Europeans and Americans began to present themselves as representatives of a people or nation. The Russian Revolution of 1917 made a difference for it brought a representative cast of mind into being, which was then taken up by Germans and Americans. The problem was that nationalism was associated with folk-life, which was incompatible with modernity. The American example was complicated by the fact that the representative man or woman of the 1930s was a victim of bad weather and economic depression. Faith in representative portraiture declined after 1945 for the new idea was that people were to be understood through their actions and preferences, or in terms of social life and consumption of goods – and for this a broader documentary format was required.

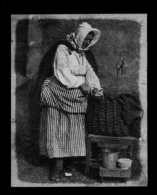

c. 1846

Hill took pictures in the fishing community at Newhaven near Edinburgh. It is likely that the pictures, the first systematic portrayal of a working-class community, were meant to introduce the people of Newhaven to charitable donors. Fishing in the 1840s was difficult and sometimes fatal. The pictures were calotypes – that is, early salt prints made by the negative–positive process recently introduced.

DAVID OCTAVIUS HILL
AND ROBERT ADAMSON

Oyster woman

1936

This was the last of six pictures Lange took of Florence Thompson – it went on to become the most famous of all Farm Security Administration icons. Lange found a melancholy beauty in adversity. National stereotypes in Germany and the U.S.S.R. were never as complex as this.

DOROTHEA LANGE

Migrant mother, thirty-two-year-old Florence Thompson and her children in a migrant labor camp at Nipomo, California

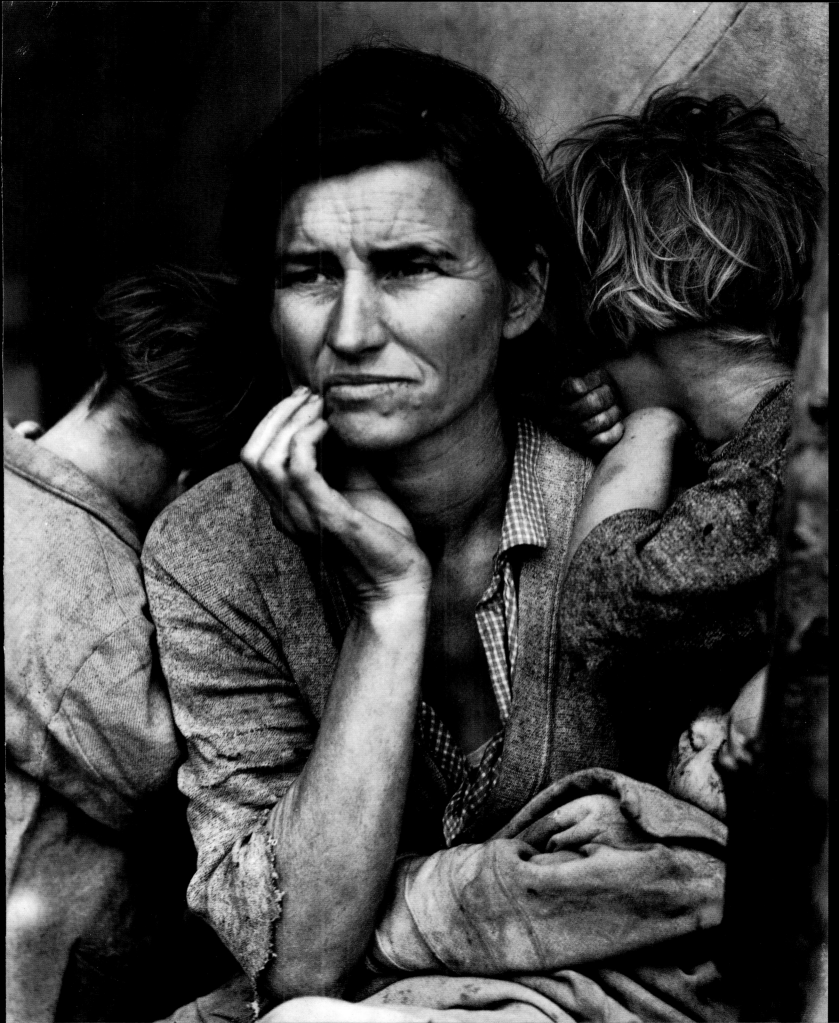

An unnamed subject can be made to represent a nation, class, or trade. Once named, however, the same figure would appear self-possessed and less capable of standing in for all the rest. The early history of photography is rich in portrayals of unknown fishermen and farm workers – often employees on the estates of wealthy pioneer photographers who were asked to pose, sometimes merely for the sake of scale. Representative portraiture only really became a serious element in photography in the modern era, around 1930. It was then that photography began to be valued for its capacity to shape public opinion through the new illustrated magazines, which were inaugurated en masse in Europe in the late 1920s.

At the turn of the century, nation states were run by politicians from hereditary castes, and the acquiescence of the people was taken for granted. Working people were targeted by reformers anxious to make improvements in social conditions, and one of photography's most dignified instances involved the reformer Lewis Hine, active in the U.S. from around 1904. Hine sought to uncover the widespread abuses of child labor, and his tactic was to photograph his subjects as if celebrating labor. The workers he photographed present themselves readily and sometimes enthusiastically, proud of their involvement in mining, smelting, and canning. Detailed naming and captioning then preserved the pictures as portraits and as poignant testimonies to the abuse at issue.

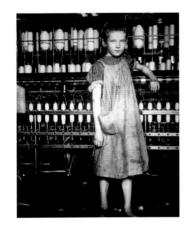

1910

Hine toured work sites in the eastern states in the first decade of the century. His self-imposed task was to expose child labor to public scrutiny, although in the end his documents survived as portraits and as representations of the human spirit – American icons.

LEWIS HINE

"Addie Laird, 12 years old. Spinner in a Cotton Mill. Girls in mill say she is 10 years old...," North Pownal, Vermont

There is an element of violence implicit in generalizing representation. Hine's opponents were not only those who defined underage workers as "hands" or contributors to a business. Hine wanted to save those he portrayed from the act of definition itself as well as from the physical violence to which they were exposed. Scruples of this sort were, however, unwelcome later in the century when national and ideological rivalries raised the stakes to a point where Hine's liberalism could no longer be tolerated.

National stereotypes, at least in Europe, had been established in the graphic arts in the late-nineteenth century. They had been worked out in the new nation states and featured peasantry in folk costumes. These stereotypes were archaic, even at the moment of their establishment, and they were troublesome to ideologues in the 1920s and after. Nationalists were well aware that culture was in transition, and that mass production looked set to iron out national differences. There would emerge a soulless international style, described in the 1930s as Functionalism. This style, promoted in the 1920s by the Bauhaus – the school of design, founded by Walter Gropius in Weimar, Germany – aimed to unify art and technology.

It promised efficiency, but would lead to alienation and the disappearance of all local cultures – to be preserved only as tourist attractions. The cultural tendency may have been functionalist, but Europe remained a continent of competing nation states to whom the idea of a universal style was un-thinkable. Yet, if they were to remain competitive, it had to be through modernization, of a kind that was inimical to old-fashioned values.

MODERN STEREOTYPES

Nationalists were racists to some extent. Racism, though, was jeopardized by regionalism and its suggestion of former tribal differences. German nationalist photographers in the 1930s chose re-gional subjects, but although they stood for antiquity and deep-rootedness, they looked at the same time archaic and even ridiculous. The situation had been complicated after 1918 by the emergence of the U.S.S.R. and Leftist ide-ologies that had appropriated worker imagery, rendering it suspect in Western eyes. Steelworkers and other heroes of modern labor were invested with Communist rhetoric and had to be treated with care if used in the German, French, or British press. One response in Paris and in London was to introduce the worker-hero as jovial and companionable, and as someone con-scious of acting his role. In the U.S.S.R., however, there were also difficulties in that local stereo-types were suspect. Ukrainians and Azerbaijanis had joined together to form a new union in the interests of workers – and under an obligation to workers everywhere. Regionalism,

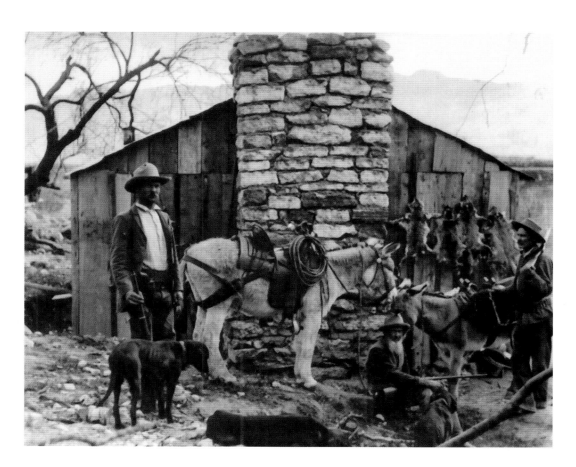

Lubken, a documentarist of the purest kind, organized his subjects to demonstrate as much as possible about their working lives: dogs, rifles, tin cans, mules, harness, and shaving habits. Practical documentary is quite rare in the history of the medium – later documentary photographers often tried to win sympathy for their subjects.

W. J. LUBKEN
Trappers and hunters in the Four Peak country, Arizona

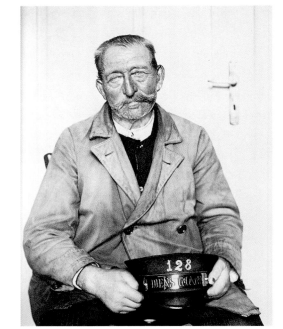

The subject is a porter and meant to take his place in Sander's proposed survey of the German people, which he had begun before the Great War. The scheme was to be called "People of the Twentieth Century," and the first volume appeared in 1929, *Antlitz der Zeit (Face of the Time)*. Sander fell foul of the Nazis, perhaps because he was a liberal who thought of his subjects as individuals rather than representatives.

AUGUST SANDER
Dienstmann, Munchen

with all its subversive potential, could not be freely admitted. It was scarcely possible even to admit to the agricultural earth, except as an idea, for the earth was also a token of localism. The result, in the propaganda photography put out by *U.S.S.R. in Construction* – a major periodical heavily illustrated and distributed internationally – was an oddly anomalous art in which laborers in peasant outfits worked to modern rhythms on generalized sites.

European propagandists, fighting for the success of their ideologies, were in a quandary that was never resolved. Traditional forces in the U.S.S.R. found the international style, with its denial of localism and its commitment to utopia hard to stomach, and they turned against it in the 1930s. Meanwhile, in Germany, modernizers in the National–Socialist era soon tired of an authentically nationalist art in which heavy-footed workers trod the German earth.

There is one German instance that warrants a mention in all histories: August

Sander's *Antlitz der Zeit (Face of the Time)*, published in 1929. This book of 60 portraits, showing a wide range of German people from all sections of society, was meant as a forerunner to a survey – that never appeared – made up of 540 portraits. In 1934 *Antlitz der Zeit* was banned by the recently elected Nazis. The plates were destroyed and available copies of the book confiscated. The authorities seem not to have given their reasons, which have to be surmised, but Sander's cross-section looks very much like a selection of portraits of people who in the main defy classification. Sander is, like Hine, a liberal photographer, dedicated to revealing the details of each individual's existence and to an extraordinary social and individual diversity – quite incompatible with any grandiose idea of nation. Sander's art was very much admired and influential in the 1960s and 1970s, not least because of its seeming refusal to recognize stereotyping.

CRISIS IN THE U.S.

At the moment when Russian and German photography was decaying under pressure from internal contradictions, American representative portraiture was coming into its own, under the aegis of the Farm Security Administration (FSA), a government agency set up in 1935. The Germans were wary of the Russians, and vice versa, and the French and British had their own problems with respect to Communism and Nationalism. The Americans, by contrast, had been harshly treated or threatened not by an opposing ideology,

but by nature itself, unsympathetic to naive farming practices. Promising farmland, in Oklahoma especially, had been blown or washed away, and the inhabitants had been forced to take to the road. The tragedy needed to be publicized to prepare the way for legislation, and the FSA sent photographers out to report on areas of unusual hardship. Among them were several who would become famous in the history of the medium: Walker Evans, Dorothea Lange, Russell Lee, Arthur Rothstein, and Ben Shahn. Like Sander, who became an exemplary photographer only in the 1960s, the FSA artists also came into their inheritance at that time, and for much the same reasons as Sander.

Soviet photographers were able to present the working people heroically and genially, for they were looking forward to a bountiful future. By contrast, the glorious future the Americans had predicted for themselves was already spoiled, through no obvious fault of their own. Circumstances, in the shape of harsh weather, had been against them and they were at a loss to know why. The outcome was a strangely equivocal "national" photography in which the people hold themselves in a baffled readiness, chastened but still prepared to believe in some kind of brighter life – even if a long way short of utopia. The virtue of FSA portraits, from the point of view of longevity of effect, is that they are not easily exhausted. The photographs, like Hine's pictures, testify to complex actualities that had been confronted by individuals each in his or her own way.

FSA portraits belong generically to the 1930s. They were taken by photographers who believed, like their Soviet counterparts, in the iconic potential of the individual. A single figure, thoughtful and tranquil, might stand for a whole

predicament. After 1945, though, this confidence in the monumental had waned. There had been a world war, stemming from the various nationalisms of the 1930s, and the credit of national and local stereotypes had been exhausted. Societies pre-war had faith in nationhood and thought that their belief would see them through. Patently they had been wrong, which prompted a new generation to put its trust in actions alone. The old orders of the 1930s could be symbolized because they involved patriotic abstractions. But actions, which would henceforth speak louder than words, occurred only between individuals and groups, and could be best expressed in crowds and on the streets.

STAGES ON THE WAY

Photographers would be as keen as ever to find a motif for the new era, but it would of necessity lack permanence and form part of a continuum that promised nothing utopian. Sander's photography, like that of his successors in the FSA, is marked by assumptions about adulthood as a finished state. Henceforth, there would be only stages in a life on the way to nowhere in particular. Children came to be especially valued in postwar iconography, less because they carried the greatest potential for good, than because of their vivacity – they were, of all people, the most urgently en route and those most intensely lodged in the instant. Futuristic projections, by which the Modernists had set such store, had proved so endangering that it had become necessary to obscure the future in a present vividly realized. Representative portraiture had been so implicated in the old culture of fixities and projections that it, too, had to be disposed of at the opening of the new age.

Nicholls made a number of studies of women enrolled in what had formerly been male occupations. His subjects, engaged in work of national importance, present themselves as individuals posing for portraits, rather than as representatives of the nation – as would be the case in the 1930s, in the U.S.S.R., for instance, or in Nazi Germany. Nicholls's peacetime specialties included High Society and London's social season.

HORACE NICHOLLS
Woman tram driver

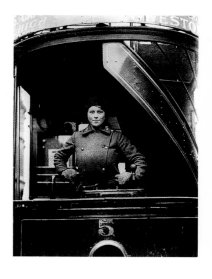

1936

Her plaited straw hat carefully placed against those grained boards tells of control and judgment. This very famous portrait of a sharecropper's daughter is from an 8 x 10 inch negative, usually contact printed.

WALKER EVANS

Lucille Burroughs, Hale County, Alabama

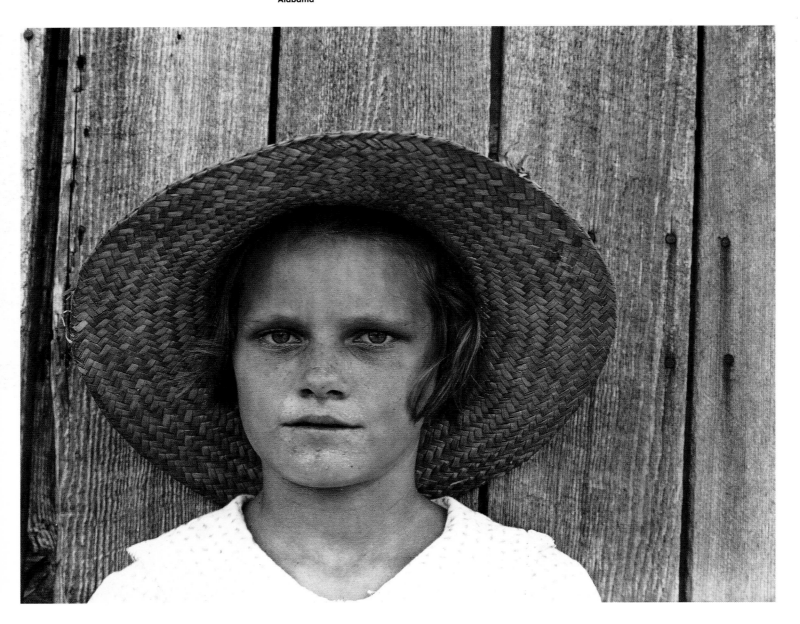

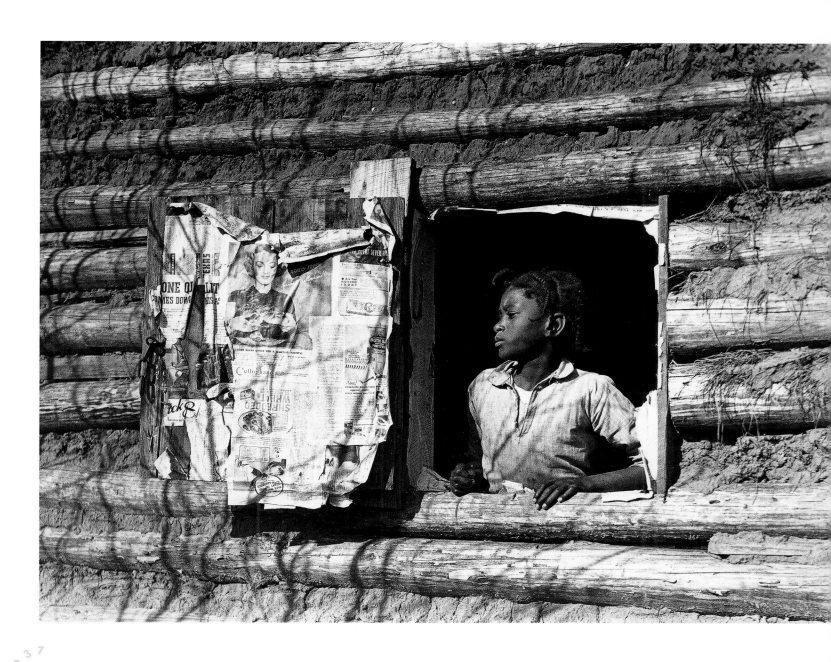

1937

Gee's Bend was an archaic community of tenant farmers, where elements of African culture still survived. Between 1935 and 1940 Rothstein worked for the Resettlement Administration, or Farm Security Administration as it became known. The insulating collage of newspapers to the left offers Shredded Wheat, Cellophane, and cakes – "your baker offers you a tempting variety."

ARTHUR ROTHSTEIN

Artelia Bendolph, Gee's Bend, Alabama

1946

American documentary pictures are often very particular as to name, place, and date, and interested, too, in decor and in the framing of individuals in domestic surrounds: doors and windows. Lee is best known for his work for the American Farm Security Administration between 1936 and 1942.

RUSSELL LEE

"Son of Clabe Hicks, miner," Bradshaw, McDowell County, West Virginia

1937

Shahn worked for the Farm Security Administration between 1935 and 1938. He used a right-angle viewfinder which allowed him to make candid portraits in the street. His pictures, of Old World Americans, only became known and popular in the 1950s and 1960s, during a period of rediscovery of the American folk past.

BEN SHAHN

Mountain fiddler, Asheville, North Carolina

1942

Parks began to work for the Farm Security Administration in 1942, and this portrait is from his first project – on racial inequality and intolerance. Ella Watson's father had been lynched and her husband accidentally shot. This carefully posed picture was too staged for the liking of the Farm Security Administration, and Parks – the first black photographer to work for the organization – was advised to involve himself more, and to photograph informally.

GORDON PARKS

Ella Watson, U.S. Government Charwoman

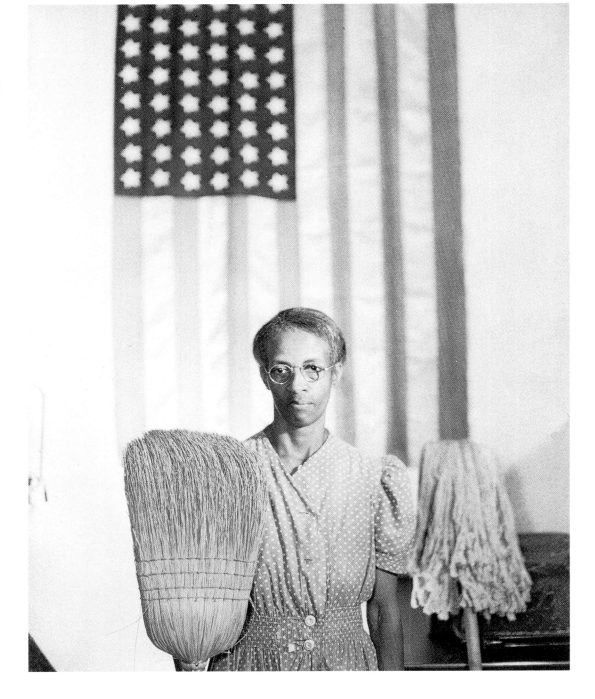

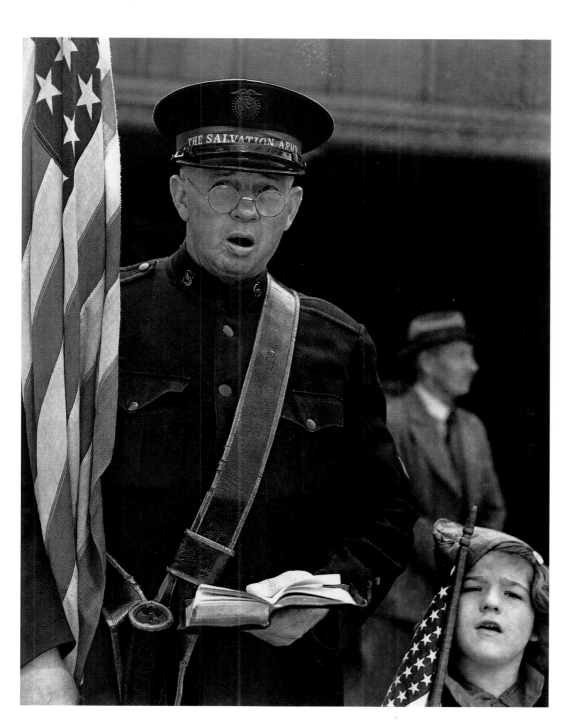

1939

Lange lived in Berkeley and worked in California for the Farm Security Administration. This was her preferred picture from a study of the Salvation Army undertaken over Palm Sunday weekend. Such contrasts between age and youth recur in documentary pictures in the 1930s.

DOROTHEA LANGE

Open-air meeting – Salvation Army, San Francisco, California

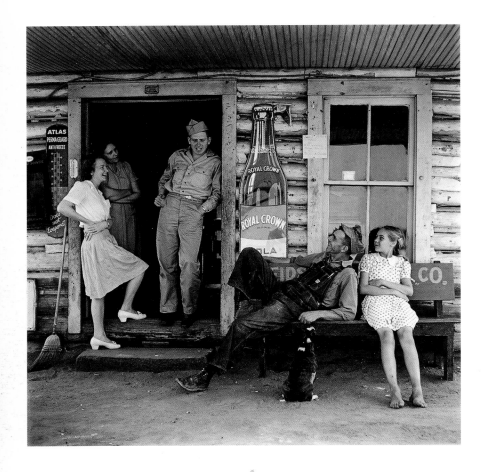

In 1944 Libsohn looked forward to genial days ahead in an America devoted to the arts of peace. One of the most utopian of documentarists, he worked for Standard Oil from 1943 to 1950.

SOL LIBSOHN

Soldier home on furlough talks with friends in front of a general store, Brown Summit, North Carolina

The Rosskams worked for Standard Oil from 1943 to 1946. They went to Wyoming to record the work of the Carter Oil Company, but took a lot of "peripheral stuff" along the way, some of which anticipates an oncoming age interested in consumer durables.

EDWIN AND LOUISE ROSSKAM

Washing the car in an oil camp, Elk Basin, Wyoming

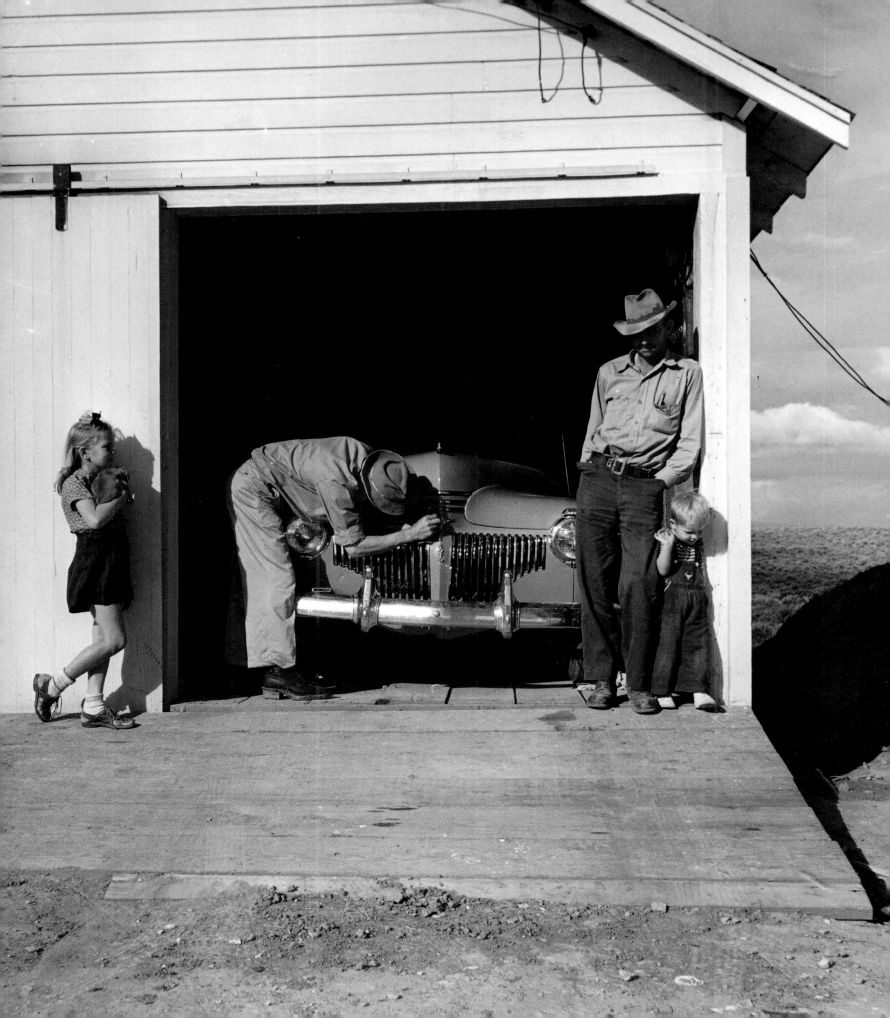

1949

A victor is carried shoulder high after a bout. Traveling in the Sudan, Rodger came across tribes living to traditional patterns. His reports, published in the 1950s – and especially in *Le Village des Noubas*, 1955 – seem to be from a heroic utopia, even then endangered by modernity.

GEORGE RODGER

Korongo Nuba wrestlers of the southern Sudan

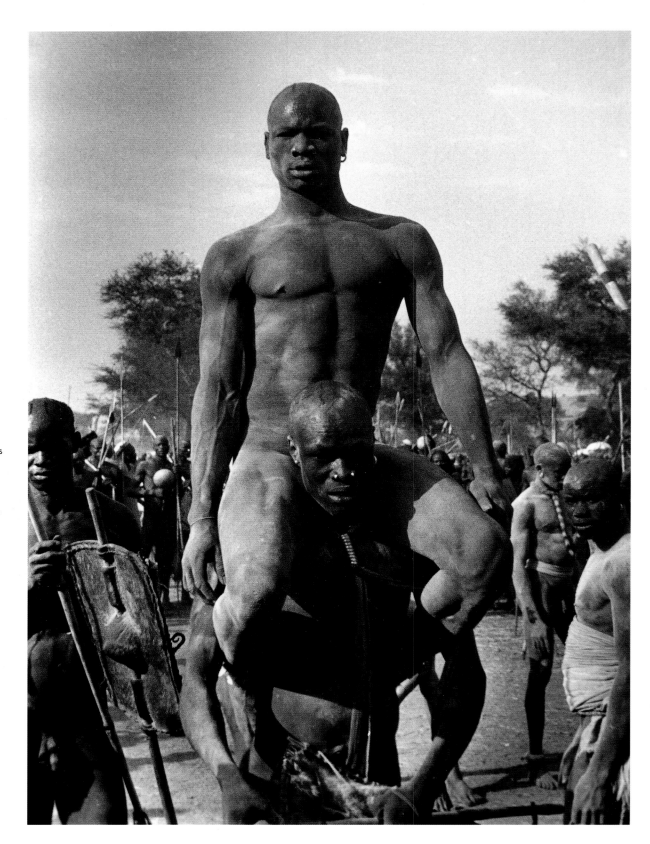

General China was a Mau Mau leader involved in the struggle against the British occupation of Kenya. Together they stand as a tableau and a postscript to a long line of anthropological portrayals dating back to the 1850s. Formerly, though, the subject submitted himself to subjection.

GEORGE RODGER
General China

1994

Harvey's documentary pictures, characteristic of a new turn of mind, take account of local cultures in relation to the wider world – and even in relation to the photographer as an emissary from that world. Harvey, a member of Magnum Photos, publishes in *National Geographic*: see, for example, *Powwow*, June, 1994.

DAVID ALAN HARVEY

A fancy dancer at a Taos Pueblo Powwow, New Mexico

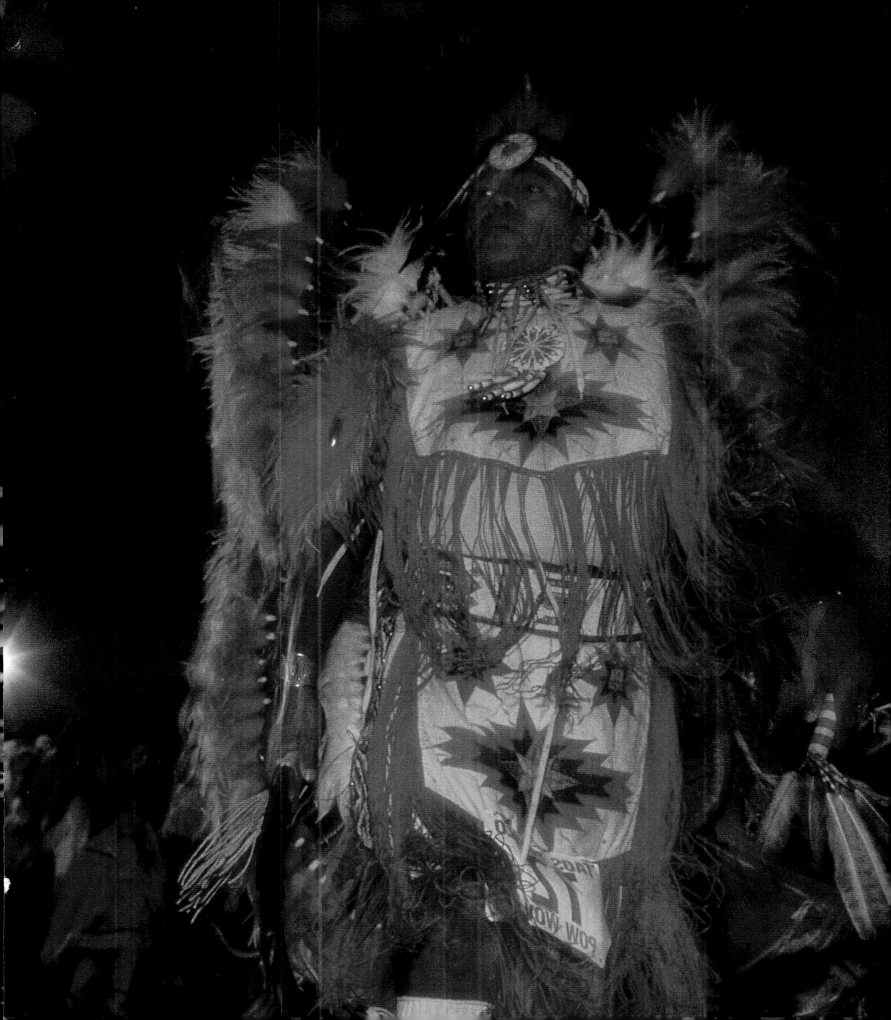

Tradespeople may have commanded space self-confidently in 1900, but by the 1990s photographers preferred to exclude settings – the better to point out that we are no longer so easily at home in the social world as we once were. This process of exclusion and severance begins in photography with a series of studies of *petits métiers* undertaken by Irving Penn in the 1950s. Da Silva is a Portuguese artist specializing in portraiture.

OLIVIA DA SILVA

Marketwomen in the Victorian Market Hall, Derby, and the Bolhão Marketplace, Porto

THE PHOTOGRAPHERS

A

ABBAS *French (b. 1944)*
Abbas, born in Iran, joined Magnum Photos in 1981. Although he has reported on civil disturbance and war throughout the world, he has also chosen to show the other side of the coin: the peaceful, even idyllic life of villages, most especially in Mexico, subject of his *Return to Mexico* (1992) (originally *Retornos a Oapan*, 1986).

ADAMS, ROBERT *American (b. 1937)*
Adams took pictures of art and architecture in the western U.S. in the late 1960s and early 1970s. Intrigued by new suburban developments he published *The New West* in 1974 and *Denver: A Photographic Survey of the Metropolitan Area* in 1977. His dispassionate style, indifferent to picturesque values, helped to establish the New Topography in the 1970s.

ALPERT, MAX *Russian (1899–1980)*
After time in the Red Army, Alpert took up photography in 1924, and in 1931 began to contribute to *USSR in Construction*, a documentary magazine set up by Maxim Gorky to represent the U.S.S.R. abroad. Alpert was a naturalist with a gift for epic subjects.

ARMSTRONG-JONES, TONY *British (b. 1930)*
Armstrong-Jones – later Lord Snowdon – began to train as an architect, but gravitated toward the theater. His first book was *London* (1958) a representation of the metropolis in terms of localities. He brought an outlook shaped by the theater to bear on his fashion work for *Vogue*.

ATGET, EUGÈNE *French (1856–1927)*
One of a handful of major artists in the history of the medium, Atget took up photography only in the 1890s after working as a sailor on transatlantic liners and as a traveling actor. His intention was only to record interesting features of Paris, and to sell his pictures to painters and to applied arts departments in museums. His fame was posthumous, and his influence widespread, especially in the 1930s – on Walker Evans, for example – after the publication in 1930 of *Atget: Photographe de Paris*.

ATTALI, ERIETA *Greek (b. 1966)*
A landscapist and archaeological photographer, Erieta Attali has participated in the revival of Greek photography during the mid-1990s – a revival centered on major exhibitions in Thessaloniki and Delphi.

B

BAILEY, DAVID *British (b. 1938)*
Bailey was contracted to work for *Vogue* magazine in 1960, and in 1962 he photographed the model Jean Shrimpton in New York. He brought a new urban street-wise style to fashion photography. He epitomized "swinging London," the subject of his book, *Box of Pin-Ups* (1965).

BALTERMANTS, DMITRI *Russian (1912–1990)*
First a printer and then a mathematician, Baltermants took up photography in 1935, turning to photojournalism in 1939. His epic pictures of the Great Patriotic War of the U.S.S.R. against Germany were printed in *Izvestia* and in *Na Razgromvraga*, the Red Army newspaper.

BEATO, FELICE *British (c.1825–c.1907)*
Beato, born in Venice, opened a studio in Istanbul with his brother-in-law James Robertson. They reported on the Crimean War in 1855–56, and then on the Indian Mutiny, 1858. Beato moved on to record the Second Opium War in China in 1860, and a U.S. military incursion into Korea in 1871 – and even a colonial war in Sudan in 1865.

BEATON, CECIL *British (1904–1980)*
Beaton – later Sir Cecil – took up photography in the 1920s, contributing beauty and personality portraits to society magazines. In 1927 he signed for *Vogue*. *The Book of Beauty* (1930) was his first major publication.

BENINGTON, WALTER *British (1872– 1936)*
Benington was a block-maker in the printing business, and a collector of Japanese prints. He began to exhibit as an artist-photographer in 1900, and became a member of the famous Linked Ring photo-society in 1901.

BENOLIEL, JOSHUA *Portuguese (1873–1932)*
A Gibraltarian, Benoliel entered photo-reportage in 1898 in Lisbon. From 1906 to 1918 he worked for *Illustracão Portugueza*. Some of his archive is in Lisbon's City Hall. An outstanding photo-reporter of his era in Europe.

BERMAN, MIECZYSLAW *Polish (1903–1975)*
Trained as a graphic designer and typographer, Berman began to make photocollages in 1930, under the influence of John Heartfield.

BING, ILSE *American (b. 1899)*
Originally an art historian in Frankfurt and Vienna, Bing moved to Paris in 1930 where she made a living as a freelance photographer: fashion, portraitures, photojournalism and theater pictures. In June 1941 she emigrated to New York, where she served mainly as a portraitist.

BOESIG *German (active 1930s)*
One of the hundreds of press photographers attached to the many Berlin agencies which flourished in the early 1930s, Boesig made pictures for Presse-Photo, which also distributed images by Walter Süssmann, Theo Eisenhart, and John Gutmann. It had a special interest in reports from the U.S.

BOHM, DOROTHY *British (b. 1924)*
Dorothy Bohm studied portrait photography in Manchester in the 1940s. During the 1950s she photographed in Paris, in the romantic and neo-realist style of the times. In the 1980s she turned to color: *Egypt* (1989) and her collected color pictures (1994) give an impression of her art..

BOND, HENRY *British (b. 1966)*
Bond is the author of *The Cult of the Street*, an extensive study of London life published by Emily Tsingou in 1998. His informal style owes something to the use of video stills and disposable equipment. Bond is from the great Goldsmiths generation of the late 1980s.

BORCHERT, ERIC *German (c.1900–1942)*
Borchert worked in Berlin in the 1920s for the American company Pacific & Atlantic, and from around 1930 for Associated Press. His book of 1941, *Entscheidende Stunden (Decisive Hours)*, covered the campaigns in Poland and in France: "Eight years I've been on my way. Journeys through continents, across land and sea." In the early 1930s he specialized in home affairs, in and around Berlin. He was killed in North Africa in 1942.

BOURNE, SAMUEL *British (1834–1912)*
Bourne arrived in India in 1862 to take pictures of landscape and architecture, and in 1864 went into partnership with Charles Shepherd in Simla. They also opened a branch in Calcutta. Bourne photographed in the Himalayas in the mid-1860s.

BRADY, MATTHEW *American (1824–1896)*
A daguerrotypist, Brady opened a portrait studio in New York in 1844. In 1858 he employed Alexander Gardner to manage a new portrait studio in Washington, D.C. Brady is best known for his coverage of the American Civil War, although mainly as an organizer and employer of photographers.

BROOKS, CHARLOTTE *American (active 1940s through 1970s)*
Brooks undertook photography for Standard Oil in 1945, making documentary studies of life in New England. In 1951 she was hired by *Look* magazine, where she remained until its closure in 1971.

BUBLEY, ESTHER *American (b. 1922)*
Bubley, from Wisconsin, worked as a technician for the Farm Security Administration, and then as a photographer for Standard Oil through most of the 1940s, leaving eventually to work for *Life* magazine – until its closure in 1972.

BURRI, RENE *Swiss (b. 1933)*
Burri, who joined Magnum Photos in 1955, studied art in Zurich, with Hans Finsler as one of his instructors. During the 1950s he reported from Germany, work which was collected in *Die Deutschen* (1962). His penchant for streetlife, taken unemphatically and in passing, was innovative in the 1950s and influential in the 1960s.

C

CAPA, ROBERT *American (1913–1954)*
Born André Friedmann in Budapest, Capa's name is synonymous with photojournalism. He worked in Berlin, and from 1933 in Paris – for *Vu* magazine. His outstanding pictures of the Spanish Civil War were collected in *Death in the Making* (1937). A co-founder of Magnum Photos in 1947, he was killed by a land-mine in Vietnam in 1954.

CARRASCO, PRISCILLA *American (b. 1933)*
A hieratic documentary photographer, in the style of Paul Strand, Priscilla Carrasco has specialized in folk-life, in particular that of Russian Old Believers, a small Orthodox sect widely scattered since persecution by Peter the Great.

CARTIER-BRESSON, HENRI *French (b.1908)*
The most famous photographer in modern times, Cartier-Bresson was one of the founders of Magnum Photos in 1947. His book of 1952, *Images à la Sauvette (The Decisive Moment)*, influenced a generation of photographers. In his early pictures in the 1930s, he was attentive to geometric formats; his pictures of the 1940s and after are more informal.

CATRICA, PAULO *Portuguese (b. 1965)*
A historian turned photographer, Catrica has tended to photograph the city – London mainly, but also Lisbon, Oporto, Newcastle, and Manchester – as a worked site awaiting analysis. Trained at Goldsmiths, London, he surveyed British urban landscapes for the Siemens organization in 1997.

CHALDEJ, JEWGENI *Russian (b. 1917)*
Chaldej worked for the Soviet news agency *TASS* from 1931. From 1941 to 1945 he served as a war reporter, subsequently attending the Potsdam Peace Conference in 1945 and the Nuremburg Trials in 1946.

CIOL, ELIO *Italian (b. 1929)*
A specialist in art, landscapes, and architecture, Ciol is the author of *Assisi* (1991), and *Venezia* (1995). His preference is for space calibrated by architectural detailing, and by traces of agriculture and habitation.

CLARKE, HENRY *American (1919–1996)*
A Californian, Clarke moved to New York in 1948 where he studied photography. He moved to Paris to become house photographer for Jean Desses and Molyneux, and in 1951 signed for *Vogue*. His style was Baroque, haughty even – in the manner of Van Dyck.

COFFIN, CLIFFORD *American (1913–1972)*
Born and brought up in California, Coffin learned photography from the Modernist George Platt Lynes in New York. He joined American *Vogue* in 1944 and British *Vogue* in 1946, before moving to Paris in 1948, thence to New York in 1950. His eccentric career is surveyed in Robin Muir's biography of 1997.

CRAWSHAY, ROBERT *British (1817–1879)*
Crawshay, an amateur photographer and "Iron King" of South Wales, lived at Cyfarthfa Castle in Merthyr Tydfil. He joined the Photographic Society of London in 1867, and in 1873 offered prizes for the best large-scale portrait heads.

CUTTING, LAURENCE *British (b. 1939)*
Cutting, trained as a photographer at the Royal College of Art in London in the 1960s, has concentrated on topics in horse-racing, an enclosed world preoccupied by style and cachet.

D

DA SILVA, OLIVIA *Portuguese (b. 1962)*
A documentary photographer, da Silva trained in photography in England in the early 1990s. Her documentary portraits were exhibited at the Centro Regional de Artes Tradiciones, Porto, 1998.

DE KEYZER, CARL *Belgian (b. 1958)*
De Keyzer, with Magnum Photos since 1990, has been a prolific reporter on postmodern social life, especially in Russia and in the old Soviet bloc, sites for *Homo Sovieticus* (1989), and *East of Eden* (1996). He came to fame in 1987 with *India*, a hectic study of life on the subcontinent.

DE MEYER, ADOLPH *American (1868–1946)*
Born in Paris, de Meyer became an art photographer in the soft-focus Pictorial style of 1900. He came to specialize in portraiture, and then during the Great War was asked to undertake fashion photography for *Vogue* magazine in New York. He established fashion photography as an independent genre.

DELAHAYE, LUC *French (b.1962)*
Delahaye joined Magnum in 1994. Although a reporter specializing in conflict, Delahaye's interests seem to have been in the long-term consequences rather than the events themselves. *Portraits* (1996) is his first book, a study of dispossessed and marginal men in Paris.

DUFFY, BRIAN *British (b. 1934)*
Duffy began to work for British *Vogue* in 1958. He helped to inaugurate a new informal style of site-specific photography. Eventually he moved from fashion photography to TV commercials.

DUNN, STEVE *American (b. 1951)*
Dunn studied photography and journalism at Boston University, and in 1984 joined the Focus West sports photo agency in San Diego, thence to Allsport USA as a staff photographer in 1988. He was part of the Allsport team at the Winter Olympics in Nagano. "The interesting part of this work is that you see a lot of what goes on behind the scenes."

DURANDELLE, EDOUARD *French (active 1860s)*
Durandelle was a member of the firm of Delmaet and Durandelle, at 22, bd. des Filles de Calvaire, Paris. They were together from 1866 to 1888, and specialized in construction work: the new Opera, the Hotel de Ville, the Sacré-Coeur, and interiors of the Hotel-Dieu and the theater at Monte Carlo.

E

EDER, JOSEPH MARIA *Austrian (1855–1944)*
Eder, a chemist, wrote an important history of technical developments in photography. In 1884 he advanced color photography – the rendering of green and yellow – and introduced gelatine chloro-bromide paper. In the 1890s he improved the Scheiner exposure metering system, in use until 1935.

EISENHART, THEO *German (active 1920s and 1930s)*
Eisenhart was a Berlin press photographer who worked, from the mid-1920s, for the Robert Sennecke Agency – the leading Berlin agency in the late 1920s.

EVANS, WALKER *American (1903–1975)*
Evans is in photography's pantheon, along with Eugène Atget for example, from whom he learned in the early 1930s. Evans used a plate camera and took scrupulously studied pictures of vernacular architecture and graphics, mainly in rural and small-town America. His book *American Photographs*, published in 1938 by the Museum of Modern Art, New York, has always been regarded as a classic.

F

FENTON, ROGER *British (1819–1869)*
Fenton, greatly admired then and now, took up photography in the late 1840s. In 1851 he visited Paris where he met the distinguished French inventor and photographer Gustave Le Gray. In 1852 he took pictures in Russia, and in 1855 of the aftermath of the Crimean War. From 1854 to 1858 he was photographer to the British Museum.

FINSLER, HANS *Swiss (1891–1972)*
Finsler worked at the School of Arts and Crafts in Halle, Germany, and in 1932 founded a photography class at the School of Arts and Crafts in Zurich, where he remained until 1957. He was for a long time the principal teacher of photography in Switzerland.

FRECHON, EMILE *French (active from the 1890s up to 1913)*
During the summer months Frechon photographed in villages and small towns throughout France. His pictures were sometimes published by the magazine *Country Life* in Britain. He used printing-out paper to achieve brown, very richly toned contact prints.

FRISSELL, TONI *American (1907–1988)*
Frissell made fashion and beauty photographs for *Vogue* between 1934 and 1940. During the war she took pictures in Europe for the U.S. Armed Forces and for the U.S. Red Cross, and thereafter took sporting subjects for Time-Life's *Sports Illustrated*.

G

GARDNER, ALEXANDER *American (1821–1882)*
Gardner, a Scotsman by birth, worked in Glasgow before moving to America in 1856 to assist the portraitist Matthew Brady. From 1860 he worked in the Civil War as a field photographer for Brady's Washington, D.C. studio, but in 1862 set up his own organization to record the war. In 1865–6 his two-volume *Photographic Sketchbook of the War* was published.

GENTHE, ARNOLD *(1869–1942)*
Born in Berlin, Genthe emigrated to the U.S. in 1896. Originally he took pictures in San Francisco to inform friends back in Berlin. In 1911 he established a studio in New York, and between 1915 and 1926 contributed regularly to the fashion magazine *Vanity Fair*.

GRANT, THOMAS *British (active c.1910)*
The Grant brothers – Bernard, Horace, and Thomas – were pioneer news photographers for the *Daily Mirror* and the *Sunday Pictorial*. Their story, up to and including the installation of the Pahlevi dynasty in Persia in 1926, is told in Bernard's *To the Four Corners* (c.1927).

GREENE, JOHN BEASLEY *American (1832–1856)*
An American, brought up in France, Greene was an amateur archaeologist. He made two journeys to Egypt and one to Algeria, taking pictures on each occasion. His pictures show the landscape settings of historic monuments, and are unusually elegant.

GRIFFITHS, PHILIP JONES *British (b.1936)*
He photographed in Vietnam from 1966 to 1970. His book of 1971, *Vietnam Inc.*, places the war in the context of Vietnamese society, and is supported by an informed text by Griffiths himself.

GRUYAERT, HARRY *Belgian (b.1941)*
Especially associated with Morocco, which he first visited in 1965. Gruyaert is above all an (experimental) colorist, taking pictures from TV screens and working with wide-format cameras.

GUTMANN, JOHN *German-American (b.1905)*
In 1933 Gutmann left Berlin and took ship for San Francisco, where he remained – "a wide-open city." He had an eye for Americana, and initially worked for the Berlin agency Presse-Photo.

H

HAAS, ERNST *Austrian-American (1921–1986)*
Although known as a photoreporter in the 1950s, Haas became a colorist in the 1960s specializing in geography and science. His book of 1971, *The Creation*, sold 300,000 copies. He remarked on elemental forces in nature, using motion-blur and unusual angles, as in his book *The Grand Canyon* (1972).

HAMAYA, HIROSHI *Japanese (b.1915)*
Hamaya specialized in the material qualities of places, their heat and their cold. From 1939 he focused on an area of northern Japan, resulting in *Snow Land* (1956). He reported on the Red takeover of China in the late 1940s, and subsequently took pictures in the U.S.

HAMMARSKIOLD, HANS *Swedish (b.1925)*
Hammarskiold was one of the new wave of European subjective photographers in the 1950s, interested in experimental forms which would express changing conditions. Taught by Rolf Winquist, Hammarskiold went into fashion when it was becoming hospitable to talent from the outside, and worked for London *Vogue*, 1955–56.

HARTMANN, ERICH *American (b. 1922)*
Born in Germany, Hartmann emigrated to the U.S. in 1938. After military service he studied photography, and took up photojournalism, joining Magnum Photos in 1951. In the 1960s and 1970s he turned his attention to the photography of science, for which work he is now best known.

HARVEY, DAVID ALAN *American (b. 1944)*
Between 1978 and 1986 Harvey was a staff photographer for *National Geographic*. In 1933 he joined Magnum Photos. Many of his documentary pictures have an anthropological and a Post-modern bias.

HILL, DAVID OCTAVIUS and ADAMSON, ROBERT *British (1802–1870 and 1821–1848 respectively)*
Hill, a painter and illustrator, and Adamson, a calotypist, began to collaborate in photography in 1843, taking portraits of priests toward a group portrait to be painted by Hill. The photographs became infinitely more celebrated than the painting. In 1846, they took pictures of people in the fishing community at Newhaven, near Edinburgh.

HINE, LEWIS *American (1874–1940)*
A social reformer, Hine is best known for his work for the National Child Labor Committee in the U.S. He was appointed to the position of chief investigator and photographer in the N.C.L.C. in 1908, and he continued his investigations for the next sixteen years.

HOPPE, EMIL OTTO *British (1878–1972)*
Hoppé, born in Munich, was by profession a banker, but on a visit to England in 1900 began to take photographs. He became an art photographer in the Art Nouveau style of the times, set up as a portraitist and expanded into the whole range of new photography during the 1920s and 1930s. He was one of the most productive and successful of all Modernist photographers.

HOYNINGEN-HUENE, GEORGE *American (1900–1968)*
In the 1920s he studied painting in Paris, and kept bohemian company. Fashion magazines used his drawings, and in 1926 he began to make photographs for *Vogue*. In 1935 he moved to New York, and from 1936 worked mainly for *Harper's Bazaar*. His principal picture books are *Hellas* and *Egypt*, both 1943.

J

JOHNS, CHRIS *American (b.1951)*
Johns, a regular contributor to *National Geographic* during the 1980s, has tended to specialize in North American subjects: regional studies, weather, and contemporary culture.

K

KALISHER, SIMPSON *American (b. 1926)*
After reading history at university, Kalisher became a freelance photographer in 1948. His first book, *Railroad Men*, came out in 1961. He helped establish the exuberant, even hysterical style of street photography which was characteristic of the 1960s.

KLEIN, WILLIAM *American (b. 1928)*
In the 1950s Klein gave a new energetic twist to urban reportage. In the 1940s he served as a cartoonist with *Stars and Stripes* and studied painting with Fernand Léger in Paris. From 1955 he made fashion pictures for *Vogue* in Paris, and became its art director.

KOUDELKA, JOSEF *French (b. 1938)*
Koudelka, originally Czech, trained and worked as an engineer. During the 1960s he took pictures of Slovakian gypsies, published in 1975. His pictures of the Russian invasion of Prague in 1968 were remarkable, and in 1970 he quit Czechoslovakia for the West.

L

LANGE, DOROTHEA *American (1895–1965)*
Lange's first teacher was Arnold Genthe, in New York. She became a portraitist in San Francisco, and then – during the 1930s – a documentary photographer, ultimately for the Farm Security Administration. In 1938, with her husband Paul Taylor, a sociologist, she prepared *An American Exodus: A Record of Human Erosion*, on the plight of agricultural workers in the U.S.

LANGENHEIM, FREDERICK and LANGENHEIM, WILLIAM *German-American (1809–1897 and 1807–1874)*
The Langenheims opened a daguerreotype studio at the Exchange in Philadelphia in 1841 or 1842, and made portraits of prominent Americans. In July 1845 they made a panorama of five separate views of the Niagara Falls. They came originally from Brunswick.

LARRAIN, SERGIO *Chilean (b.1931)*
Larrain studied forestry in California and Michigan, and took up photography in the mid-1950s. A British Council arts scholarship helped him to study in London in 1958. His pictures from the 1950s can be seen to advantage in *Valparaiso* (1991).

LARTIGUE, JACQUES-HENRI *French (1894–1986)*
Lartigue took up photography at the age of seven and continued to take pictures of his family and social life. His oeuvre only came to public attention in the 1960s. In the history of the medium he represents the innocence and exuberance of the Belle Epoque.

LEE, RUSSELL *American (1903–1986)*
Lee photographed for the Farm Security Administration in the U.S. from 1936 until 1942, subsequently joining the Standard Oil documentary project. Trained as a chemical engineer, Lee was one of the F.S.A.'s outstanding documentarists.

LIBSOHN, SOL *American (b.1914)*
Lisbohn, a New Yorker, participated in the Photo League from 1938, documenting bad housing in the city. Roy Stryker, at Standard Oil, asked him to contribute to that documentary scheme, which he did between 1944 and 1950. He recorded "the myriad ways in which Americans relaxed and played during the 1940s."

LLEWELYN, JOHN DILLWYN *British (1810–1882)*
Llewelyn, a chemist by profession, was the first photographer to achieve anything like instantaneity in available daylight. He took many pictures of the sea and of coastal landscapes. He was a member of the Royal Society, and related by marriage to Fox Talbot, the inventor of the negative-positive process.

LLORENS, MARTI *Spanish (b. 1966)*
Llorens is one of a new generation of Spanish photographers in love with fictions, and with photography's ability to re-phrase history. He claims to have discovered early annals of flying, featuring English pioneers from the 1850s.

LOWE, PAUL *British (b. 1963)*
A documentary and reportage photographer associated with Magnum Photos since 1993, Lowe has covered many "international news events," the small wars and crises which have been such a feature of post-Soviet politics.

M

MAN RAY *American (1890–1976)*
Born Emmanuel Rudnitsky, he trained as an artist in New York, took up photography in 1915, and in 1917 co-founded the New York Dada group. In 1921 he went to Paris, mixed with the Surrealists, experimented with photograms, or cameraless pictures, which he called Rayographs, and during the 1930s brought vanguard practices into fashion photography.

MARTIN, PAUL *British (1864–1944)*
A pioneer of informal picture-making, Martin was a wood engraver by trade, working for the *Illustrated London News*. Using a modified "Facile" hand-camera, he photographed city types in London, as well as weekends on Hampstead Heath and holidays at Great Yarmouth.

MAYFIELD, WILLIAM *American (1896–1974)*
As a boy, Mayfield took pictures of the Wright brothers on their return to Dayton in 1909 after touring their aircraft in Europe. Mayfield went on to work for the *Dayton Daily News*. Such inventions as that of the flying machine promised to put provincial towns and cities on the world stage.

McCURRY, STEVE *American (b. 1950)*
Associated with Magnum Photos since 1985, McCurry epitomizes the adventure photographer of the 1980s and 1990s. He has reported from many of the crisis zones of the era – Afghanistan, in particular – but rather as a traveler in the hinterland. His pictures are often carried by *National Geographic*.

MERMELSTEIN, JEFF *American (b. 1957)*
A street-photographer and specialist in New York City, Mermelstein works principally for magazines intrigued by the idea of N.Y. as a city of the imagination. In Mermelstein's epiphanies the city reveals itself in a sometimes religious or apocalyptic light.

MOORE, RAY *British (1920–1987)*
Moore, Britain's outstanding art photographer in the 1970s, worked along existential lines, remarking on encounters with figures in the environment. He taught for many years in a school of art in Nottingham, England.

MUNKACSI, MARTIN *Romanian-American (1896–1963)*
Munkacsi began as a self-trained sports photographer for the Budapest newspaper *Az Est* in 1921. In 1927 he moved to Berlin, on contract to the Ullstein Press (*Berliner Illustrirte Zeitung*). In 1934 he moved to New York where he made fashion pictures for *Harper's Bazaar*, and for a while was the best paid of all photographers.

MURDOCH, HELEN MESSENGER *American (1862–1956)*
Murdoch took up photography in the 1890s, and is best known for her Autochromes, many of which were taken on a round-the-world trip in 1913–14. In the 1920s she became an aerial photographer.

MURRAY, JOHN *British (1809–1898)*
Murray, a Scottish doctor and cholera specialist, served in the East India Company Army. He took up photography around 1849, and took a documentarist's interest in India. He made salted paper and albumen prints from paper negatives, always to a high standard.

MUYBRIDGE, EADWEARD *British-American (1830–1904)*
Taught photography in the 1860s by the American landscapist Carleton Watkins, Muybridge took pictures for the U.S. Government and for the Central & South Pacific Railroad and the Pacific Mail Steamship Co. In May 1872 he began his experiments with instantaneous pictures of animals in motion, for which he became famous.

MY, HUYNH THANH *Vietnamese (1937-1965)*
Originally employed by CBS to carry news equipment, he was enrolled by Associated Press as a staff photographer in 1963. Some of his pictures appear in *Requiem*, edited by Horst Faas and Tim Page (1997).

N

NACHTWEY, JAMES *American (b.1948)*
Northern Ireland in 1981 was the first theater of conflict from which Nachtwey reported– the first of many, from El Salvador, Lebanon, Gaza, Rwanda, Bosnia, Afghanistan, and Albania. His early pictures appear in *Deeds of War* (1989).

NEWKIRK, GARY *American (b. 1951)*
A Californian and an avid sports fan, Newkirk soon decided to make sports photography his career. He followed the triathlon and bicycle racing circuits prior to joining the Allsport agency. He left Allsport in 1993, and began to specialize in golf photography.

NEWTON, HELMUT *Australian (b. 1920)*
Born and brought up in Berlin, Newton emigrated to Australia in the late 1930s. After experience as a freelance photographer he began, in 1958, to contribute regularly to the world's major fashion magazines – and continued to do so. His first book, *White Women/Femmes secrètes*, appeared in 1976.

NICHOLLS, HORACE *British (1867–1941)*
Nicholls was one of the early news photographers. He reported on the Boer War in South Africa, took pictures of the Edwardian social scene and then of civilian involvement in World War I.

O

O'SULLIVAN, TIMOTHY *American (1840–1882)*
An Irishman originally, O'Sullivan was an apprentice in the portrait studio of Matthew Brady. First of all for Brady and then, from 1862–63, for Alexander Gardner he photographed battlefields and encampments of the American Civil War. Subsequently he worked as a survey photographer in the American West. His influence as a landscapist was greatest in the 1960s and after.

P

PARKS, GORDON *American (b.1912)*
Parks took pictures for the Farm Security Administration just before its photographic project was discontinued. Like several F.S.A. documentarists he was then employed by Roy Stryker to undertake similar work for Standard Oil. Between 1949 and 1970 he worked for *Life* magazine, and was the most successful black photographer of that era.

PENN, IRVING *American (b. 1917)*
After studying design, Penn worked as a graphic artist in New York. In 1942 he painted for a year in Mexico, and in 1943 was contracted to design title pages for *Vogue*. He began to use his own pictures and in 1945 established himself as a freelance photographer, opening his own studio in New York in 1952.

PERESS, GILLES *French (b.1946)*
Peress has specialized less in war than in its environments. During the 1970s he took many pictures in Northern Ireland, and in 1979 in Iran – the subject of *Telex Persan* (1984). Rwanda was the setting for *Le Silence* (1995).

PETSCHOW, ROBERT *German (1888–1945)*
An engineer, Petschow became a balloonist and then a photographer. In 1914–18, he served as a balloon observer. During the 1920s he became a professional aerial photographer, and editor of *Die Luftfahrt*, an air travel magazine. His pictures were in vogue in the 1920s. During World War II his archive of 30,000 negatives was destroyed.

PINKHASSOV, GUEORGUI *Russian-French (b.1952)*.
From 1969 to 1971 he studied at the VGIK Cinema Institute in Moscow, and then worked in the Mosfilm Studios, finally as a set photographer. Moved to Paris in 1985, and joined Magnum Photos in 1988.

PONTING, HERBERT *British (1871–1935)*
Ponting was official photographer to Captain Scott's second and last South Pole expedition of 1910–12. Previously he photographed art, life, and landscape in Japan: *Japanese Studies* (1906).

POST WOLCOTT, MARION *American (1910–1990)*
After studying photography in Vienna, Post Wolcott became a photojournalist in the U.S., on the *Philadelphia Evening Bulletin*. She was recruited by the Farm Security Administration in 1938, where she remained until 1942 – when she retired to raise a family. One of the principal documentarists to work for the F.S.A.

R

RENGER-PATZSCH, ALBERT *German (1897–1966)*
Best known for a book of photographs published in 1928, *Die Welt ist schon (The World is Beautiful)*, in which he remarks on parallels between design in nature and in manufacture.

RIO BRANCO, MIGUEL *Spanish-Brazilian (b.1946)*
Rio Branco originally took up photography to help plan his paintings. He trained for a short period in Rio de Janeiro, after which he turned to photography and film-making. His color pictures appear in a book of 1985, *Dulce Sudor Amargo (Sweet Bitter Sweat)*. Color is a large part of his subject matter.

RODCHENKO, ALEXANDER *Russian (1891–1956)*
Rodchenko is synonymous with Modernism. He trained as a graphic designer, and in 1924 took up photography, in the process presenting the new Russia dynamically, as a largely urban culture peopled by artists and athletes. His style, with all its novel viewpoints and foreshortenings, went out of fashion in the 1930s.

RODGER, GEORGE *British (1908–1995)*
Rodger was a co-founder of the famous cooperative agency Magnum Photos in 1947. He covered World War II for *Life* magazine, specializing in Africa and the Middle East. He is best-known for *Le Village des Noubas* (1955) a study of Sudanese village life undisturbed – at that point – by modern intrusions.

RONIS, WILLY *French (b. 1910)*
Ronis became a full-time photographer in 1936, reporting on life and events in and around Paris. In the autumn of 1947 he began to photograph in the Ménilmontant and Belleville area to the east of central Paris. He continued to take pictures there through the early 1950s, eventually collected in 1954 in *Belleville-Ménilmontant*, an outstanding study of the city as an extension of provincial life.

ROSSKAM, EDWIN and LOUISE *American (Edwin b.1903)*
Edwin was a writer, editor, and layout specialist and he worked for Roy Stryker at the Farm Security Administration, 1938–43. He moved with Stryker to the Standard Oil project in 1943, where he worked with his wife photographing until 1946. Their book *Towboat River* (1948), on life on the Mississippi, combined photographs and texts from recorded speech.

ROTHSTEIN, ARTHUR *American (1914–1985)*
Rothstein was the first photographer to be hired by Roy Stryker to serve in what became the Farm Security Administration. He was hired originally to organize and to make copy pictures but, influenced by Ben Shahn and Dorothea Lange, soon became a documentary photographer in his own right. In 1940 he joined *Look* magazine, where he remained until its closure in 1971.

RUGE, WILLI *German (1892–1961)*
Ruge was always an enthusiast for flying, and in 1914–18 served as a Luftwaffe photoreporter. In 1919 he made a reputation for his coverage of the revolutionary period in Germany. He set up his own agency, Fotoaktuell, and was always the model of an enterprising news photographer. His archive was destroyed in a bombing raid on Berlin in 1943.

S

SALOMON, ERICH *German (1886–1944)*
Salomon has been credited with the invention of "candid" photography. After studying law, serving in the German army, and working in the stock exchange and in the car hire business, he joined the Ullstein publishing house in Berlin in 1926 – in public relations originally. He acquired one of the new Ermanox cameras, and in 1928 took some courtroom pictures which made his reputation as an expert in reportage in "available light."

SANDER, AUGUST *German (1876–1964)*
In 1929 Sander's *Antlitz der Zeit (Face of Our Time)* was published, a book of sixty portraits meant to be the first volume in an extensive study of People of the Twentieth Century. The book fell foul of the Nazis and was banned in 1934. In the 1960s and early 1970s he was acknowledged as one of the exemplary artists in the history of the medium.

SARFATI, LISE *French (b. 1958)*
She became a full-time photographer in 1986, and was associated with the agencies Vu and Contact Press before joining Magnum Photos in 1977. A Postmodern colorist, she has specialized in Russian subjects.

SCHARFMAN, HERB *American (active 1930s to 1950s)*
Scharfman joined International News Photos as a motorcycle messenger in 1931, and became a news photographer ten years later. He specialized in sport, and in long-distance photography, using a 5 x 7 inch Graflex with a 40 inch telephoto lens.

SEELEY, GEORGE *American (1880–1955)*
Seeley was a typical artist-photographer of the early 1900s. He began to exhibit in 1904, and between 1906 and 1910 had his pictures published in Alfred Stieglitz's *Camera Work*.

SHAHN, BEN *American (1898–1969)*
Primarily a graphic artist and painter, Shahn was introduced to photography by the renowned Walker Evans. Both worked for the Farm Security Administration in the 1930s. Shahn used a right-angle viewfinder to take candid pictures in passing.

SINGH, RAGHUBIR *Indian (b. 1942)*
Raghubir Singh has taken and published more photographs of India than anyone in his generation. *The Grand Trunk Road* (1995) was his eleventh book. His tendency in the 1990s has been to show India in terms of small episodes and travel incidents.

SMITH, EDWIN *British (1912–1971)*
Smith trained as an architect, and took up documentary photography in 1935. After working across the spectrum he began to specialize in architectural pictures in 1950. *English Parish Churches* (1952) was the first in a distinguished series of books, followed by *English Farmhouses and Cottages* (1954).

STERNFELD, JOEL *American (b. 1944)*
Sternfeld began to work as a freelance photographer in 1966, and turned exclusively to color in 1968. He was one of the first to recognize the implications of color in reportage. *American Prospects* (1987) is his major book.

STRAND, PAUL *American (1890–1976)*
A student of the documentarist Lewis Hine, Strand was also influenced by Alfred Stieglitz, the art photographer. He made his name in the 1940s and after, with a series of regional studies of New England, France, Italy, and the Hebrides.

SUDEK, JOSEF *Czech (1896–1976)*
Sudek, trained as a bookbinder, lost an arm in World War I. He took up photography professionally in the 1920s, and in the 1930s and after he turned his attention to landscape in and around Prague resulting in, for instance, his celebrated *Praha Panoramatická* (1959).

SÜSSMANN, WALTER *German (active 1930s and after)*
Süssmann was one of the most capable of the great generation of Berlin photojournalists of c.1930. A Jew, he changed his name to Lueders on the Nazi takeover in 1933. In the U.S. he was known as Walter Sanders.

T

THOMPSON, CHARLES THURSTON *British (1816–1868)*
Thompson, originally an engraver, took pictures of exhibits at the Great Exhibition of 1851 in London, and at subsequent international exhibitions in 1855 and 1857. He worked as a museum photographer at the Victoria and Albert in London.

THOMSON, JOHN *British (1837–1921)*
A chemist by training, Thomson took up photography in the 1860s. He worked for years in the Far East, publishing his *Antiquities of Cambodia* (1867), and *Illustrations of China and its People* (1873–74). He became even better known for *Street-Life in London* (1877–78).

V

VACHON, JOHN *American (1914–1975)*
After several years of work as a file clerk in the photographic section of the Farm Security Administration, Vachon became a photographer in 1941. He then worked for Standard Oil until 1948, and after that for *Look* magazine. He was one of the most lyrical and even melancholic of all American documentarists.

VAN DER ELKSEN, ED *Dutch (1925–1990)*
An innovator, Van der Elsken came to fame in 1956 with *Love on the Left Bank*, a photo-novel made at a time when all around him were documentarists. *Bagara* (1961) is set in French Equatorial Africa, and it also has narrative tendencies. His art is surveyed in *Once Upon a Time* (1991).

VAN MANEN, BERTIEN *Dutch (active 1980s and 1990s)*
A Hundred Summers, a Hundred Winters, published in 1994 and made up of portraits of Russian people at home, as well as pictures of the homes themselves, is her principal publication.

W

WALKER, ROBERT *Canadian (b. 1945)*
Walker has always viewed the city – New York in particular – as a stimulus to Dadaist poetics, as a source of entertainment and learning, a true land of the imagination. He introduced himself in 1984 with *New York Inside Out*, prefaced by William Burroughs.

WARBURG, AGNES *British (1872–1953)*
Warburg began to exhibit in London in 1900, at a time when ambitious pictorial photographers exhibited rather than publishing. She became interested in color photography: the Autochrome and then the Raydex process.

WEBB, TODD *(b. 1905)*
After a career in banking, export, and gold prospecting in South-West and Central America, Webb turned to photography and from 1946 worked for the Standard Oil documentary project, using a large-format camera. From 1949 he worked for such illustrated journals as *Fortune* and *Life*.

WINOGRAND, GARRY *American (1928–1984)*
Winogrand studied painting in the late 1940s, and then photography with Alexey Brodovich at the New School for Social Research in New York. He became a specialist in the surreal "social landscape" photography which characterized the 1960s in the U.S.

WOLFF, PAUL *German (1887–1951)*
One of the most prolific of modern photographers, Wolff is especially associated with the Leica which he started to use in 1925. Wolff demonstrated that the Leica could be used across the photographic spectrum: landscape and portraiture to microphotography.

WYLIE, DONOVAN *British (b.1971)*
Wylie, who joined Magnum Photos in 1922, has always chosen to photograph society's margins, often among gypsies, travelers, and refugees.

TECHNIQUES AND INSTITUTIONS

Aerial photography

Nadar, the French portraitist, took the first aerial picture from a balloon in 1858, but aerial photography was only established during World War I. The German army developed a maneuverable "sausage" balloon capable of providing a stable platform even in high winds. Photography from aircraft became the norm during the later stages of the war, and in the 1920s aerial pictures were used in archaeology and map-making – see, for instance, O. G. S. Crawford's *Air-Photography for Archaeologists* (Ordnance Survey Professional Papers, no. 12, London, 1929), W. T. Lee's *The Face of the Earth as Seen from the Air: A Study of the Application of Airplane Photography to Geography* (American Geographical Society, 1922), and George R. Johnson's *Peru from the Air* (American Geographical Society, 1930).

Agencies

Agencies commissioned and distributed photographs, and constitute the infrastructure of photography. Their precursors in the 1890s distributed stereoscopic cards: The London Stereoscopic Company and Underwood & Underwood in Britain, the Keystone View Company and H. C. White & Co. in the U.S. Staff photographers, such as Tom and Bernard Grant, worked directly for newspapers – the *Daily Mirror* in their case. The growth of the magazine market in the late 1920s, especially in Germany, accelerated the growth of agencies, and the establishment of photojournalism as a profession. Berlin's principal agencies were Dephot (German Photo Service) and Weltrundschau (Worldpanorama), set up and directed by Simon Gutmann and Rudolph Birnbach respectively in 1928. Pacific & Atlantic was another famous name, taken over by Associated Press in the early 1930s.Previously Associated Press had distributed pictures, but became a commissioning agency in 1930. Many agencies, in their heyday in Berlin around 1930, were quite small, employing no more than two or three people. Some, dependent on one or two leading lights, flourished and then went under in a matter of years. Photographers and organizers moved from agency to agency or set up for themselves – Léon Daniel, for instance, an administrator for Associated Press in Berlin; he moved to New York in 1933. The German side of things is given in *Die Gleichshaltung der Bilder: zur Geschichte des Pressefotografie 1930–36* (*The Co-ordination of Pictures: on the story of press photography*), by Diethart Kerbs, Walter Uka, and Brigitte Walz-Richter (Berlin, 1983).

Albumen prints

This process was an advance on the salted-paper process. Paper was treated with a mixture of salt and egg white and allowed to dry; it was then sensitized with silver nitrate and allowed to dry in the dark. Contact prints were then made after long exposures. At first albumen was diluted with salt water to give a matte effect, like that in salted paper, but from the 1850s onward this process was discontinued in order to achieve more and more lustrous effects – high gloss by the 1870s.

Autochrome

In 1907 the French inventors, Auguste and Louis Lumière, introduced a color transparency process, which they called "Autochrome." This involved powdering one side of a glass plate with starch grains colored red, blue, and green. The grains were covered with a panchromatic emulsion. One side of the glass plate was untreated, and this faced the lens. The plate was then developed as a black and white negative, and treated chemically to make the image into a colored positive. Exposure was around forty times longer than with black and white. Autochromes were in use until the early 1930s.

Collodion process

An English inventor, Frederick Scott Archer, experimented with collodion (gun cotton dissolved in ether) sensitized with iodide of potassium. The solution was applied to glass plates and exposed while wet. It was a complicated business, but it did reduce exposure times greatly – to the benefit of portraitists. Dry collodion plates, introduced from the mid-1850s, were less sensitive and slower, but altogether more convenient, and could be bought ready prepared. Collodion remained in use until the 1880s, when it was replaced by the gelatin dry-plate process.

Color processes

Experimentation with color began in the 1870s. Ordinary collodion emulsion, then in wide use, contained silver bromide particles. When the emulsion was treated with aniline dyes, these silver particles became sensitive to the colors absorbed by the dyes. Experiments continued through the 1880s and the first gelatine isochromatic plates were marketed in 1882. Colors were mastered one at a time in the search for a properly panchromatic emulsion – first achieved around 1905 by the Otto Perutz Co. in Munich, and by Wratten & Wainwright in London. Dye transfer printing, which made use of three negatives, was developed in the 1920s. Dye coupler prints, made from color negatives, were introduced in the 1950s, and Cibachromes, printed from color transparencies, in 1963.

Chronophotography

There was enormous interest in the 1880s and 1890s in high-speed photography and the study of bodies in motion. Experiments started in the 1870s, carried out by Eadweard Muybridge in California, and by Etienne Marey in Paris. Motion pictures eventually resulted from these experiments, which were carried out – in the first instance – in the spirit of showbusiness. In Germany high-speed analytical photography was carried out by Ottomar Anschütz who developed a camera with very short exposure times – manufactured by Carl Paul Goerz – which became a favorite with early press photographers.

Daguerreotype

Louis-Jacques-Mandé Daguerre published his process for making direct positives in 1839. Silver-coated copper plates were treated with iodine and bromine vapors, making a light-sensitive halide. After exposure the plate was developed over a dish of heated mercury, and the image was then fixed in sodium thiosulfate. Daguerreotypes were unique images, and they were reversed – and at first needed long exposure times. The image also had to be protected under glass. By 1840–41 the process had been refined sufficiently to be used for portraiture. In the U.S. it remained in use for portraiture into the mid-1860s.

Development

The negative–positive process was invented by W. H. Fox Talbot in September 1840. He applied silver iodide to paper and this was then sensitized with a solution containing silver nitrate, acetic acid, and gallic acid. The paper was then exposed in a camera and developed as a negative using the same sensitizing solution, before being fixed in a solution of potassium bromide. In 1843 he patented an improvement: placing of the developed negative in a hot bath of sodium hyposulfite, to improve the whites and to increase permanence. This strengthening of the latent image was known at first as "physical" development.

Ermanox

The Ermanox camera, introduced in 1925, had the fastest lens in the world at the time – fast enough to make it possible to take indoor pictures in available light, at political conferences, for instance, and at boxing bouts. Pictures could be taken in electric lighting, with an exposure of only half a second. It was, however, a plate camera, taking one plate at a time which had to be replaced after each exposure, and it had to be used with a tripod. Focus and rangefinding were complicated, and out of doors it was inferior to the Nettel Contessa 6 x 9 cm plate camera. Tim N. Gidal in his important memoir, *Modern Pho-

tojournalism: Origin and Evolution, 1910–1933 (New York, 1973), remarks, however, that until 1930 both the Ermanox and the Leica "were chiefly regarded as little more than amusing playthings."

Farm Security Administration (F.S.A.)

In 1935, Franklin D. Roosevelt set up the Resettlement Administration as part of the New Deal. It was meant to improve the lot of poor farmers and of migrant farm workers. In 1937 it was absorbed by the U.S. Department of Agriculture and became the Farm Security Administration. In 1935 Roy Stryker, a young economics lecturer at Columbia University, was asked by Rexford Tugwell, a Roosevelt adviser, to prepare a pictorial documentation of rural areas and rural problems in the US. He was appointed Chief of the Historical Section. His appointees as documentary photographers included Arthur Rothstein, Walker Evans, Ben Shahn, Dorothea Lange, Marion Post Wolcott, and Russell Lee. They produced around 270,000 pictures before the project was wound up in 1943 – when Stryker moved on to manage a similar project for Standard Oil. The F.S.A. is the greatest collective enterprise in the history of the medium. Although never forgotten, it was substantially rediscovered in the 1970s, on the pages of *In This Proud Land: America 1935–1943 as seen in the FSA Photographs* (1974) by Roy Stryker and Nancy Wood.

The Family of Man

"The greatest photographic exhibition of all time – 503 pictures from 68 countries – created by Edward Steichen for The Museum of Modern Art." Steichen described the selection process – a shortlist of ten thousand pictures. "The photographers who took them – 273 men and women – are amateurs and professionals, famed and unknown." It looks like an enterprise of the U.N., meant to encourage international understanding. Its pastoral outlook has sometimes been criticized as unrealistic.

Flashlight photography

Experiments with artificial light are as old as the medium itself. In the 1860s magnesium wire which burned with a bright light, made it possible to take pictures at night, and in mines and Egyptian tombs. In the 1880s magnesium powder came into use. Flash bulbs, using aluminium wire in oxygen, were a development of the late 1920s. High-speed electronic strobe lighting was perfected at the same time, although it had been the subject of experiments from the 1850s.

Gelatin dry-plate process

This was developed during the 1870s in Britain by Dr. Richard Leach Maddox. It used gelatin as a base, in preference to either albumen or collodion, and was both sensitive and fast. Gelatin with its chemical additives had to be carefully prepared by heating, and this was best done commercially and on a large scale. Previously photographers had expected to be in control of the entire process themselves, preparing the plates, developing, and printing. From 1889 gelatin emulsions were also applied to roll film.

Gernsheim

Helmut and Alison Gernsheim worked together to produce *The History of Photography, from the camera obscura to the beginning of the modern era*, first published by the Oxford University Press in 1955. The Gernsheims took care of the technical development of the medium, gave it shape, and indeed established "the history of photography." Their preferences were for "straight" photography, as opposed to dishonest art photography.

Glass negatives

Abel Niépce de Saint-Victor, a French inventor, found a way of applying photosensitive materials to a glass base. The details were published in 1848. Glass plates were covered with a thin layer of

albumen (egg white) to which a solution of iodide of potassium had been added. These plates were washed with an acid solution of nitrate of silver, exposed, and developed with gallic acid. It was a slow process, but capable of rendering fine details. The perfect transparency of albumen on glass stimulated the development of magic-lantern slides and stereoscopic positives in the 1850s.

Leica
The Leica, which would be all-important in reportage, developed as a byproduct of the film industry. It was meant originally to replace unreliable exposure meters, and had a single shutter speed of 1/40th of a second. It was loaded with two yards of movie camera film, 24 x 18mm per frame. The focal plane shutter was coupled with a film advance system, as on a movie camera, thus guarding against double exposures. The inventor was a Dr. Oskar Barnack, who worked for the firm of Leitz in Wetzlar, and development took place from 1913. Barnack doubled the size of the frame to 24 x 36 mm, to allow for enlargement, and introduced a direct viewfinder and metal cassettes, to help with the preservation and changing of films. In 1924 Leicas – six of them – appeared on the market. They were popularized by Dr. Paul Wolff, originally a physician. By 1935 around 180,000 Leicas had been sold.

Magazines
In October 1896 the weekly *Paris Moderne* first appeared, featuring candid pictures of Parisian street-life, but it survived only until February 1897. *L'Illustration*, first set up in 1843, gained a reputation for documentary photographs of Paris from around 1900. Rotogravure, which was introduced in 1905, encouraged illustration by photography, but it was only in the 1920s that magazine publishing and photography integrated. Germany, for example, had the *Berliner Illustrirte Zeitung*, which came under the influential editorship of Kurt Korff around 1918 – until March 1933. In Paris *Vu* was established in 1928 under the editorship of Lucien Vogel. In England *Weekly Illustrated* was established in 1934 and *Picture Post* in 1938. In the U.S. *Life* came into being in 1936. German-Jewish émigrés were closely involved in the formation of the illustrated press in Britain and the U.S. In the 1950s television began to challenge the paramountcy of the illustrated weeklies.

Magnum Photos
This is the title of a cooperative photo agency established in 1947 by, among others, Henri Cartier-Bresson, Robert Capa, and George Rodger. Its first office was in New York, but others opened in Paris, London and, Tokyo. Magnum became synonymous with documentary and reportage from the 1950s onward. The organization was founded to give photographers greater control over their own work. Previously they had been little more than suppliers of material, which could be treated wilfully by editors. Magnum allowed its members to follow their own interests and even to stipulate how their pictures should be used.

Newspapers
The *Daily Mirror*, founded in London in November 1903, became the first newspaper – on January 7, 1904 – to be illustrated exclusively with photographs. It was followed by the *Daily Graphic* and the *Daily Sketch*. In France the first daily to use photographs throughout was the *Excelsior*, founded on November 16, 1910. Photographic half-tone illustrations had appeared in the press since the 1880s – the first half-tone reproduction from a photograph was in *The Daily Graphic*, New York, March 4, 1880.

New Topography
This term was introduced in 1975 by William Jenkins, organizer of the exhibition *New Topography: Photographs of a Man-Altered Landscape*,

staged at George Eastman House in Rochester, New York in 1975. The New Topography was objective, even forensic, with respect to urbanization and its impacts. The style established itself, and became the Postmodern style in photography, replacing the taste for street photography which flourished in the 1960s.

The Photo League
A New York organization with an interest in promoting documentary photography. It evolved from the Film and Photo League, set up in 1930 as a cultural branch of the Workers' International Relief, a charitable organization of the Left with its HQ in Berlin. The W.I.R. organized Workers' Camera Leagues in European and American cities. The New York section became the Photo League in 1936, and survived until 1951. It was put on a government blacklist in 1947 and its activities stifled. The League organized exhibitions and lectures, undertook documentary projects, and was a major influence in U.S. photography in the 1940s and 1950s.

Rotogravure
Printing from etched copper plates produced high-quality images, at great cost. The photogravure process was invented by the Austrian Karl Klíc in the 1880s, and then in the 1890s adapted for use on rotary cylinder presses, which allowed the rapid printing of large editions. Rotogravure was a great advance on half-tone, introduced in the 1880s, and it helped make the magazine into a major medium for photography. At first though, around 1910, it was used sparingly, in special sections.

Salted-paper prints
Positive prints made on uncoated paper soaked with light-sensitive silver salts: silver chloride, and sometimes silver iodide, silver bromide, and silver oxalate. Starch was sometimes applied to the paper to keep the silver from too great absorption. The salts were in themselves not light-sensitive, and had to be sensitized with silver nitrate just before use. Albumen prints were preferred from the 1850s onward.

The Standard Oil (New Jersey) Project
In 1941, Standard Oil was the world's leading producer and distributor of petroleum products, and it employed over 50,000 people in the U.S. To improve a tarnished public reputation Standard Oil turned to public relations consultants, who advised involvement in the visual arts – painting at first, unsuccessfully, and then photography. Roy Stryker, former head of the Farm Security Administration photographic project, was approached in 1943, and despite reservations he undertook similar work for Standard Oil. The project petered out in 1950, having accumulated 67,000 black and white images and at least 1,000 color transparencies. One of the greatest collective ventures in the history of the medium, it is all the more interesting for its focus on ordinary, small-town life rather that the scenes of hardship which had attracted the F.S.A. photographers in the 1930s. John Vachon, Harold Corsini, Edwin and Louise Rosskam, Esther Bubley, Gordon Parks, Sol Libsohn, Charlotte Brooks, and Todd Webb were among its employees. The collection is now held by the University of Louisville, and is introduced by Steven W. Plattner in *Roy Stryker: USA, 1943–1950*, published by the University of Texas Press in 1983.

Subjective photography
The German photographer Otto Steinert organized an exhibition of *subjektive fotografie* in Saarbrucken in 1951. His idea was to draw attention to individual and to national styles, and to stress that photography was creative, rather than merely documentary. It was one of many attempts to identify a new art for a new age, and to discard old styles grown tired. Steinert was successful, and the 1950s was an age of "subjective photography." See the catalogue "Subjective

Fotografie," introduced by Ute Eskildsen for the Folkwang Museum, Essen in 1984.

Szarkowski
John Szarkowski was curator of photographs at the Museum of Modern Art in New York from the 1960s through into the 1980s. He epitomized the idea of the curator as demiurge, as a gifted visionary able to intuit the import of photographs, anonymous as well as authored. His publications include *The Photographer's Eye* (1966), and *Mirrors and Windows* (1978). Photographs were "mysterious and evasive images" that, to the right eyes, might appear "ordered and meaningful." Europe's demiurge was Robert Delpire, although a publisher rather than a curator – and with more interest in the vital force of pictures, rather than their iconographic content. *In Our Time*, a survey of Magnum photography published in 1990, typifies Delpire's approach.

Waxed paper negatives
An important development in the 1850s, pioneered by a Frenchman, Gustave Le Gray. Paper was first waxed and then iodized with rice water, sugar of milk, iodide of potassium, cyanide of potassium, fluoride of potassium, white honey, and egg white. The paper was sensitized with an acid solution of nitrate of silver and developed with gallic acid. Le Gray worked for the Committee of Historic Monuments in France, and wanted to use photography on remote sites. Waxed paper negatives could be prepared up to two weeks before use and developed several days after exposure, a great improvement on calotypes, which had to be prepared on the day before use and developed immediately after exposure.

Wire photography – also telephotography and radiophotography
In principle these terms refer to the conversion of radio pulses into pictures. The process was developed by Arthur Korn in Germany between 1902 and 1907, and it depended on the properties of selenium, the electrical resistance of which varied according to its exposure to light. The original was scanned by a narrow beam of light and the transmission picked up by a cathode tube from which a negative was printed. The process was developed by the Frenchman Edouard Belin, and in 1914 a reportage picture transmitted by wire first appeared in *Le Journal*. It was refined during the 1920s and in widespread use during the 1930s. Horizontal transmission lines were a feature of wire pictures – especially during the Vietnam War – and became part of the rhetoric of news, signifying urgency.

Worker photography
In August 1925 the Neuer Deutscher Verlag, Berlin, began to publish the weekly illustrated *Arbeiter-Illustrierte Zeitung* or *AIZ* (*Workers Illustrated Journal*). It was modeled on the famous *USSR in Construction*, a Russian propagandist periodical established in 1921. The *AIZ* encouraged worker photography in Germany from 1926. The workers established their own magazine, a monthly – *Der Arbeiter Fotograf*. Their no-nonsense style of documentary helped purge European photography of old-fashioned artistic elements.

X-rays
X-rays were discovered by Wilhelm Röntgen working in the Institute of Physics in the University of Würzburg in Bavaria on November 8 1895. At the time he was working with a Crookes tube, or cathode ray tube (developed in 1879), sealed off behind black cardboard. He noticed a faint light and an image registered on fluorescent paint. X-rays passed through flesh but were impeded by bone and other hard substances. Röntgen's discovery caught the imagination immediately and seems to have stimulated a contemporary interest in invisible powers, vital forces emanating from the spirit and the unconscious.

INDEX

CREDITS

The photographs in this book are published courtesy
of the following:

Every effort has been made to contact holders of copyright
material. The publishers would be grateful to be informed of any
errors or omissions for inclusion in future editions.